MILWAUKEE
THEN & NOW

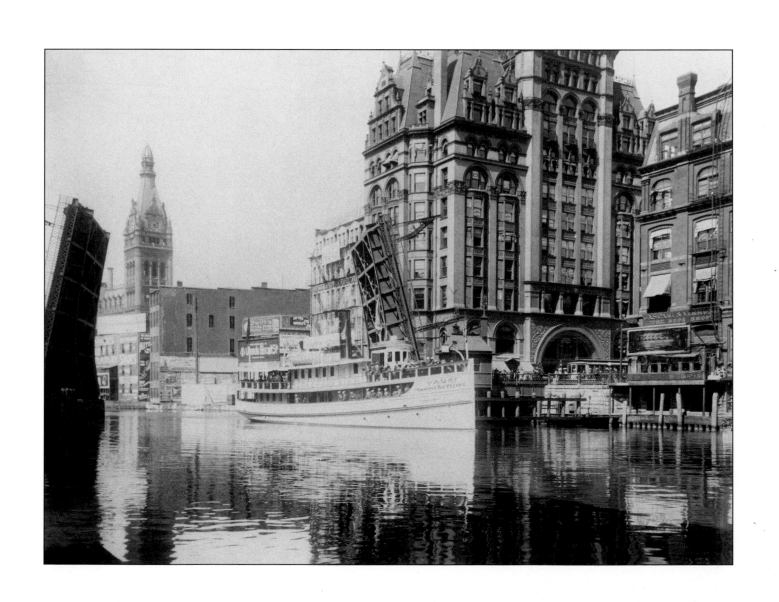

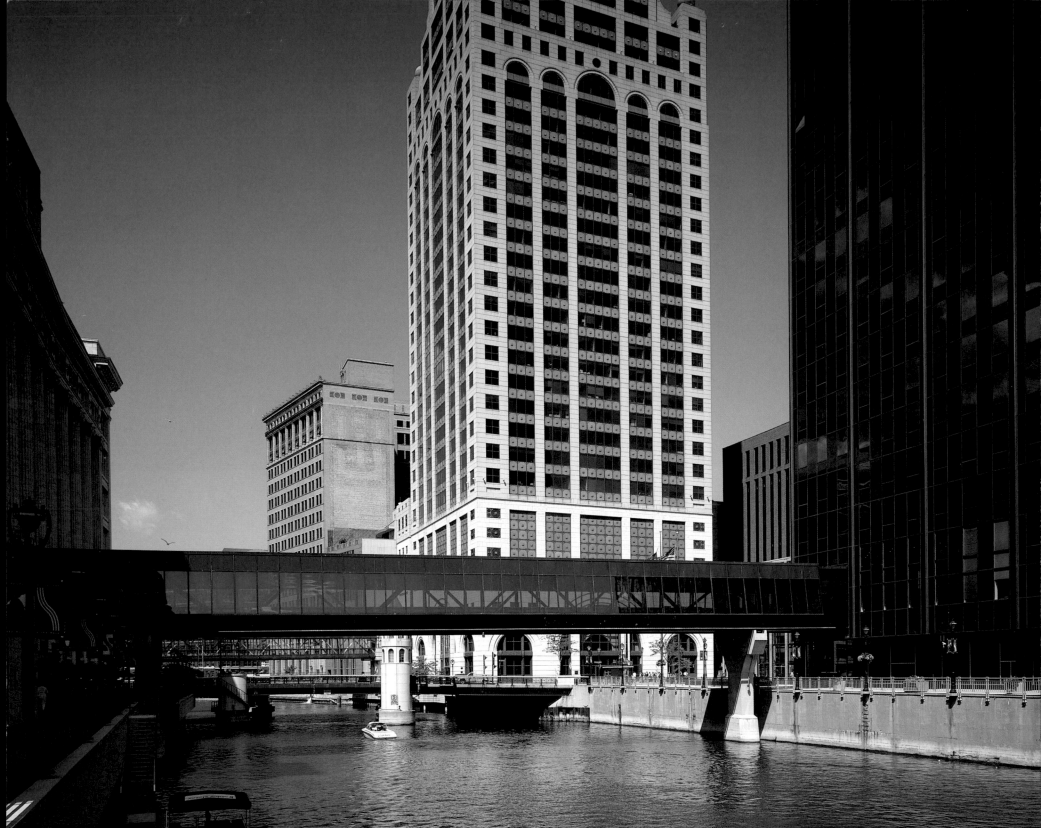

MILWAUKEE THEN & NOW

SANDRA ACKERMAN

THUNDER BAY
P·R·E·S·S

San Diego, California

Thunder Bay Press
An imprint of the Advantage Publishers Group
10350 Barnes Canyon Road, San Diego, CA 92121
www.thunderbaybooks.com

Produced by Salamander Books,
an imprint of Anova Books Company Ltd
10 Southcombe Street, London W14 0RA, U.K.

"Then and Now" is a registered trademark of Anova Books Ltd.

ISBN–13: 978-1-59223-203-1
ISBN–10: 1-59223-203-5

Library of Congress Cataloging-in-Publication Data

Ackerman, Sandy, 1940–
 Milwaukee then & now / Sandra Ackerman.
 p. cm
 ISBN 1-59223-203-5
 1. Milwaukee (Wis.)--Pictorial works. 2. Milwaukee (Wis.)--History--Pictorial works. I.
Title: Milwaukee then and now. II. Title.

F589. M643A23 2003
977.5'95'00222--dc22 2003070305

Printed and bound in China
4 5 6 7 8 12 11 10 09 08

ACKNOWLEDGMENTS

The publisher wishes to thank the following for kindly supplying the images
in this book:

"Then" Photographs:
All "then" photography in this book was kindly supplied courtesy of Milwaukee
County Historical Society, with the exception of the photographs on the following
pages:
Page 38 by kind permission Usinger's Famous Sausage.
Pages 68 and 70 courtesy of Frank Alioto.
Page 116 (both) courtesy of Harley-Davidson Photography & Imaging.
Page 120 courtesy of Historical Photo Collection, Milwaukee Public Library.
Page 122 courtesy of © G.E. Kidder Smith/CORBIS.

"Now" Photographs:
All "now" photography in this book was taken by Simon Clay (© Anova Image
Library), with the exception of the photographs on the following pages:
Page 61 courtesy of Summerfest (photographer: Dan Zaitz).
Page 107 courtesy of © Lee Snider; Lee Snider/CORBIS.
Page 117 (main) courtesy of Harley-Davidson Photography & Imaging.

Pages 1 and 2 show: Milwaukee River at Michigan then (photo: Milwaukee
County Historical Society) and now (photo: Simon Clay/© Anova Image Library);
see pages 52 and 53 for further details.

Special thanks to Wendy Haase of Greater Milwaukee Convention & Visitors
Bureau; Lisa Bisciglia of Harley-Davidson Motor Company; Steve Daily of
Milwaukee County Historical Society; Dana Hartenstein and Patrice Harris of
Summerfest; and Usinger's Famous Sausage, 1030 N. Old World Third Street,
Milwaukee.

Historic Milwaukee, Inc. (HMI) is a nonprofit education organization that fosters
awareness and appreciation for Milwaukee's history and the preservation of its
built environment. HMI is the recognized leader in creating awareness of and
commitment to Milwaukee's history and the preservation of its built environment.
HMI provides this through innovative, responsive programs and strong community
and civic alliances. HMI has over 800 members including 150 volunteers who
lead tours, do research, and offer assistance wherever needed. For more information
about the organization, check out the Web site at www.historicmilwaukee.org.

INTRODUCTION

Milwaukee has been described in many ways over the years: "the most German of American Cities," "City of Steeples," "City of Festivals," and "a Great Place on a Great Lake." However, its name comes from the Indians who made this area, "the gathering place by the waters," their home. Located on Lake Michigan, Milwaukee's harbor consists of the convergence of three rivers, the Milwaukee, Menomonee, and Kinnickinnic, which allowed settlers to move inland away from the whims of the lake.

It has been estimated that there were about 36,000 Native Americans in Wisconsin in 1660, representing the most important center of American Indian population in what was known as the West. The first white men to visit the area were fur traders and missionaries. The fur traders sold muskets, beads, blankets, textiles, and other goods in exchange for the Native Americans' beaver pelts. The area soon became a thriving trade center, attracting men such as Solomon Juneau, one of Milwaukee's founders, who arrived here in 1819 and built his log cabin and fur trading post along the Milwaukee River in what is now downtown Milwaukee. By 1834, Juneau was joined by Milwaukee's other founders, Byron Kilbourn and George Walker. When land went up for sale in 1835, all three men bought 160 acres each and established their villages—Juneautown, Kilbourntown, and Walker's Point. Milwaukee's population at that time was only 125, but it grew rapidly despite the repeated setbacks caused by a boom-and-bust economy and outbreaks of disease. By January 1846, when the three villages incorporated as the City of Milwaukee, the population was 9,500.

Many of the early settlers were Yankees from New York and New England. The Yankees were young, well educated, and seeking opportunity. Within a short period of time they had organized political institutions, church congregations, schools, and cultural activities. German immigrants began to arrive in Milwaukee at the time of the land sale in 1835, with large numbers following between 1848 and 1920. Many of the early arrivals were interested in farmland and were passing through Milwaukee on their way to the farming frontier. Those that had finished apprenticeships in Germany came knowing this growing town would welcome their skills. Others came for religious and political reasons, finding asylum here after the failed 1848 revolutions of the German states. Milwaukee developed a strong German ethnic orientation, but mostly the German residents stayed in their own community with their own churches, social clubs, stores, and German language newspapers.

In the early years, major commercial activities were tied to the land. By 1851, the predecessors of all four of Milwaukee's largest breweries were in operation, and by 1859, nine tanneries were turning out over $200,000 worth of product annually. From 1860 to 1890, a number of men became very successful and wealthy from the industries tied to the land and from real estate, banking, insurance, and the making of iron. Brewer Captain Fred Pabst, tanners Guido Pfister and Frederick Vogel, meatpacker John Plankinton, banker and railroad owner Alexander Mitchell, and others built commercial buildings and private residences that demonstrated the status of their owners.

From 1890 to the Great Depression, the production of machinery became a major industry in Milwaukee and there was a transition from small workshops to large factories and offices. After World War II, industries experienced changes, including loss of local ownership for many companies.

With the increased use of automobiles allowing people to move further out from the center of town, Milwaukee's downtown area began to decline. The building of the freeway system cut many neighborhoods in half as houses and businesses were leveled to make room for construction. Urban renewal in the 1960s also caused the demolition of vast areas of Milwaukee. As more and more mansions, homes, apartments, and commercial buildings fell to the wrecking ball, grass-roots groups began to form hoping to save what was still standing. Milwaukee adopted a preservation ordinance in an effort to strengthen the existing intact neighborhoods.

Renewal got its start in the Historic Third Ward when, starting in the 1980s, many empty or underused warehouses were converted into apartment units. Over the last four years, Milwaukee's downtown housing boom has exploded, with over 3,000 new condominiums and apartments either being carved out of existing buildings or included in new construction going on all over downtown. With an increase in business since the opening of the Midwest Airlines Convention Center in 1998, former office buildings are being converted to hotels. The new Calatrava addition to the Milwaukee Art Museum is attracting visitors from all over the world. New restaurants, coffee shops, and other retail businesses are opening to cater to the needs of visitors and the young executives and "empty nesters" that are now making downtown their home. New streetscaping has made the pedestrian walkways more pleasant, while "downtown ambassadors" help welcome visitors and hometown folks alike. All of these recent developments help to make Milwaukee's downtown a vital and vibrant destination, which in turn makes all of the Milwaukee area a great place to live.

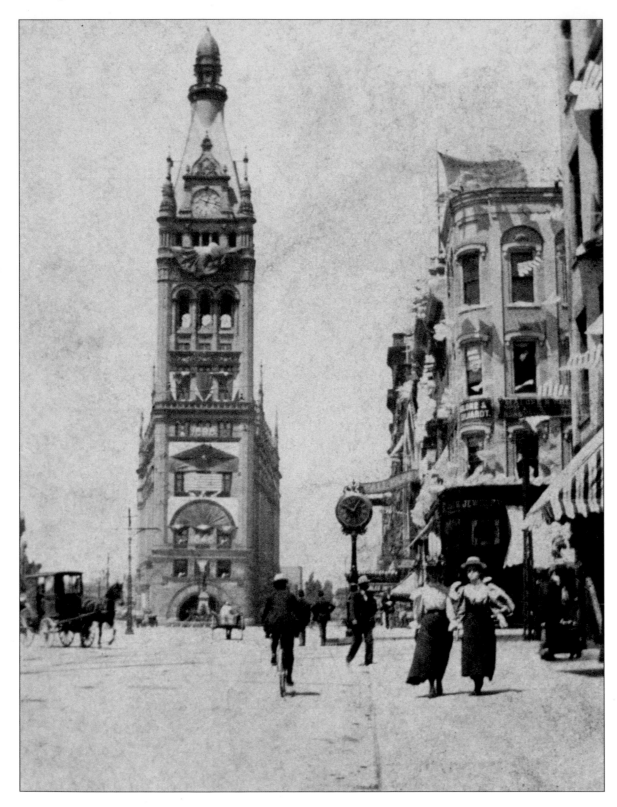

City Hall, just two years old when this picture was taken in 1898, was all decked out in bunting for a celebration of Wisconsin's fiftieth anniversary of statehood. This impressive structure was designed by the architect Henry Koch in a Richardsonian-Romanesque style and had Flemish-German Renaissance Revival influences. It replaced a smaller building—Market Hall—which housed both a farmers' market on the first floor and the city offices on the upper floor. City Hall's foundations consist of 2,500 cedar piles, driven into the marshy land found along the river.

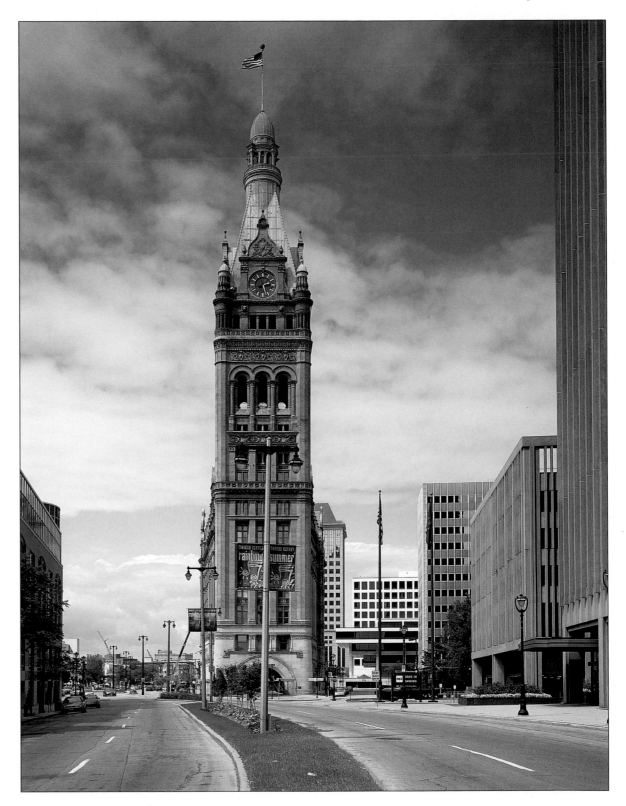

While much has changed around it over the years, City Hall still has a commanding presence downtown. The M&I Bank Building to the right may tower over City Hall, but the small-scale buildings to the left help to give balance to this stately building. City Hall's interior eight-story atrium was restored in the early 1990s and the rest of the interior was renovated. Local citizens raised money to have the bell restored, and now, after being silent for decades, the bell—named for city founder Solomon Juneau—rings on the hour. There are plans to restore the exterior in the future.

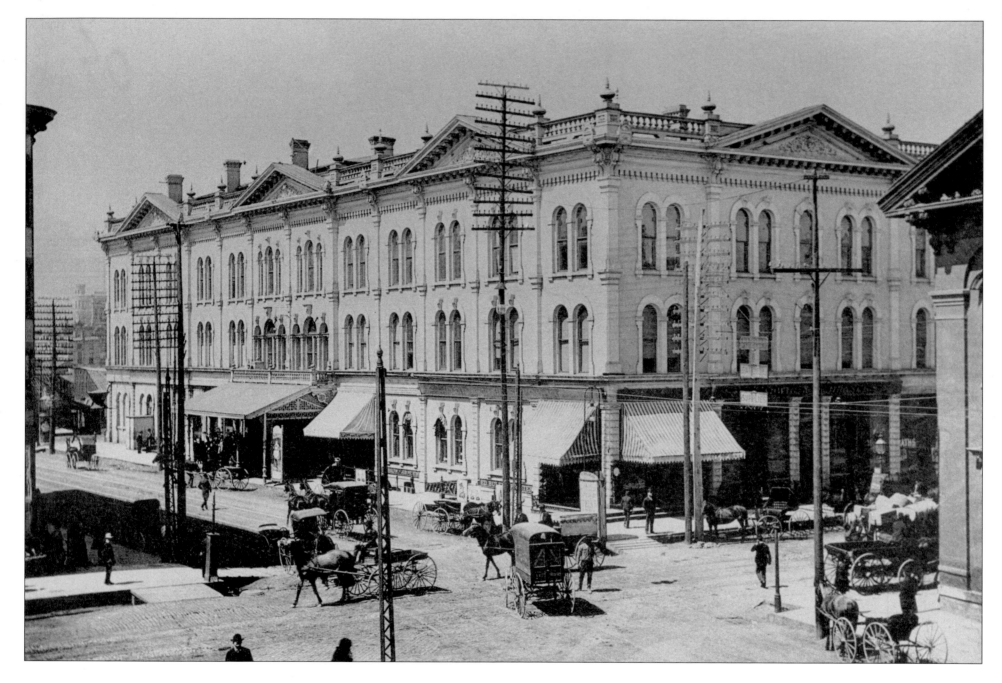

Nunnemacher Grand Opera House was located east of Market Hall (the building just visible on the right). Milwaukee already had a well-established German acting company at the Stadt Theater on Third Street, but when the Stadt closed in 1890, the company moved here. Captain Frederick Pabst bought the opera house in 1890 and renamed it the Stadt Theater. When this building was destroyed by fire in January 1895, Pabst, who was in Europe at the time, cabled home that another theater was to be built. The architect for the new theater, Otto Strack, worked for Pabst Brewing.

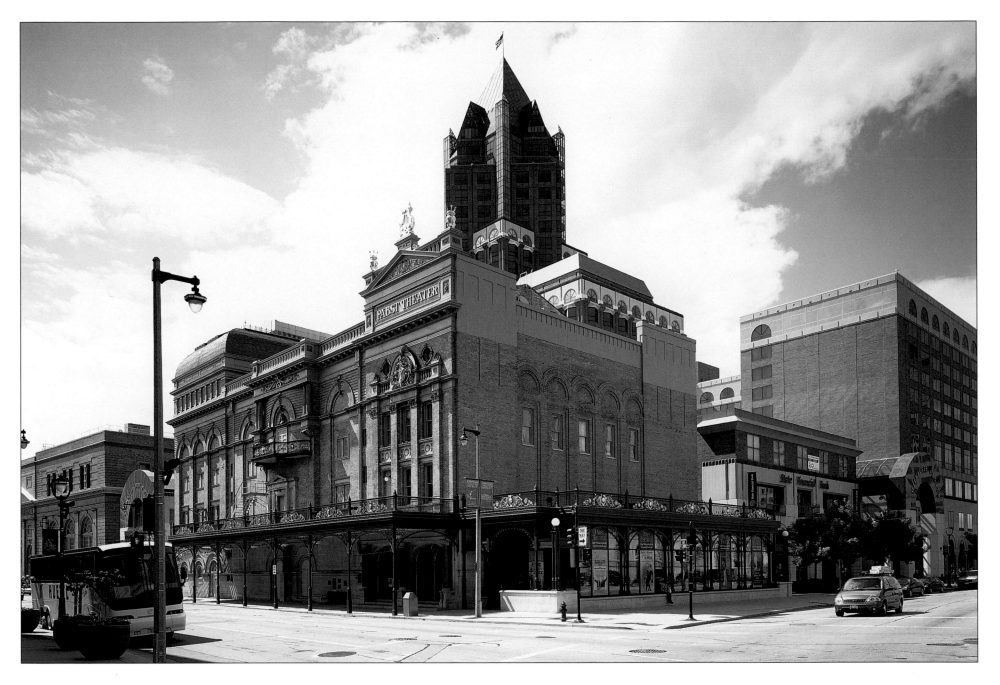

Pabst Theater was built in 1895, on the site of the razed Nunnemacher Opera House. It was designed in the German Renaissance Revival style and the brown-brick building has rich ornamentation, with wrought iron, sheet metal, and orange terra cotta. The interior has elaborate decoration and the acoustics are superb. The theater opened in November 1895 with a comedy in German and a show that traced the history of German theater in Milwaukee. In 1976, the City of Milwaukee purchased the theater and restoration work began. It changed hands again in 2001, when philanthropist Michael Cudahy purchased the theater from the city. The Pabst now offers a variety of musical shows and concerts.

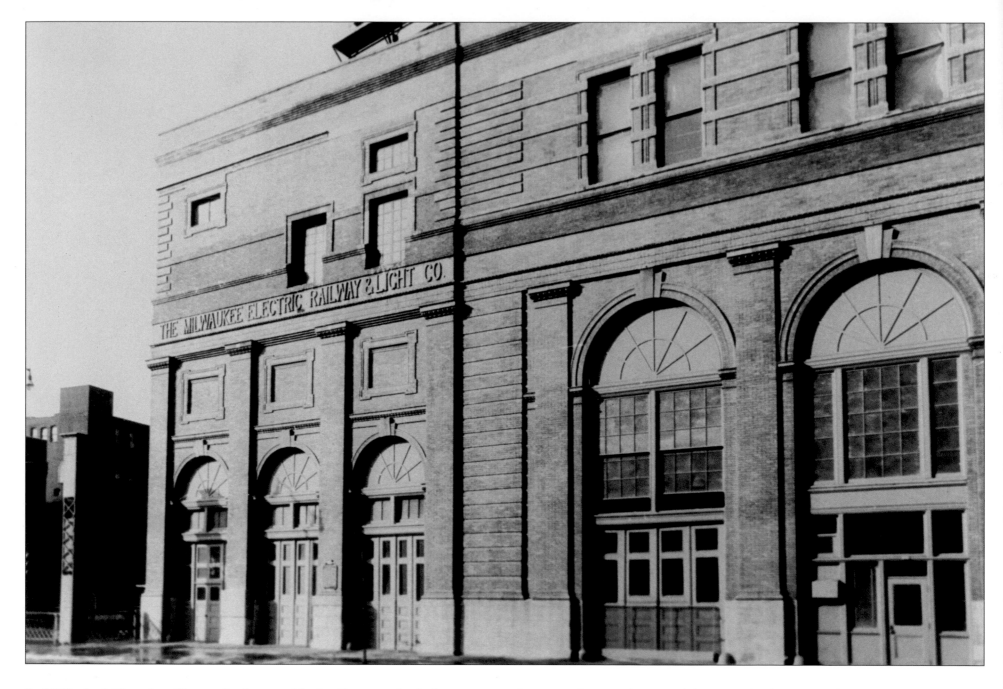

In 1900, the Milwaukee Electric Railway and Light Company built this power station designed by the architect Herman J. Esser. The building was used to provide steam for heating downtown buildings. Here, pulverized coal was burned to produce electricity, an innovation that was a radical departure from conventional firing methods. It gained international acceptance and resulted in reduced costs for electric power for both producers and consumers worldwide. This innovation won the Milwaukee company an award in engineering.

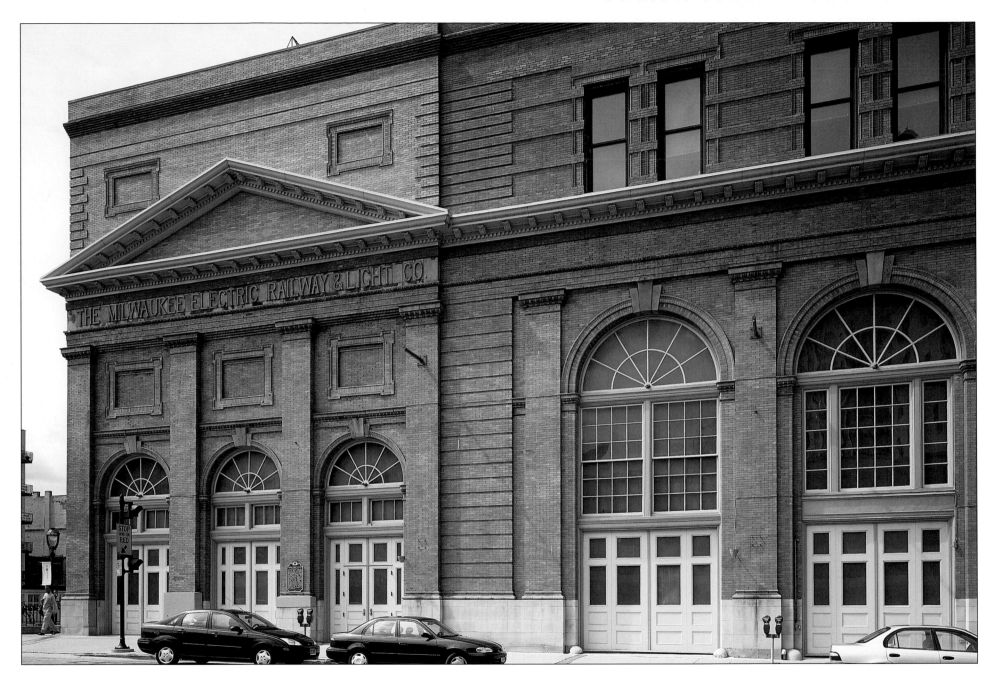

When the new power station was built in the Menomonee Valley, this power plant closed. Wisconsin Electric (now We Energies) donated the building to the Milwaukee Repertory Theater, who had been using one of the smaller stages in the Marcus Center for the Performing Arts. The building was renovated and now houses the large Quadracci Powerhouse Theater, the Stiemke Theater, the Stackner Cabaret, and rooms for costuming and scenery building. The Milwaukee Repertory Theater celebrated its fiftieth anniversary in 2003, and the building is listed on the National Register of Historic Places.

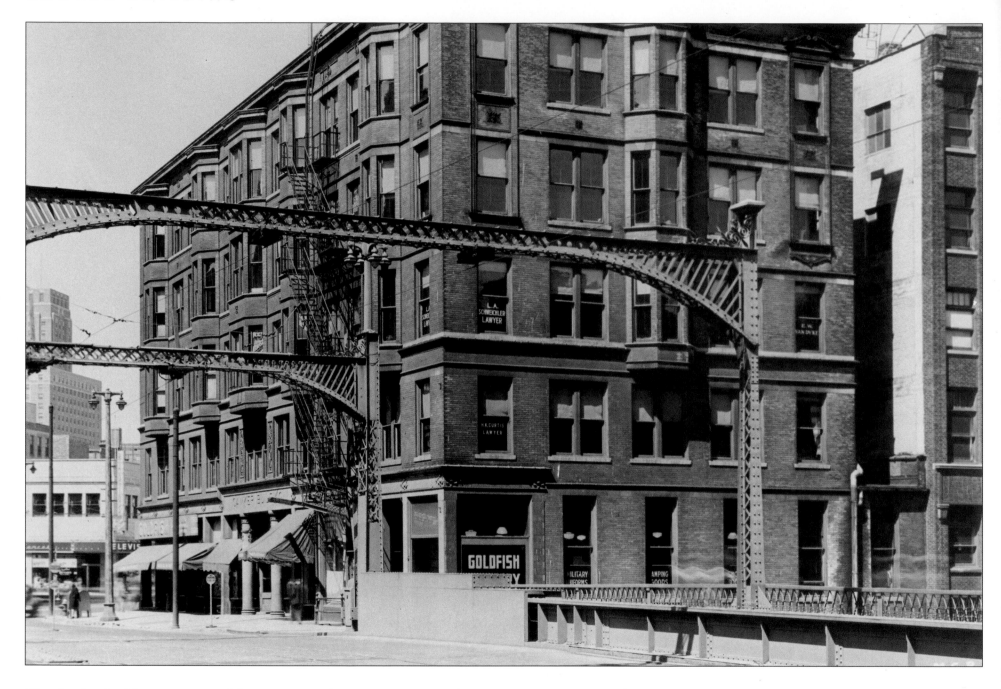

The Cawker Building, constructed for Lenore Cawker in 1897, is located at the west end of the Wells Street Bridge. The office building was referred to as "the lawyers' building" simply because of the many lawyers who had their offices there. Lenore's family lived just west of the Pabst Mansion on Grand Avenue. Cruel destruction of stray animals by the city pound prompted Lenore to start a shelter for these animals in the barn located behind the family house. Although the Humane Society existed, it functioned to prevent cruelty to children, livestock, horses, and helpless adults, but not stray animals. In 1928, Lenore Cawker bought property at Thirty-seventh and Wisconsin and built a shelter that closed in 1930. Since then, the Humane Society's chief function has been the sheltering of small, stray animals.

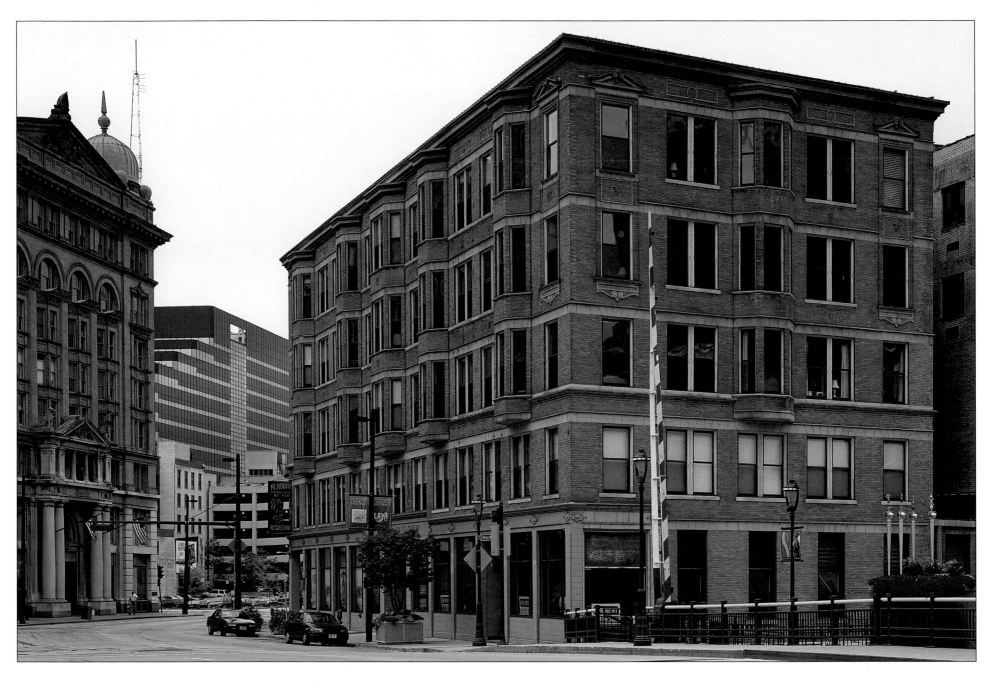

In 1997, developers Dick Leep and John Raettig renovated the Cawker Building. The four upper floors were turned into seventeen airy condominium units—some of the first on the west side of the river. When barn-board panels from the 1960s were removed from the exterior, cartouches, terra-cotta scallops and rosettes, and the shadow of an ornamental ribbon streaming down the side of a battered column emerged. Stonework that didn't fare so well was either restored or replicated, using old photos for reference. The first floor contains retail space including Aladdin's Restaurant.

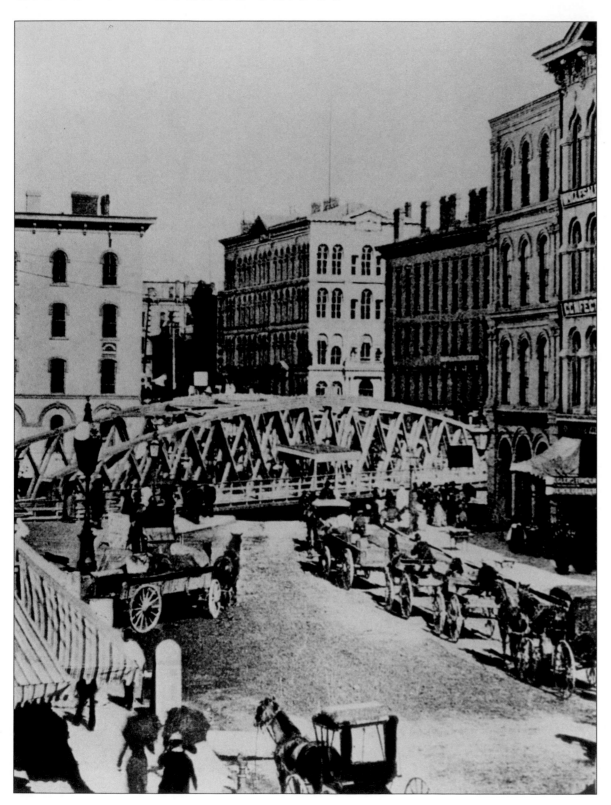

This Civil War–era picture shows the swing bridge between Spring Street (later Grand Avenue) on the west side and Wisconsin Street on the east side of the Milwaukee River. When land went up for sale in 1835, Solomon Juneau, a fur trader, bought land east of the river and Byron Kilbourn, a surveyor, bought land west of the river. The serious competition for newcomers between Juneautown and Kilbourntown was helpful at first. The bluffs along the river were leveled to fill in the wetlands and roads were built, as well as hotels where early settlers could find lodging. However, due to lack of cooperation in those early years, the roads did not line up at the river and they did not have the same names.

The small-scale buildings gave way to today's larger office buildings. The glass curtained building on the right is the twenty-eight story Marine Bank Building constructed in 1961. Its construction marked the beginning of the revitalization of downtown Milwaukee and was the first new building in downtown in decades. The large building on the left, the 100 East Building, stands on the site of Solomon Juneau's trading post and cabin, where the *Milwaukee Sentinel* was first published in 1837.

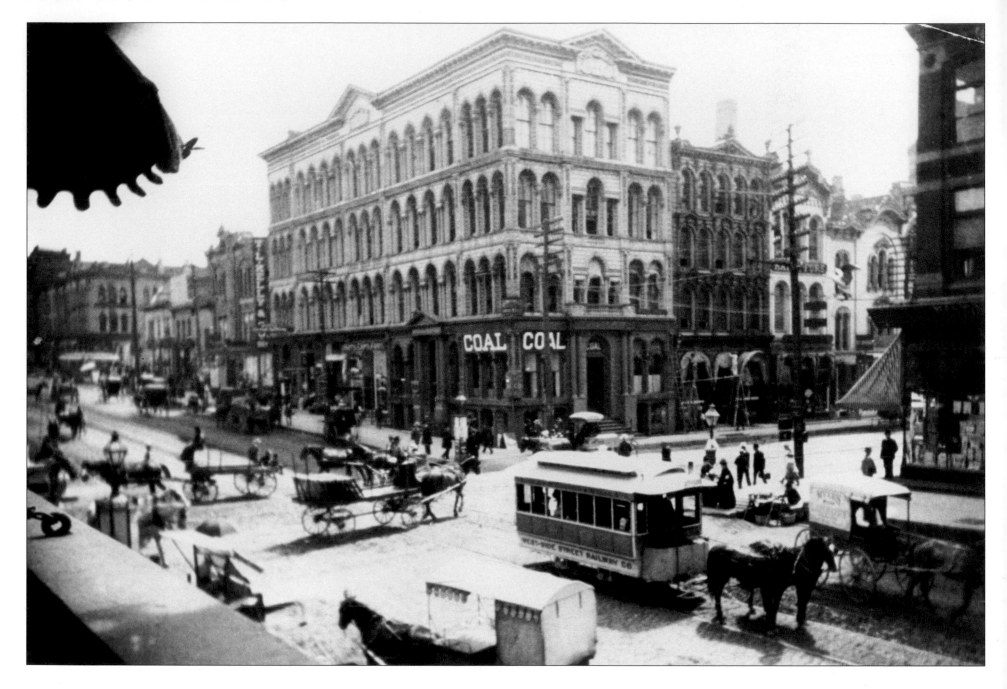

In 1860, James Baynard Martin commissioned George H. Johnson to build an Italian Renaissance–style office block. The framing of the Iron Block is conventional brick and timber, but the north and west facades are cast iron, manufactured at Daniel Badger's Architectural Iron Works in New York City. Cast-iron buildings were considered safe during thunderstorms because the exterior of the building would conduct lightning down to the ground and cast iron was regarded as fireproof. However, during the Chicago Fire it was discovered that in great heat, the cast iron would melt and pull the building down with it.

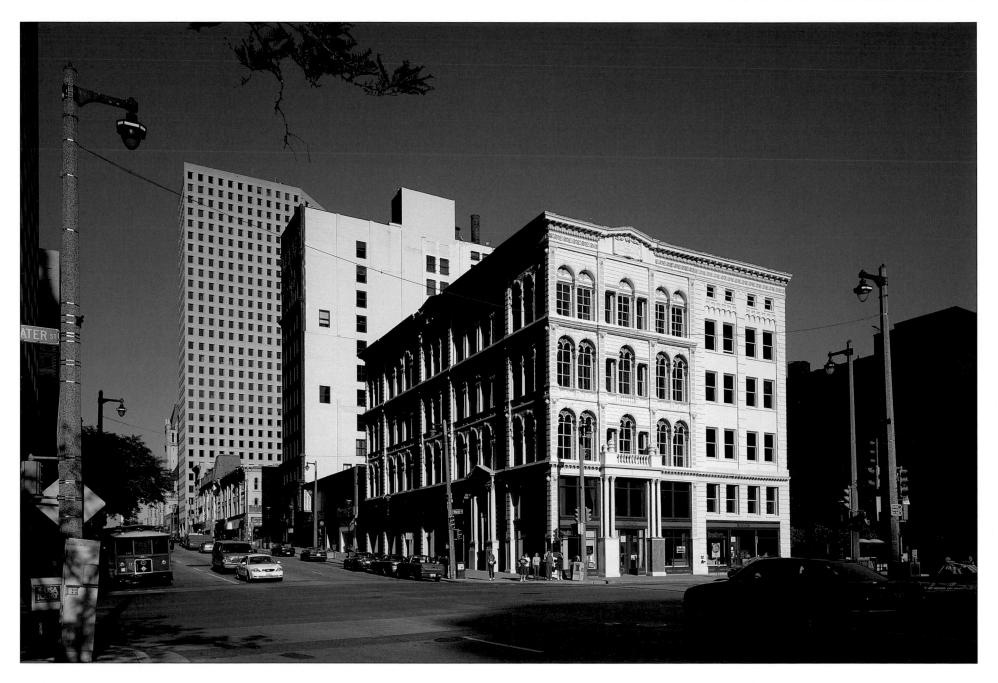

Another problem associated with cast-iron buildings was that they rusted and had to be painted often. Milwaukee's Iron Block Building suffered the same fate, and in 1983, its rusted facade was an eyesore. Developer Charles Trainer purchased the building and a facade easement was granted to Historic Milwaukee—a nonprofit education organization. This allowed the developer to take advantage of federal tax incentives and to assign a value to the easement, claiming it as a charitable deduction in order to receive low-interest loans. Today the restored Iron Block Building is a reminder of bygone days.

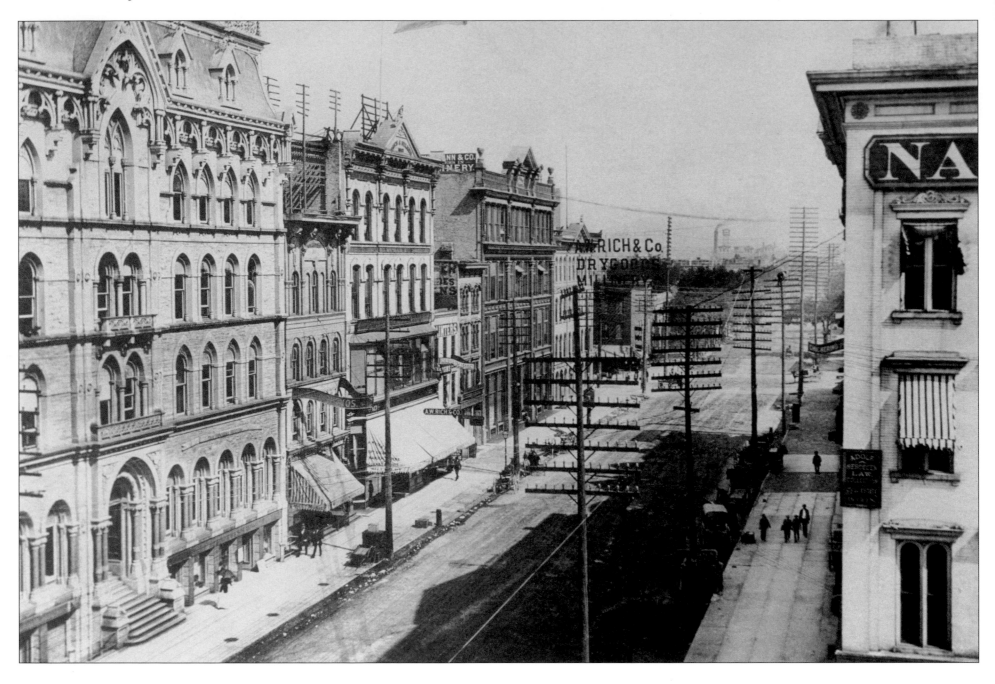

In this early view of Broadway looking north from Wisconsin Street, the building on the left is the third home of the Northwestern Mutual Life Insurance Company. The company started in Janesville, Wisconsin, in 1857, and in 1859 they moved to Milwaukee. After renting in several buildings, they moved into this High Victorian Gothic–style building designed by the architect E. T. Mix. A few doors down on the left, the A. W. Rich & Co. sign is visible. A. W. Rich was a Hungarian Jew who began an optical company in the town in 1863, then moved on to start a business that sold corsets and hoopskirts before eventually opening a dry goods store that was the largest in Milwaukee. The large building on the right is the home of the National Fire Insurance Company. At one time, the Milwaukee House Hotel, considered the finest in frontier Milwaukee, stood on that site.

Today Broadway is lined with modern office suites and parking structures. The building on the left is 250 Plaza and includes an office tower, parking structure, and Grenadiers Restaurant. The tall building on the right, behind the glass-curtained Wisconsin Building, was built by the Wisconsin Telephone Company. An eight-story building was completed in 1919 on the site of their original offices. Five additional floors were added in 1924 and three more in 1930. The building is faced with orange brick, trimmed with tan terra cotta, and capped by three penthouse floors and a massive hipped copper roof.

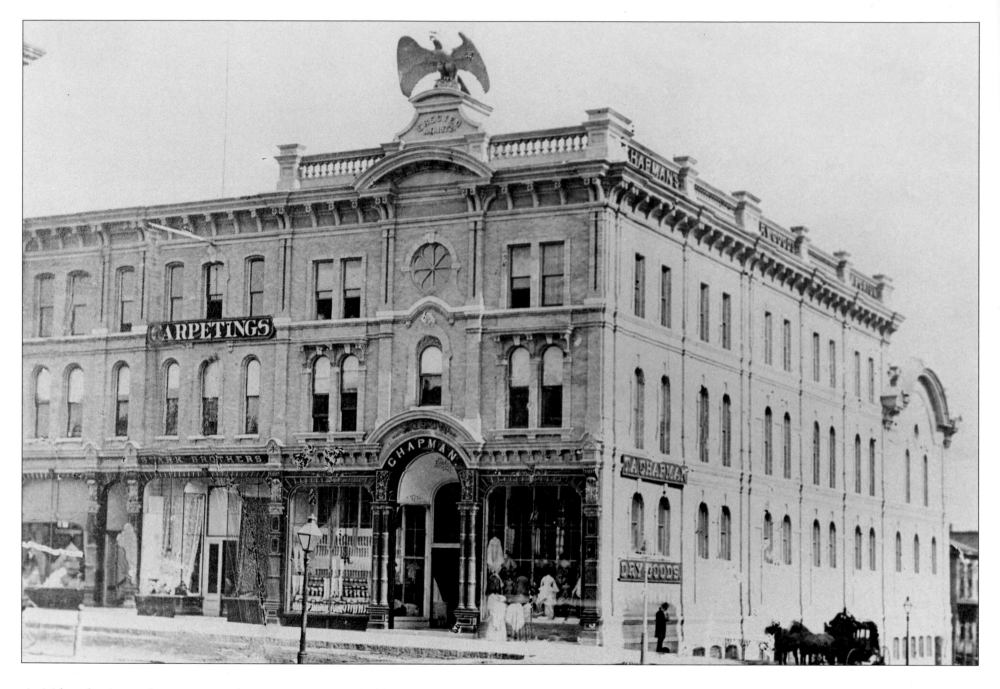

As Milwaukee's population grew and its economy expanded because of job and wage improvements, many of the residences along Wisconsin Street were razed to make room for retail businesses. T. A. Chapman moved his department store from East Water to Milwaukee Street in 1877. After this building burned in 1884, a new, larger building was constructed and featured four large murals in the skylight that were visible from the main floor. Chapman's was an upscale department store that operated at this location until 1981. Their branches at Mayfair, Northridge, and Bay Shore malls have also closed.

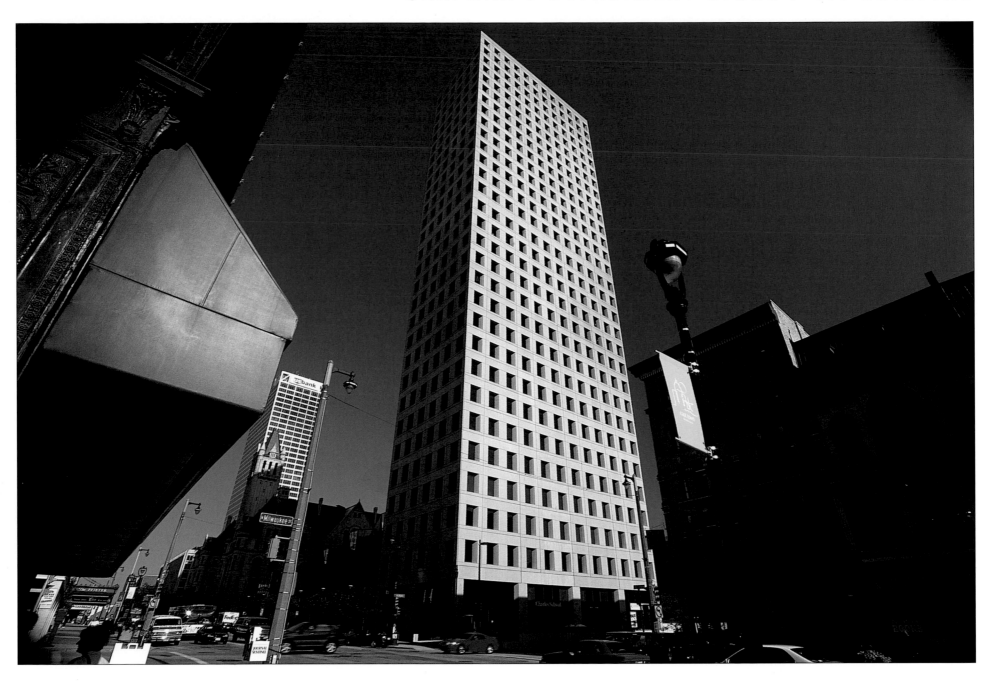

The postmodern 411 Building was completed in 1985 and designed by Harry Weese & Associates of Chicago. This thirty-story, six-sided building is the third tallest in Milwaukee. The U.S. Bank Building to its left is the tallest and the 100 East Building just west of here is second tallest. The beige concrete building has deeply inset bronzed windows, and the secluded garden on the east of the building offers a retreat from the downtown noise.

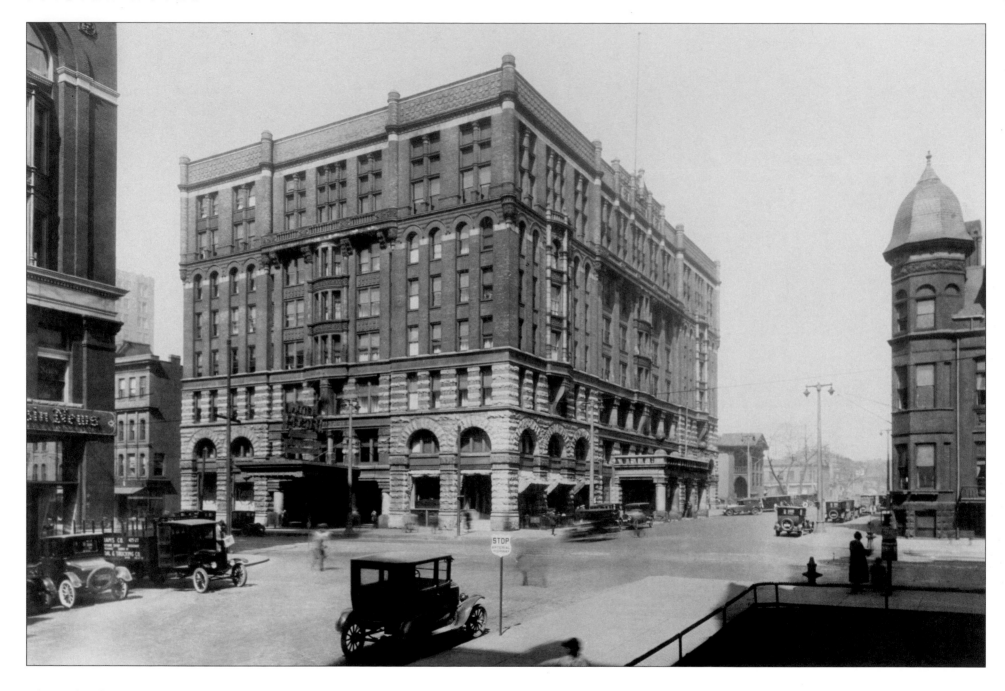

The Richardsonian Romanesque style Pfister Hotel, designed by architect Henry Koch, was completed in 1893. Tanner Guido Pfister had wanted to build a fine hotel, and after he died, his son Charles carried out his father's dream. According to the *Milwaukee Sentinel*, the opening of this "Grand Hotel" was to Milwaukee what the opening of the World's Colombian Exposition was to Chicago. The turreted building to the right is the Milwaukee Club, an exclusive businessmen's club organized in 1882. Alexander Mitchell, a financier, railroad magnate, and former U.S. Congressman, was its first president.

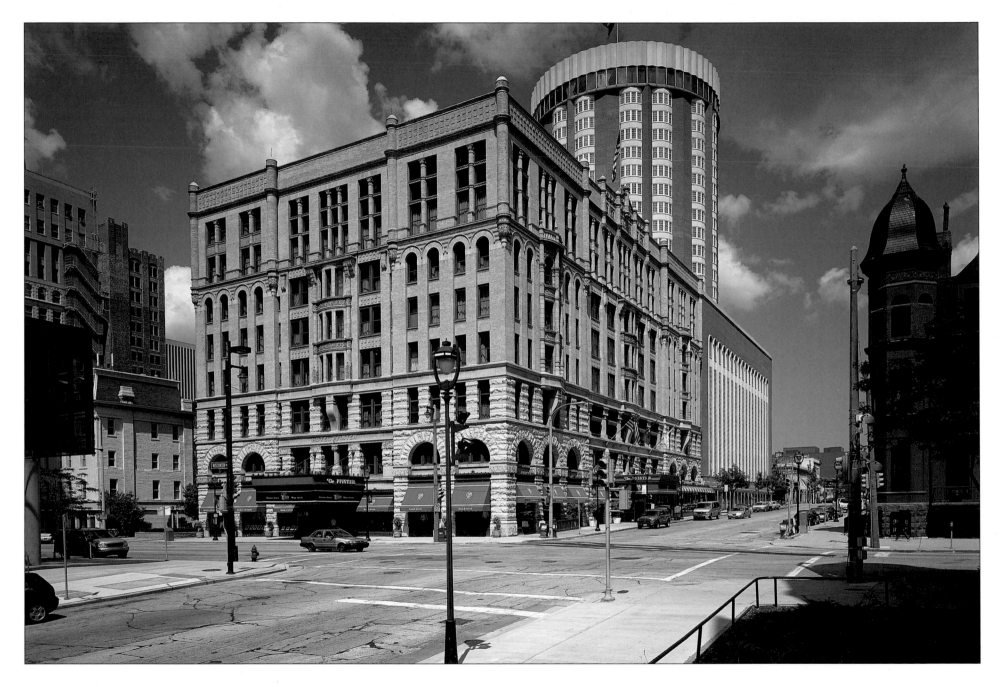

The twenty-three-story tower added to the back of the hotel was constructed in 1962, on the site of the original Pfister home. The lobby was restored in 1992 to its former grandeur. The celebrated Pfister Art Collection comprises eighty pieces of nineteenth- and early twentieth-century salon and genre works and are on permanent display in the lobby, mezzanine, and grand ballroom. The Pfister continues to attract distinguished travelers. The Hall of Presidents meeting rooms are named for Presidents Roosevelt, Taft, McKinley, and Kennedy, in recognition of these former guests. Many celebrities, artists, and politicians, from Sarah Bernhardt to the Beatles, Buffalo Bill to the Baroness Rothschild, have stayed at the Pfister.

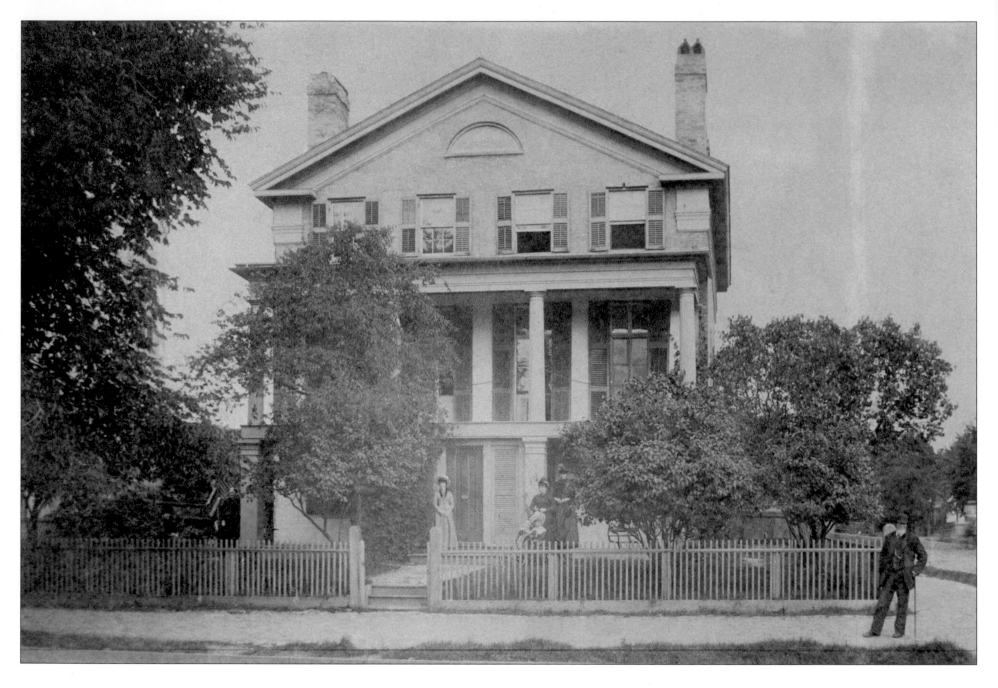

In the summer of 1843, Reverend Lemuel B. Hull, rector of St. Paul's Episcopal, built the first brick dwelling at Wisconsin Street and Jackson Avenue in what was then Juneautown. The house is in the Greek Revival style that was very popular from 1820 to 1865 and evoked nostalgia for past civilizations. The brick used for this house would have been made at one of the new brickyards along the lakefront. When bricks were made from the clay found along the shores of Lake Michigan, they turned cream-colored instead of red or brown because of the chemical makeup. The light-colored brick earned the city the nickname of "Cream City."

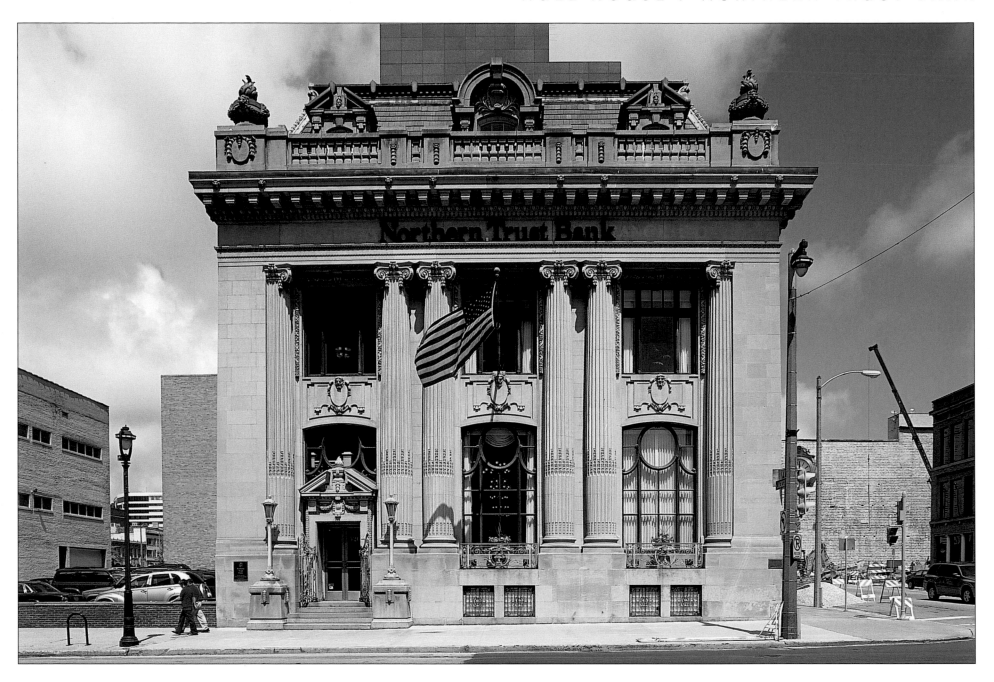

The Northwestern National Insurance Company was a general fire and marine insurance business started in 1869. They built a new building here, on the site of the old Hull House, in 1906. Alexander Mitchell served on the board of directors and was the first president of the company. Architects Ferry and Clas used the French Renaissance style of the eighteenth century for the three-story building and Cyril Colnik designed the bronze grillwork. At each corner is a stone urn surrounded by a flame-shaped carving that symbolizes the ancient warning signal for mariners. The building is now home to the Northern Trust Bank.

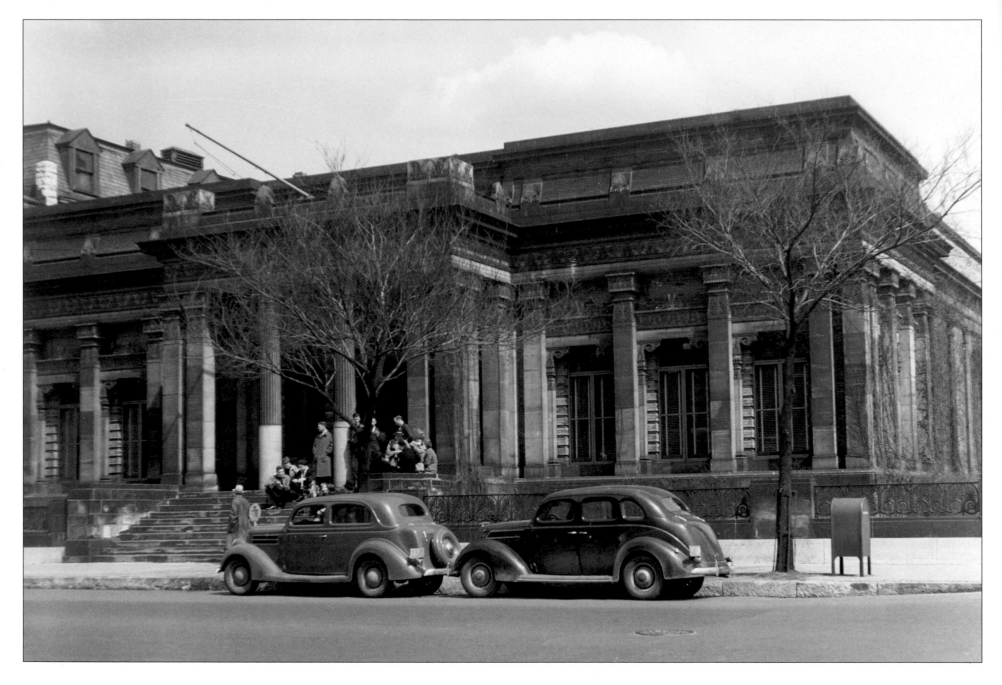

Frederick Layton and his father John came to Milwaukee in 1843 from England and opened a successful meatpacking business in the downtown area. Frederick became one of Milwaukee's wealthiest men. He loved art and wanted to share that passion with other Milwaukeeans. In 1888, he erected this spacious gallery, filled it with his own art collection, and set up an endowment for its operation. In 1910, the Milwaukee Art Society (later Milwaukee Art Institute) moved into a building just north of the Layton Gallery. In 1957, the Layton Art Gallery and Milwaukee Art Institute moved into the newly built Milwaukee County War Memorial Center art gallery designed by Eero Saarinen.

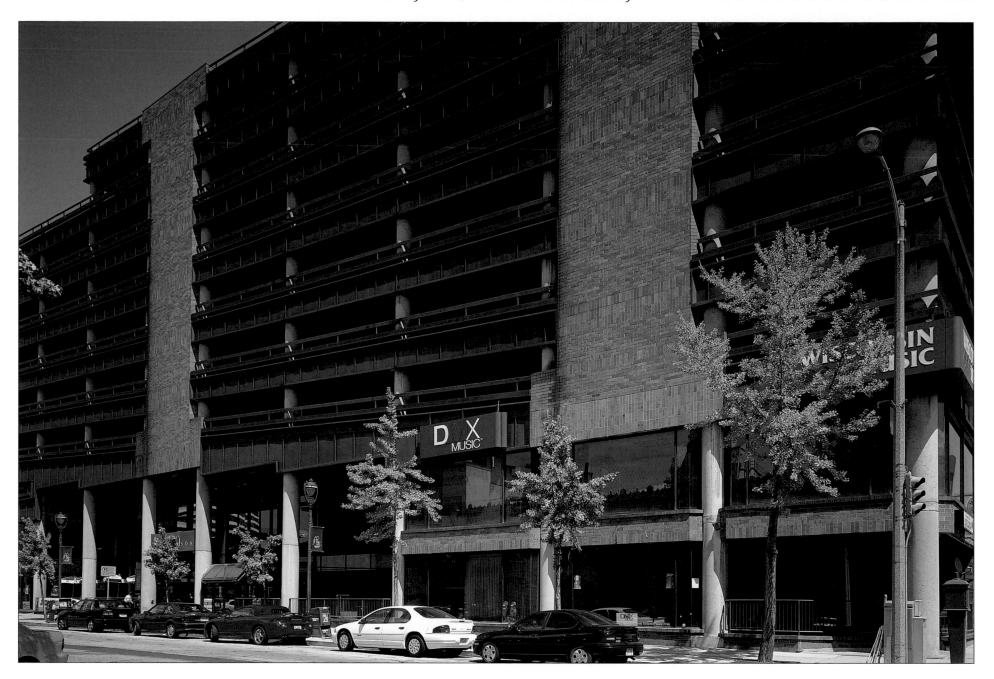

Urban renewal caused the demise of many buildings downtown, including the Layton Art Gallery, the building that housed the Milwaukee Art Institute, a Moose Lodge, and a Masonic Temple. In 1975, the 770 Jefferson Building was constructed on the site of the old Layton Art Gallery. Today, the 770 Jefferson Building is a combination of office and retail space with an attached parking structure.

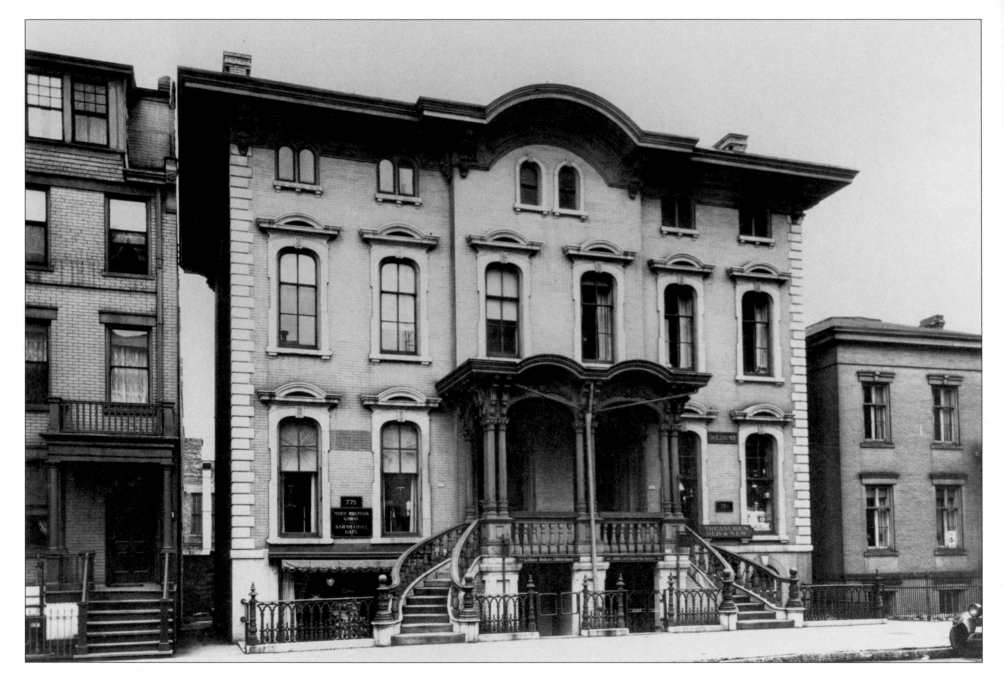

This luxurious double town house was constructed in 1860 for Matthew Keenan, by the architect E. T. Mix. The upper floors were used by the family, with the basement level reserved for the kitchen and servants' quarters—a typical arrangement in urban and rural houses—and there may have even been a ballroom on the third floor. Matthew Keenan was a prominent Milwaukee businessman and politician and was at one time a vice-president of the Northwestern Mutual Life Insurance Company, clerk of court, tax commissioner, alderman, state representative, vice-president of the Chamber of Commerce, and a regent of the University of Wisconsin.

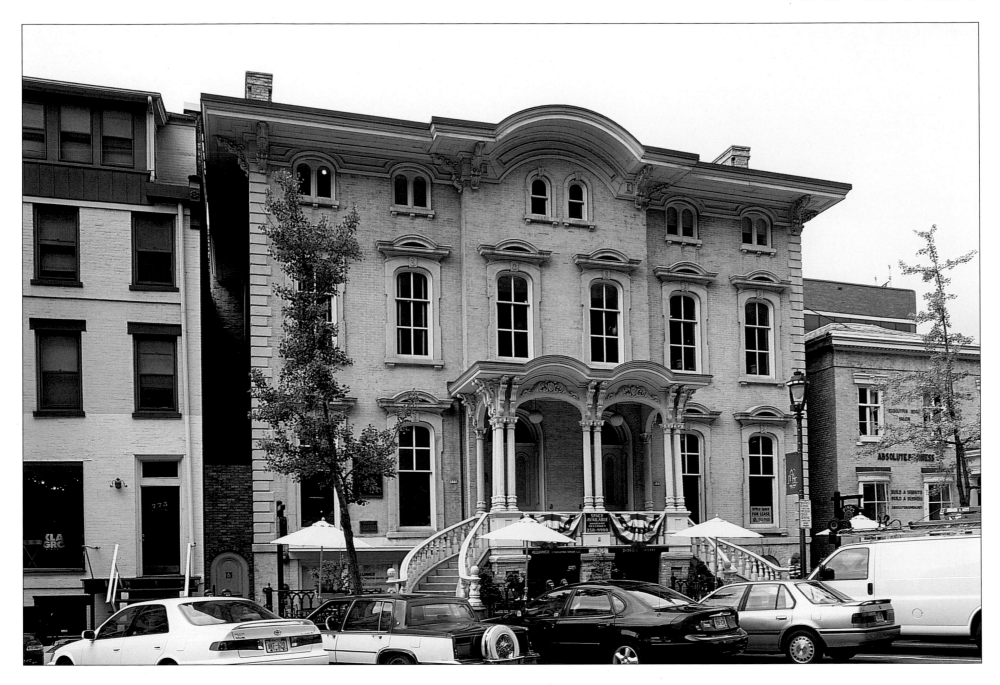

Keenan died in 1898 and his widow lived here for eight more years. After this time the building had a variety of occupants including the Milwaukee County House of Detention and the Wisconsin Players Drama Club. Later the building housed offices and stores. A major tenant on the ground floor for many years was the Madame Kuony Postilion Great House Restaurant and the Madame Kuony Postilion School of Culinary Arts. However, a fire in February 1984 gutted the building and only the facade and exterior walls survived. The exterior of the building has since been restored with modifications made to the interior, and it once again houses offices.

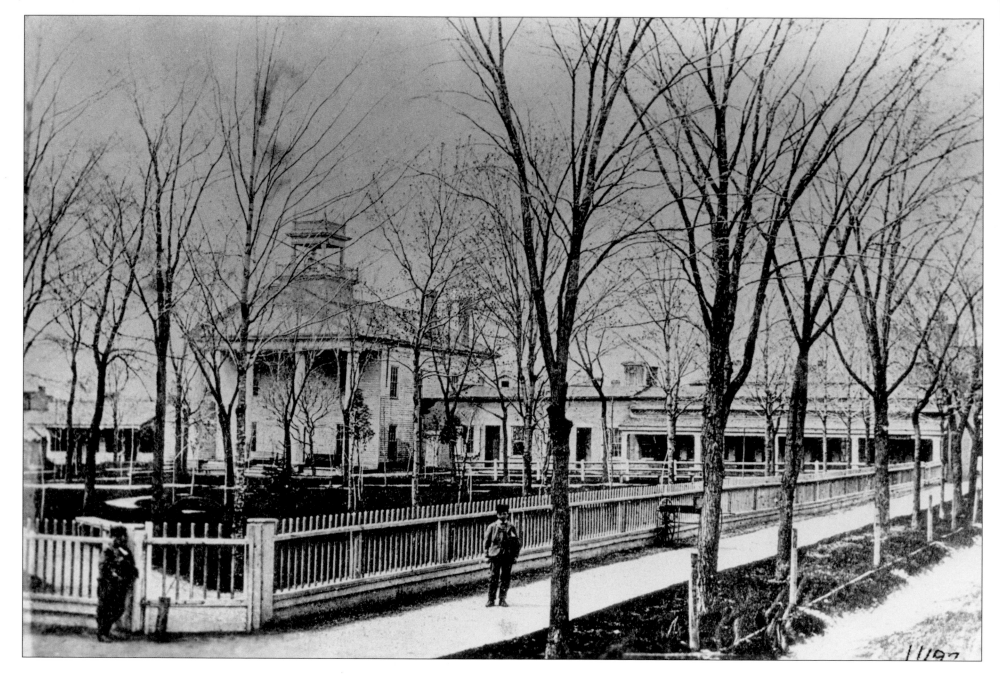

Early open public spaces were donated to the city by its founding fathers—Solomon Juneau donated what became Courthouse Square, and in 1836, Juneau and Morgan L. Martin, his financial partner, built this Greek Revival courthouse on the north end of the square. The other surrounding buildings housed various county offices. In 1870, a larger courthouse was built on the square and remained there until 1939.

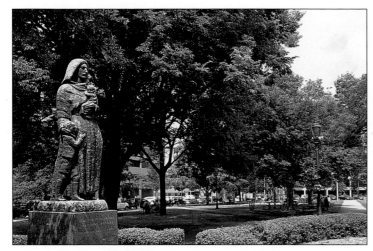

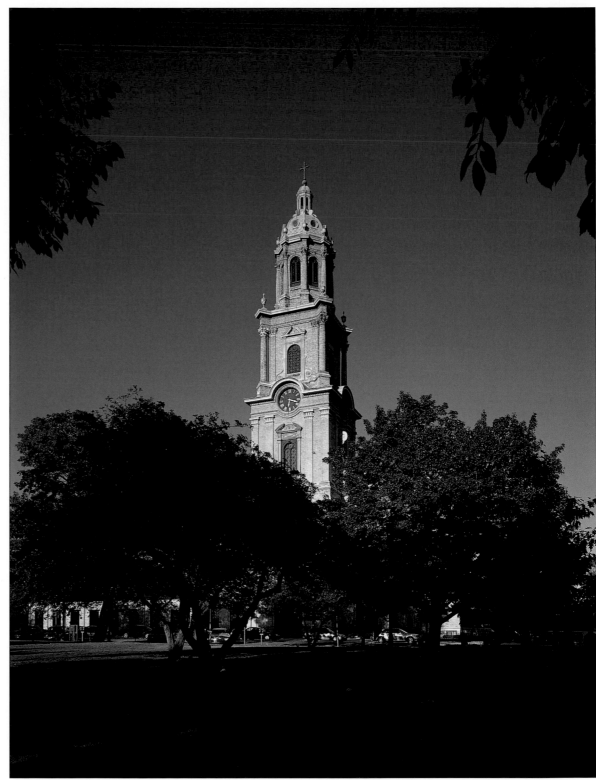

After the second courthouse was demolished in 1939, the site became a county park and the square was renamed in honor of St. John's Cathedral located just east of the park (*right*). The statue Valiant Immigrant Mothers (*above*) is the work of the Croatian-born sculptor Ivan Mestrovic and was donated by Milwaukee publisher William George Bruce in honor of his mother. During the summer and early fall months, a farmers' market takes place every Saturday morning, and on Thursday evenings during the summer, Jazz in the Park is a popular music event held in the square.

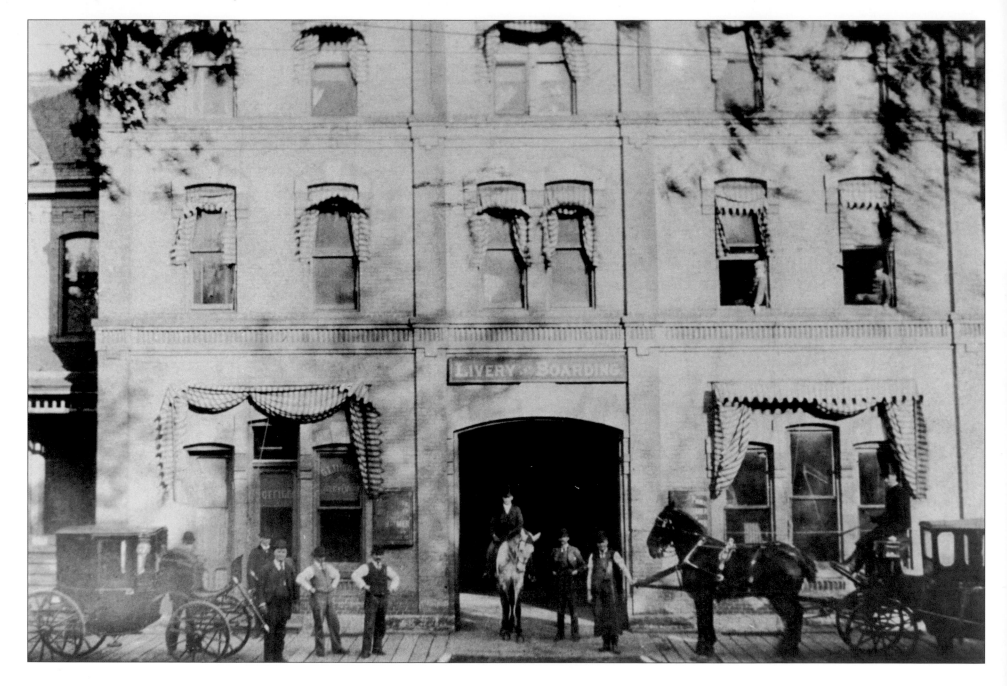

This large livery and boarding stable was located on Jackson Street just north of State Street. It was a thriving business as, at this time, most people kept their horses and buggies at a local livery stable rather than on their own property. It started out in 1870 as the Thomas & Sivyer Livery, but by 1880 it had become the George L. Thomas Livery. The first floor held the office and storage rooms for carriages, the second floor had room for horses and space for hay, and boarding rooms were on the third floor.

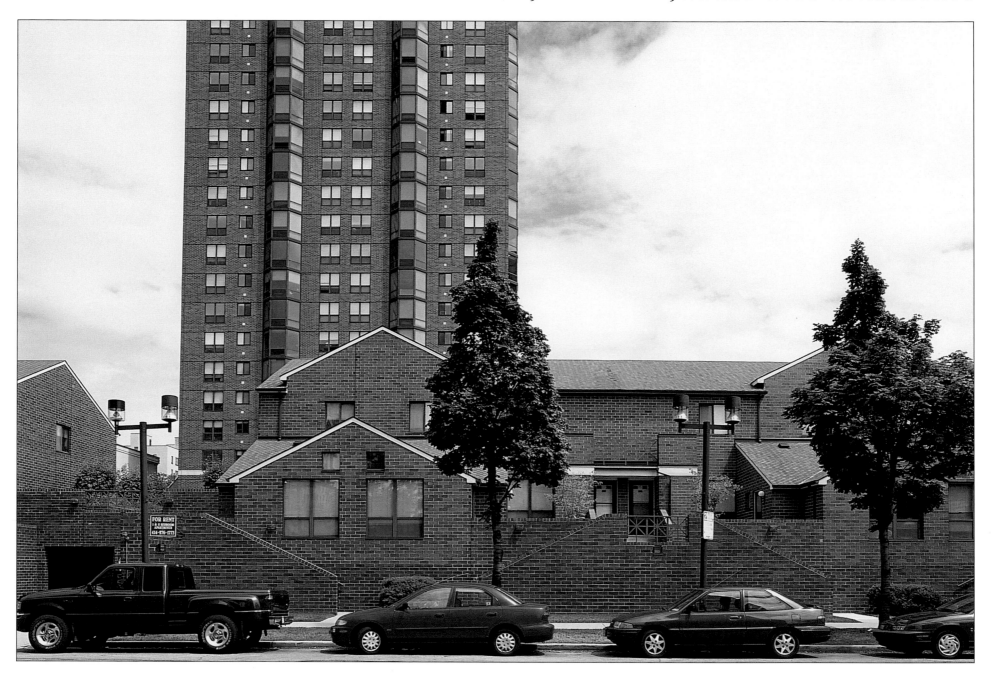

As the demand for more downtown housing units grew, so did Milwaukee's skyline. The Yankee Hill Apartments were designed by Kahler Slater Architects of Milwaukee and were completed in 1987. The complex includes 170 luxury apartments in two towers—one of twenty-three stories and the other of nineteen stories—surrounded by forty-four town houses. This area of town is called Yankee Hill because the people who moved further out from the city center in the mid-1800s were Yankees from New England.

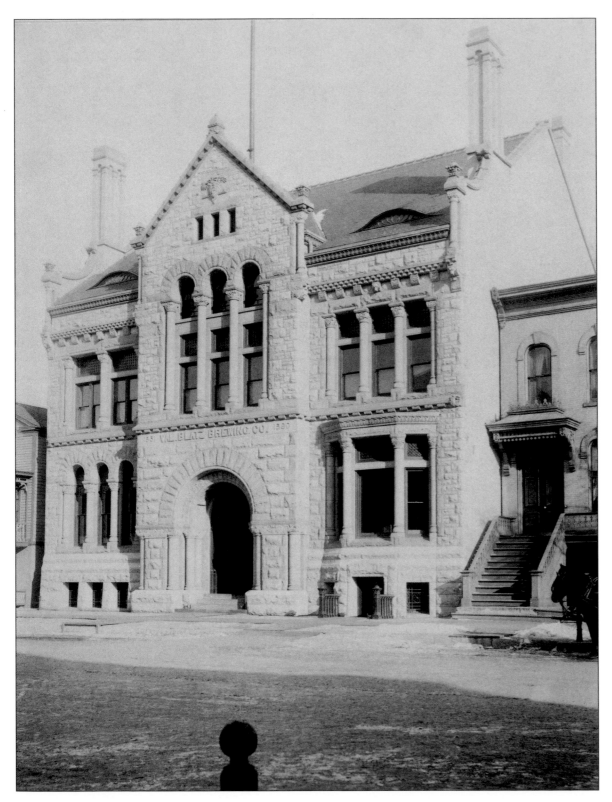

What became known as the Val Blatz Brewery was founded by John Braun in 1846 as the City Brewery—it continued to exist for another 113 years. In 1851, Val Blatz, a former employee, established a brewery of his own next door. When Braun died later that same year, Blatz married his widow, combined the breweries, and produced 350 barrels that year. By 1884, they were the third largest brewery in Milwaukee and Blatz became the first Milwaukee brewery to sell beer nationally. This Richardsonian Romanesque building was constructed in 1890 and served as the corporate headquarters for Blatz.

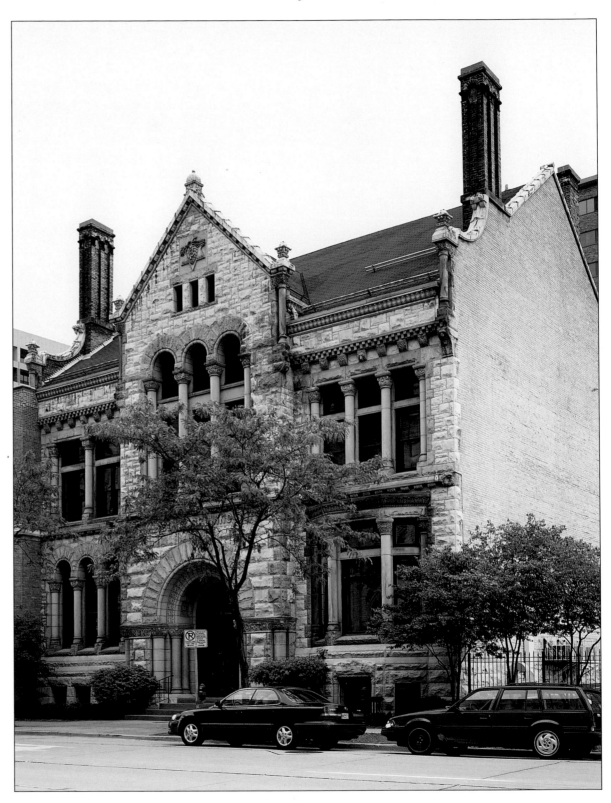

In 1890, Blatz sold the brewery to a group of London investors who operated until Prohibition. In spite of the fact that Blatz flourished after Prohibition, they eventually succumbed to their bigger Milwaukee competition, Miller, and Blatz ceased operations in 1959—the first of the big "Milwaukee Four" to close. Above the entrance to the building is the company trademark—a carved six-point star with a hop bud and the initials V. B. During the 1980s, the building housed a bar and restaurant called the Beer Barons. Today it serves as the Milwaukee School of Engineering Alumni Partnership Center.

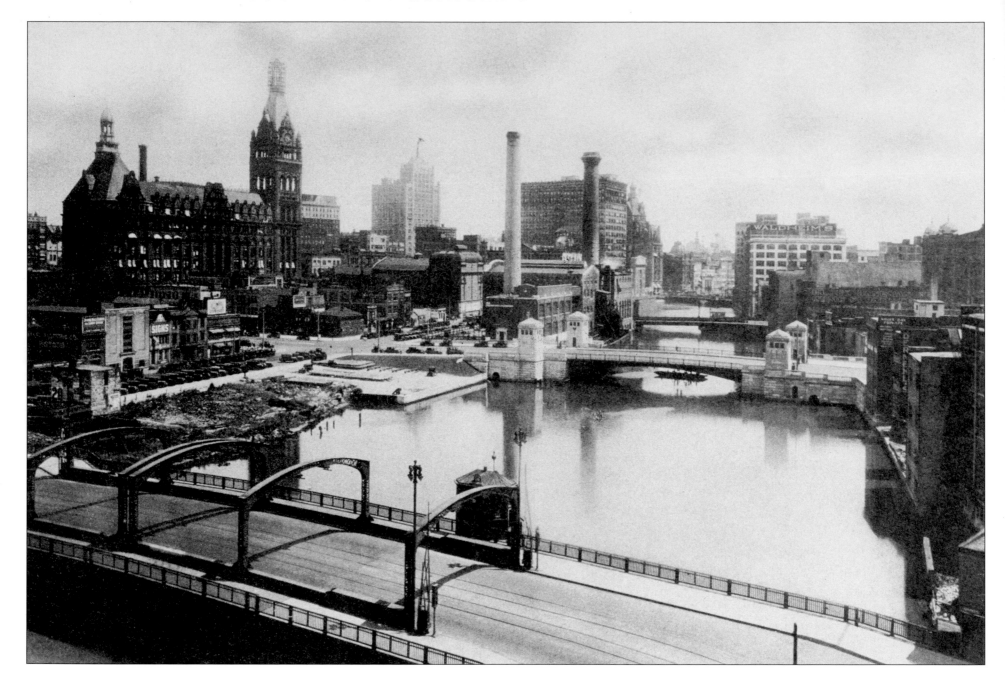

In this view looking south down the river from State Street, the smokestacks of the Oneida Street Power Station are visible. Just to the left of the power station is the Pabst Theater. Between the station and the theater is River Street—Milwaukee's early 1900s red-light district until the Socialist mayors cleaned it up in 1910. The tall building between the smokestacks and City Hall is the home of Wisconsin Bell. Waldheim's furniture store is across the river from the First National Bank Building.

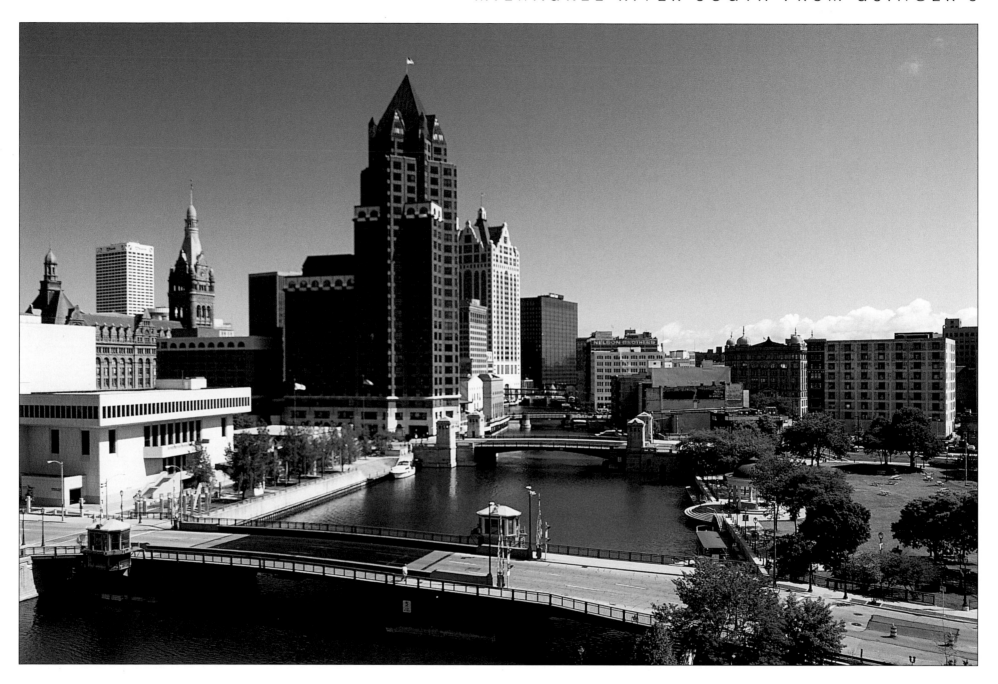

The view today is much changed. Just across the bridge on the left is the Marcus Center for the Performing Arts, constructed in 1969, which contains Uihlein Hall and two smaller stages. Peck Pavilion, part of the Marcus Center, provides a venue for Rainbow Summer—a series of outdoor concerts held during the summer. The Milwaukee Center complex (the tall building in the center) includes a twenty-eight-story office tower, the Wyndham Hotel, and a central atrium that connects the complex to the Milwaukee Repertory Theater and Pabst Theater. Pere Marquette Park is on the right, so named because the explorers Father Marquette and Louis Joliet are believed to have set up camp here along the banks of the Milwaukee River in 1674.

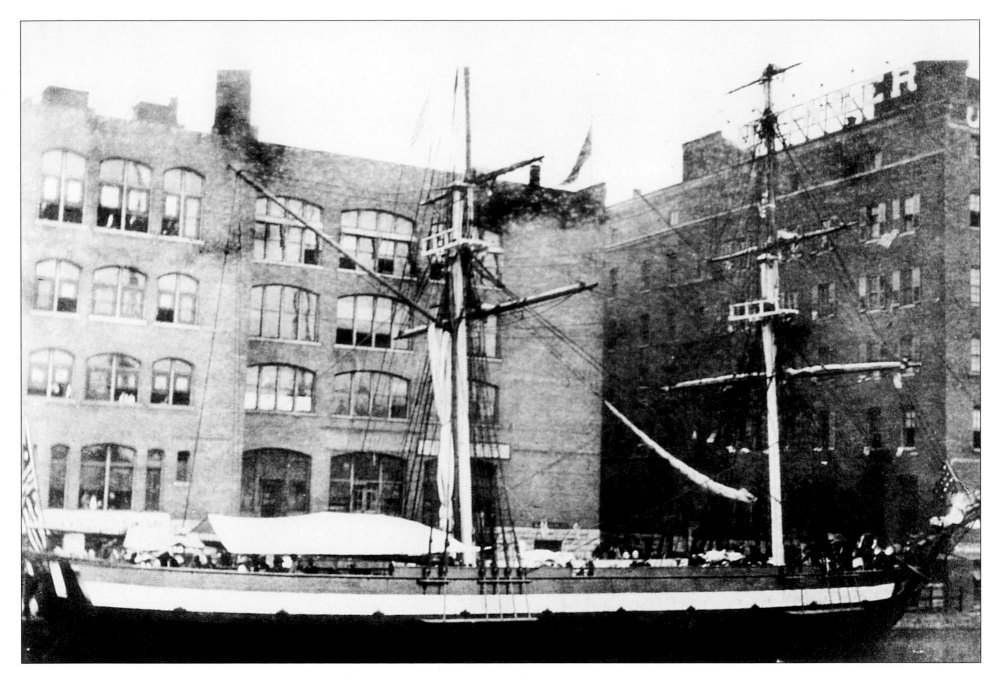

In the late 1870s, Fred Usinger arrived in Milwaukee at age nineteen with $400 and some sausage recipes he acquired when he was an apprentice to a German sausage maker. Mrs. Julia Gaertner hired him to work in her butcher shop that stood on this site. Within a year he married her niece Louise, bought the shop, and moved in upstairs. The couple worked sixteen to eighteen hours a day making and selling their sausages, especially to saloon keepers who depended on the quality of their free lunches. After the turn of the last century, Usinger's was shipping sausages as far away as New York.

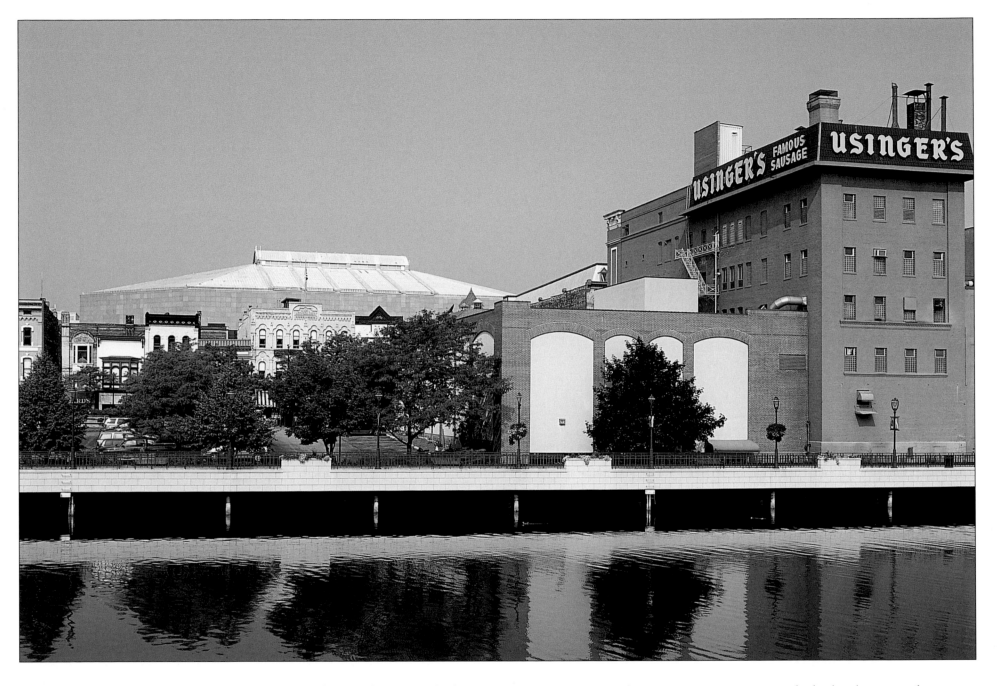

Today fourth-generation Usingers are still involved in production and sales. The mid-morning "sausage break" serves as an informal type of quality control, even today. German-speaking clerks and wall murals by the German panorama painter George Peter keep alive the 1880s flavor of the store. The

German verse murals are a toast to sausages, with the last lines translating as "In closing, a hearty toast to the sausage! May it long taste good to us." Their slogan "America's Finest Sausage" tells it all. Usinger's was selected to supply the beef frankfurters for the 2002 Winter Olympics in Utah.

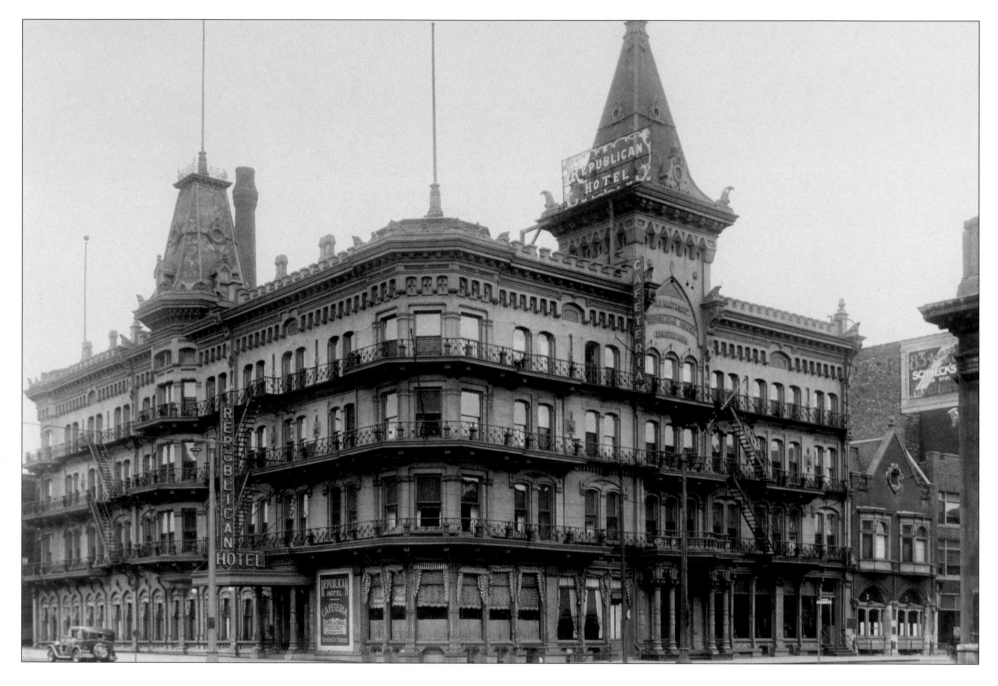

The Republican Hotel, designed by architect Fred Velguth, was one of several large hotels west of the Milwaukee River. For years, this elaborately styled hotel housed the famous George Diamond's Steak House, which sold dinners at forty-five cents a plate. In 1935, the Milwaukee Chess Club permanently rented rooms here and kept them open for members twenty-four hours a day, seven days a week. Across the street stood the Gilpatrick Hotel, where, on October 14, 1912, President Theodore Roosevelt was shot during a campaign event. The Republican Hotel stood on this site until 1961.

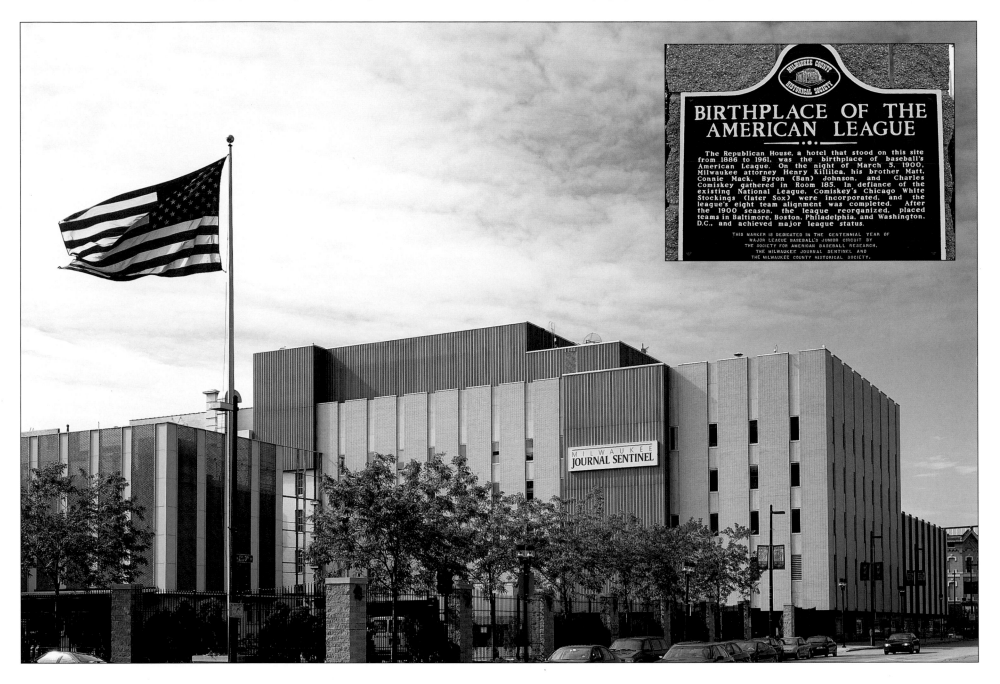

BIRTHPLACE OF THE AMERICAN LEAGUE

The Republican House, a hotel that stood on this site from 1886 to 1961, was the birthplace of baseball's American League. On the night of March 5, 1900, Milwaukee attorney Henry Killilea, his brother Matt, Connie Mack, Byron (Ban) Johnson, and Charles Comiskey gathered in Room 185. In defiance of the existing National League, Comiskey's Chicago White Stockings (later Sox) were incorporated, and the league's eight team alignment was completed. After the 1900 season, the league reorganized, placed teams in Baltimore, Boston, Philadelphia, and Washington, D.C., and achieved major league status.

THIS MARKER IS DEDICATED IN THE CENTENNIAL YEAR OF MAJOR LEAGUE BASEBALL'S JUNIOR CIRCUIT BY THE SOCIETY FOR AMERICAN BASEBALL RESEARCH, THE MILWAUKEE JOURNAL SENTINEL AND THE MILWAUKEE COUNTY HISTORICAL SOCIETY.

Although the land is now used as a parking lot, the city requires that it be fenced in. Here it was done with brick pillars and metal fencing, thus taking away the stark look of most surface lots. The parking lot serves the staff of the *Milwaukee Journal Sentinel*, which was created in April 1995 from the merger of the *Milwaukee Journal* and the *Milwaukee Sentinel*. The site is also famous in baseball history because the Republican Hotel was the birthplace of the American League (*see inset*). On the night of March 5, 1900, Milwaukee attorney Henry Killilea and several other men including Connie Mack and Charles Cominsky gathered in Room 185 to establish this new league. After the 1900 season, the league reorganized and achieved major league status.

The Second Ward Savings Bank was completed in 1913 and designed by architects Kirchoff and Rose in a Neoclassical Revival style based on a French design often called Beaux Arts. The building is encased in Bedford limestone, with windows framed in cast iron. It was known as the "Brewers Bank" because brewers Valentine Blatz and later August Uihlein served as presidents. It was also the bank for the German community and built its success on small savings accounts. This was the third building erected for the bank and later became a branch of the First Wisconsin Bank (now known as the U.S. Bank).

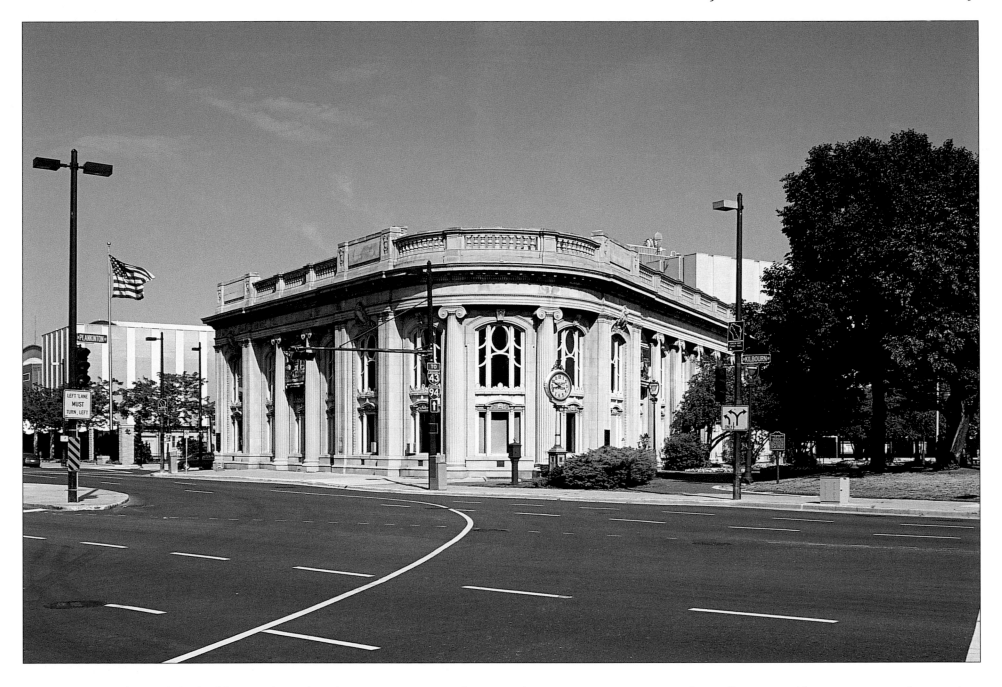

First Wisconsin donated the building to the Milwaukee County Historical Society, who have had their headquarters here since 1965. This image shows the southerly aspect of the building. The structure has been substantially restructured and is currently undergoing a $7.6 million face-lift with restoration of the cast-iron framed windows and other interior renovation.

The society maintains an artifact collection and has a museum and research library. The building's unique wedged-shaped design was the result of the converging streets when Plankinton Avenue was closed. The new Pere Marquette Park is on the right, and on Wednesday evenings during the summer, River Rhythms, a series of free concerts, is held in the park.

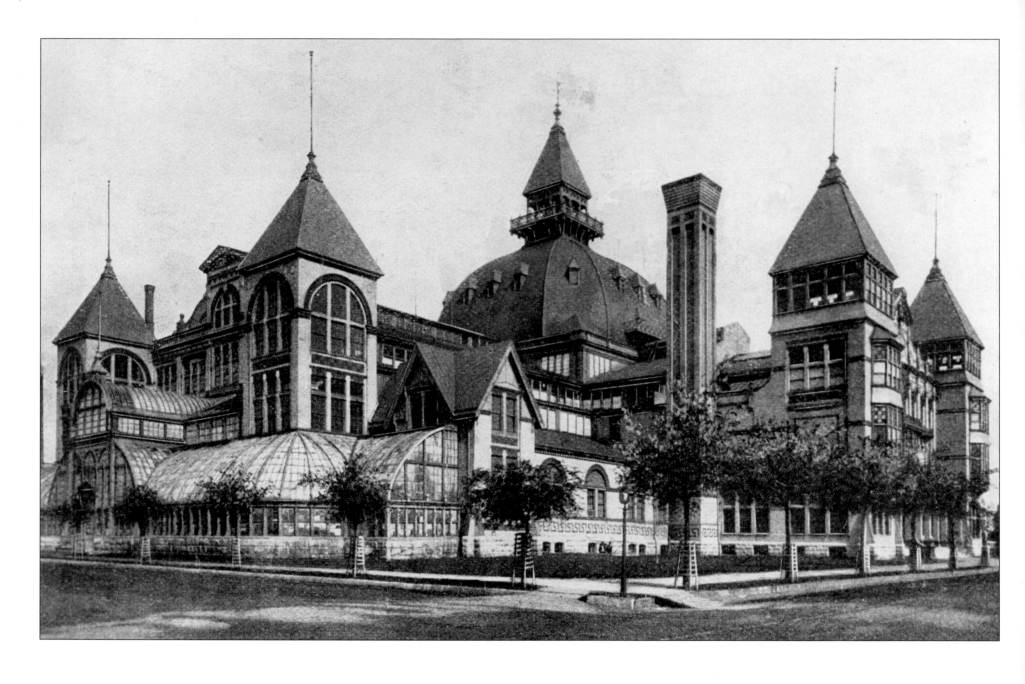

Believing it was time to sponsor a trade show, a group of businessmen formed an association in 1878 and raised a stock fund to erect the Industrial Exposition Building. They hired E. T. Mix as their architect and his ornate building, completed in 1881, was a brick-and-glass palace with a polygonal dome. There was an annual fair that ran for forty days and showcased the latest in "Manufacturing, Inventions, Industrial Products, Art, Education, Natural History, and Music." Other uses for the building included a convention center, roller-skating rink, bicycle racetrack, concert hall, ice-skating rink, state fish hatchery, and art museum.

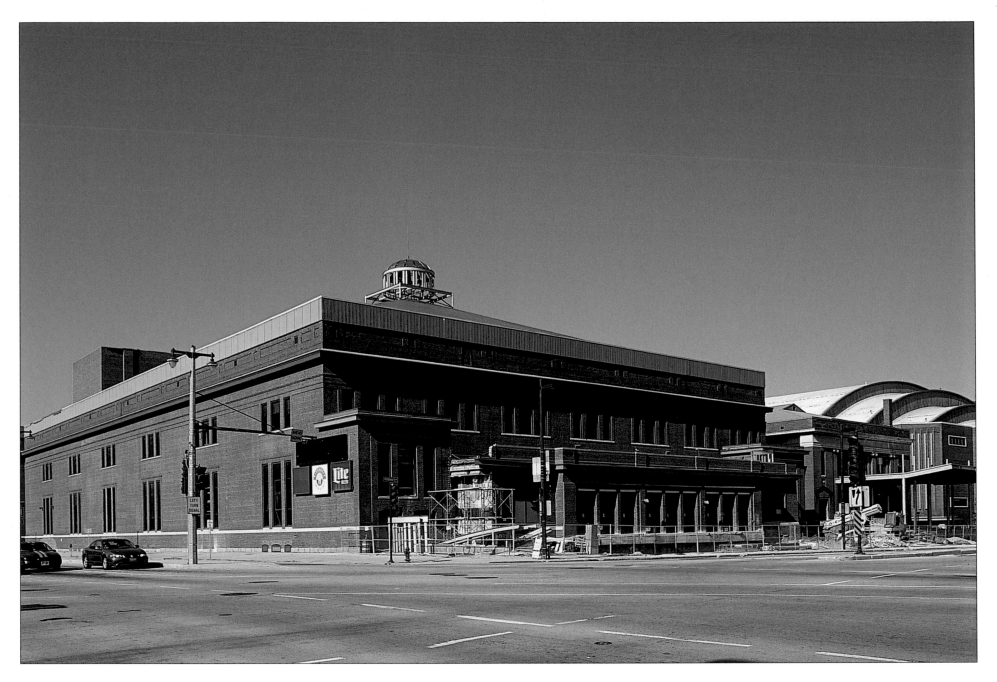

The city decided to replace the Exposition Building with a "modern convention hall." In 1905, a disastrous fire hastened the planning process, reducing the building to rubble. The new, state-of-the-art auditorium was completed in 1909, fulfilling Milwaukee's need for a central gathering place. It has served that need well over the years. Today the Milwaukee Theater is being carved out of the former Milwaukee Auditorium, and it will host touring Broadway shows.

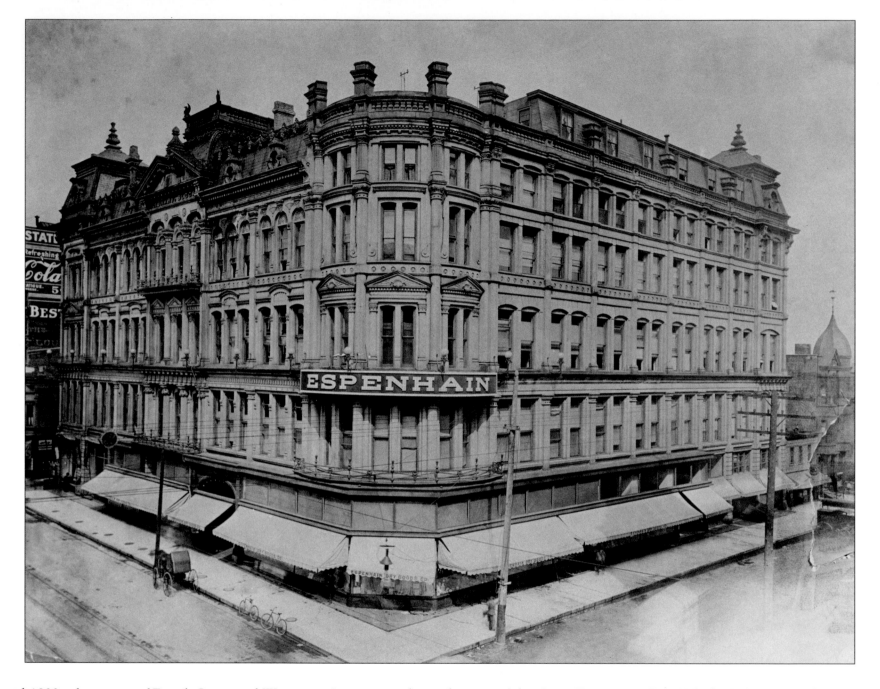

In the mid-1800s, the corner of Fourth Street and Wisconsin Avenue was the site of Milwaukee founder Byron Kilbourn's home. Espenhain Department Store opened here in 1875 as a branch of the main store in St. Louis, Missouri. It was first located on East Water Street and, in 1906, moved to this location. Like many other businesses, it was forced to close in 1932 because of the Great Depression. By 1935, the J. C. Penney Company occupied a new building on this site that was further remodeled in 1961. Penney's occupied the building until the early 1980s. In 1985, the building was again remodeled for Time Insurance.

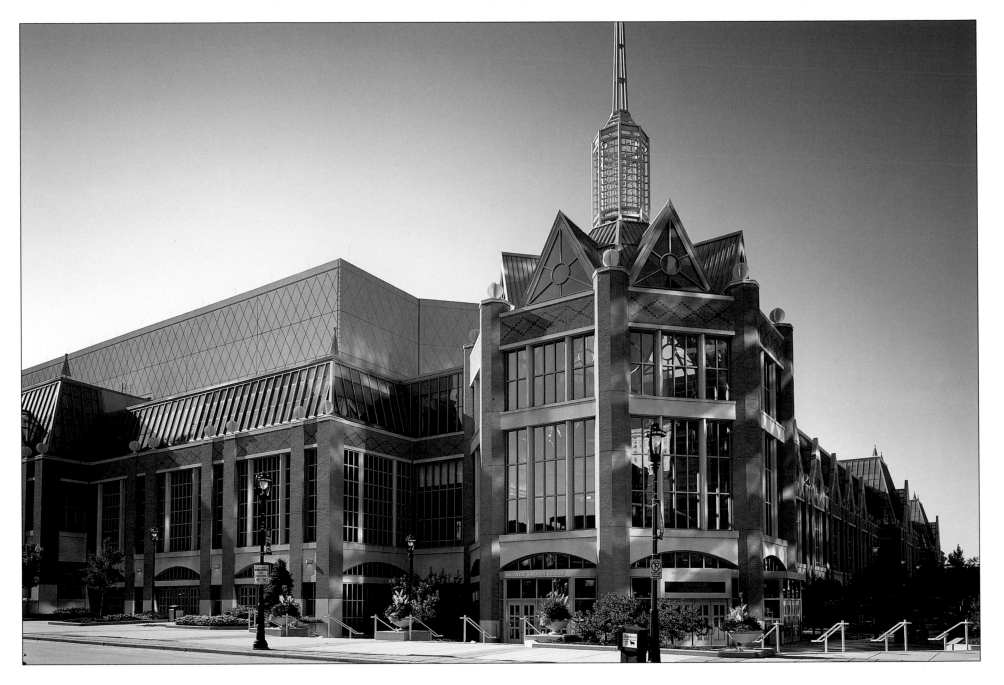

Milwaukee's new convention center, the Midwest Express Center (now called the Midwest Airlines Center), had its grand opening in July of 1998. Early in the planning stages, the Milwaukee City Arts Board suggested that the work of Wisconsin and national artists be incorporated into the new building. The Wisconsin Center District, the organization created to build and maintain the center, agreed. As a result the center has everything from rolled-up sidewalk sculptures that serve as benches to a mosaic-tiled map of Wisconsin and the works of Wisconsin writers inscribed on the walls. The exterior design pays tribute to Milwaukee's German heritage.

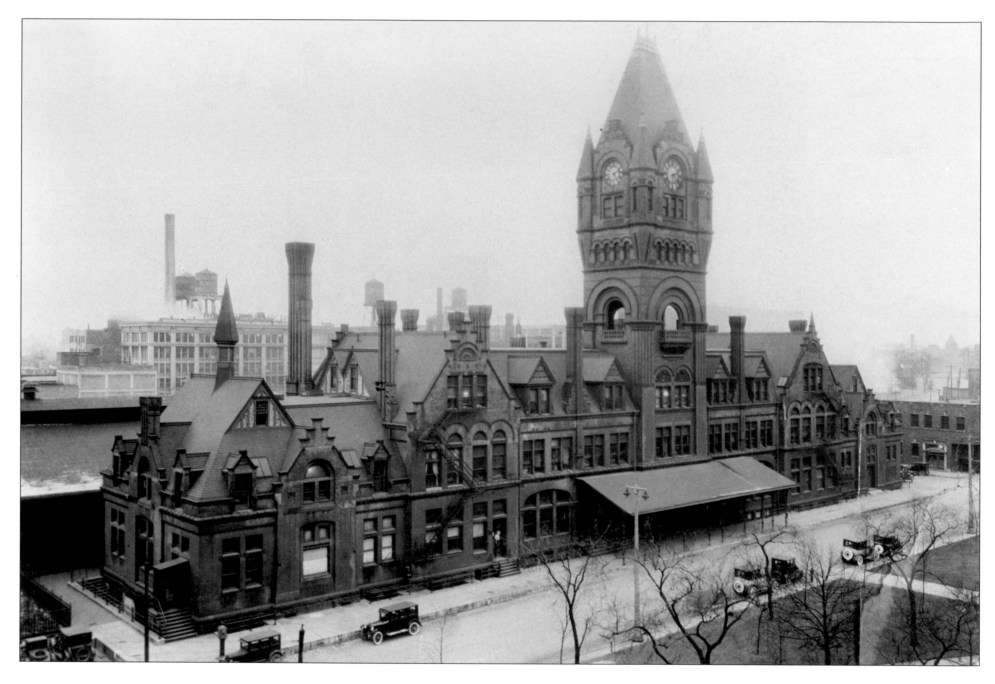

Alexander Mitchell, a prominent banking figure in the city, led the way in railroad development of the area. Mitchell knew that a railroad network, along with the Great Lakes water route, was essential to the industrial and commercial growth of Milwaukee and the surrounding areas. Mitchell reorganized the bankrupt Milwaukee and St. Paul Railroad and served as president. The general office was located in the Mitchell Building downtown. The main stores were located in the Menomonee River Valley and the station was located just south of Michigan and Third Street along the banks of the Menomonee River. The Milwaukee Road Depot was designed by E. T. Mix and erected in 1884.

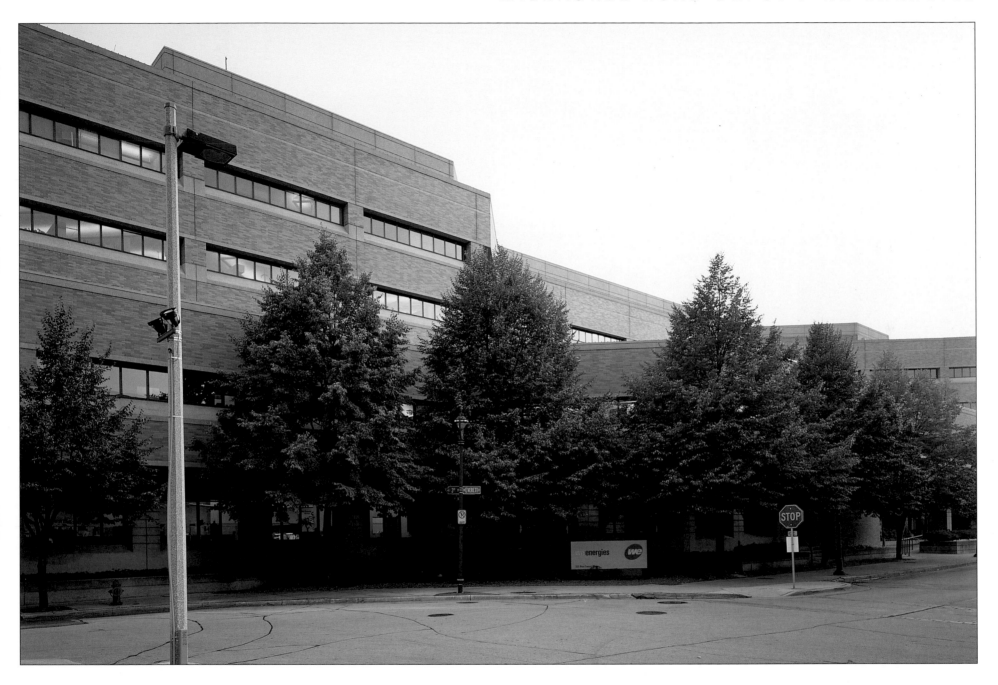

In 1965, the Milwaukee Road Depot was razed. Wisconsin Electric Power Company, now called We Energies, added a five-story parking structure on the site in 1984 and a five-story annex that houses offices, laboratories, and computer facilities in 1986. Skywalks link the parking structure and annex to the restored headquarters building. Across from the annex is Zeidler Park, an early public square, which is today named for Mayor Carl Zeidler and contains a Wisconsin Workers Memorial.

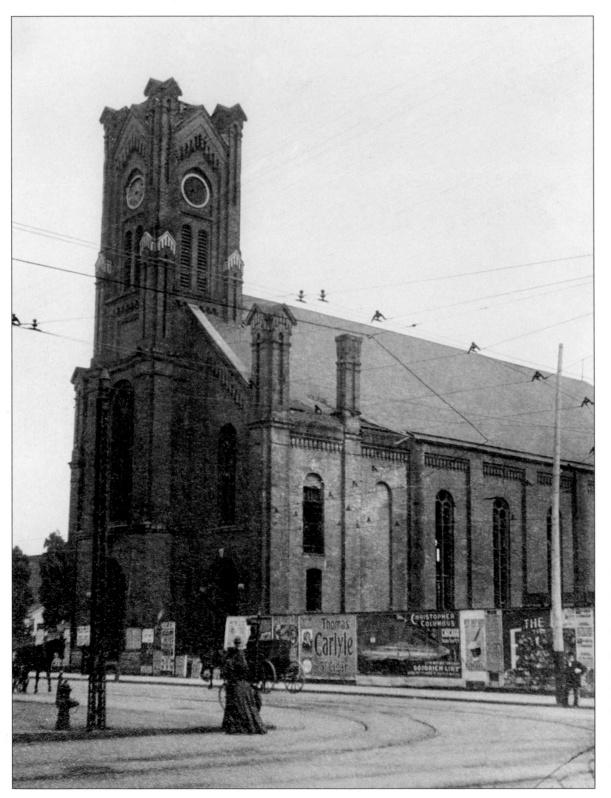

St. Gall's was first erected as a frame church on Second and Sycamore (now Michigan) in 1849. This brick church, which replaced it, was built at a later date on the same site. The church served English-speaking Catholics on the south and west sides of Milwaukee and was named in honor of an Irish monk and missionary because Milwaukee's bishop at the time, Bishop Henni, had studied at the gymnasium of St. Gall in Switzerland. The last service was held here in October 1894. St. Gall's merged with the Holy Name parish and became Gesu, and the church building was demolished in 1899.

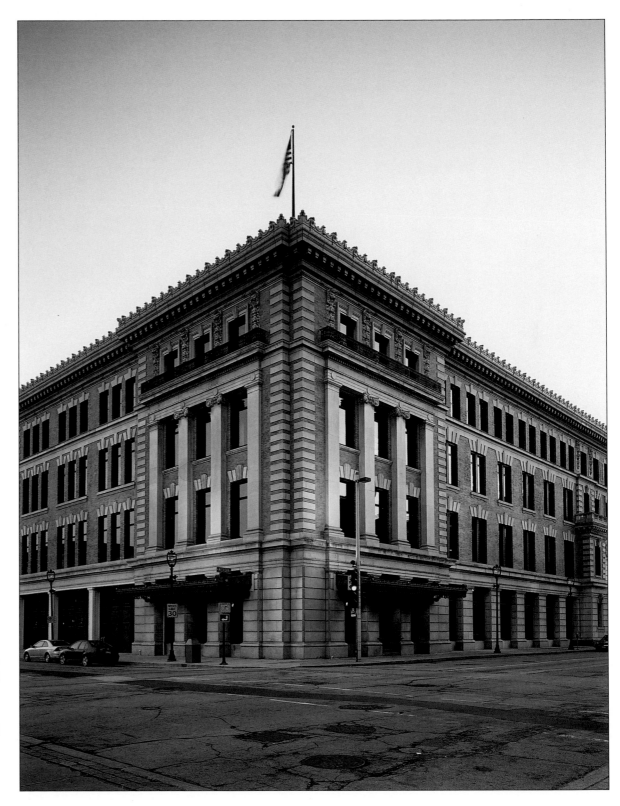

In 1906, the Public Service Building opened as the headquarters for the Milwaukee Electric Railway & Light Company. Soon the first electric interurban passenger trains rolled through the building that, at the time, was the largest railway terminal in the United States. In 1955, the last interurban trains rolled out of the building, and in 1956, a fifth floor was added. The company is now called We Energies and still occupies the site. Renovation of the building occurred in 1997, including removal of the added floor. The former train doors on the east and west sides of the building were replicated to bring back the original look to this impressive building.

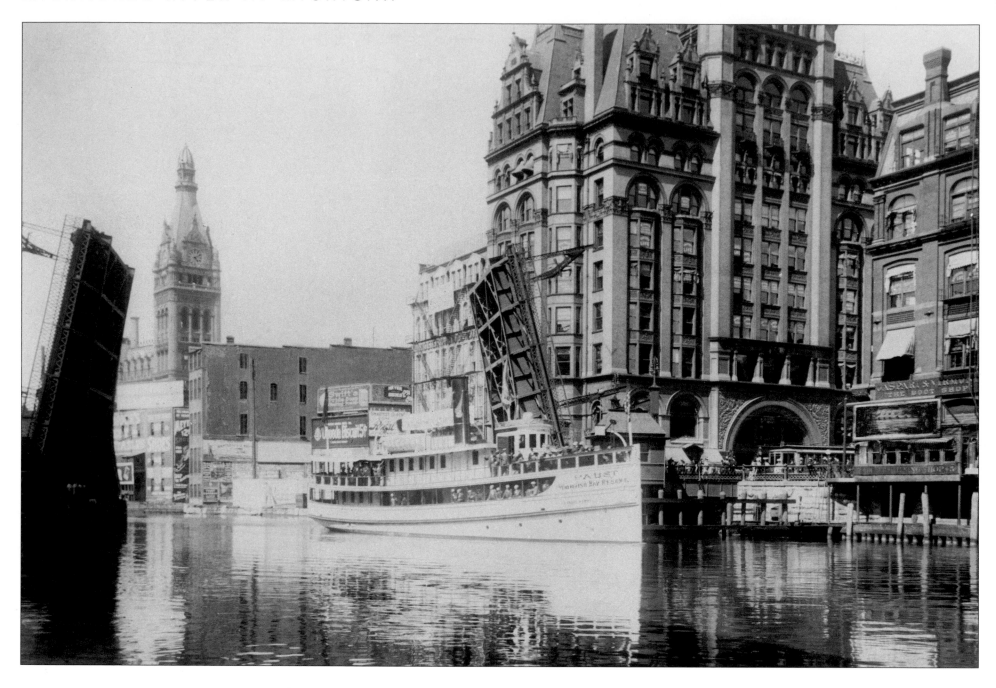

The ornate building at Wisconsin and Water is the fourteen-story Pabst Office Building (named for Captain Frederick Pabst of Pabst Brewing) that was built in 1892. It was on that corner that Solomon Juneau, one of Milwaukee's founding fathers, built his log cabin and trading post on the banks of the Milwaukee River. The Chequamaque—a pleasure boat that carried passengers to the Pabst Whitefish Bay Resort—is shown passing through the Grand Avenue bascule bridge here in 1905. The tower of City Hall is visible in the background.

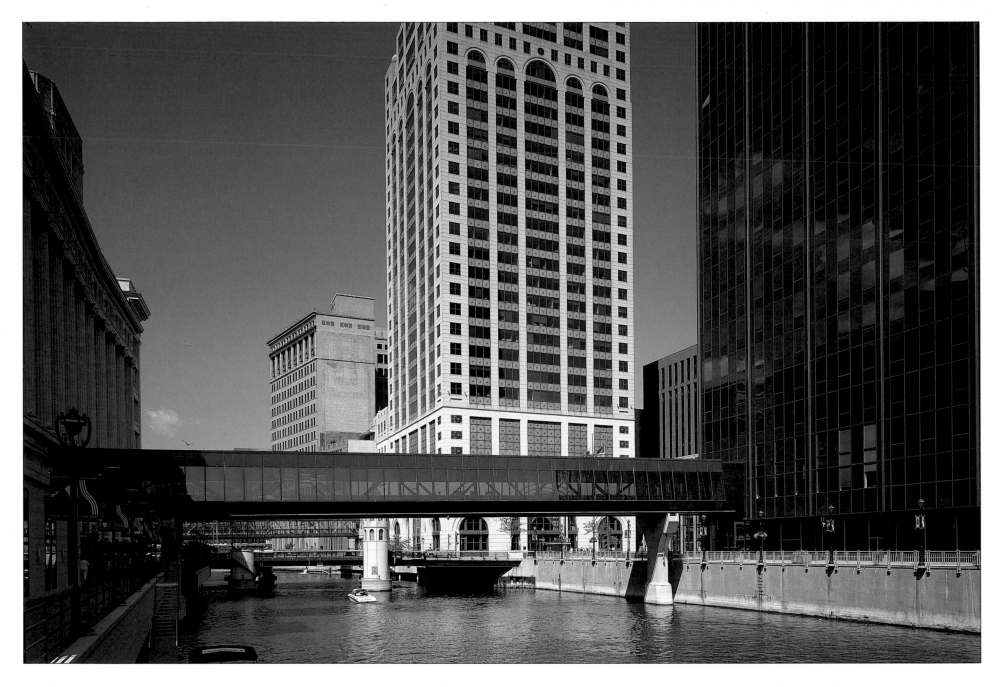

The ornate Pabst Building was razed in 1981 and that land stood vacant until 1989 when the $75 million 100 East Building was constructed. At thirty-five stories, it is Milwaukee's second tallest skyscraper. The skywalk connects the old Gimbels Department Store (*left*) to the Marine Bank (now Bank One) Building (*right*). It is the only skywalk in the United States to be constructed over a navigable waterway. The Gimbels Building now houses offices, retail space, and the Residence Inn by Marriott Hotel. Both Gimbels' and the Marine Bank's walkways along the river are now part of the riverwalk system that will eventually extend from Cherry Street on the north to Lake Michigan on the south.

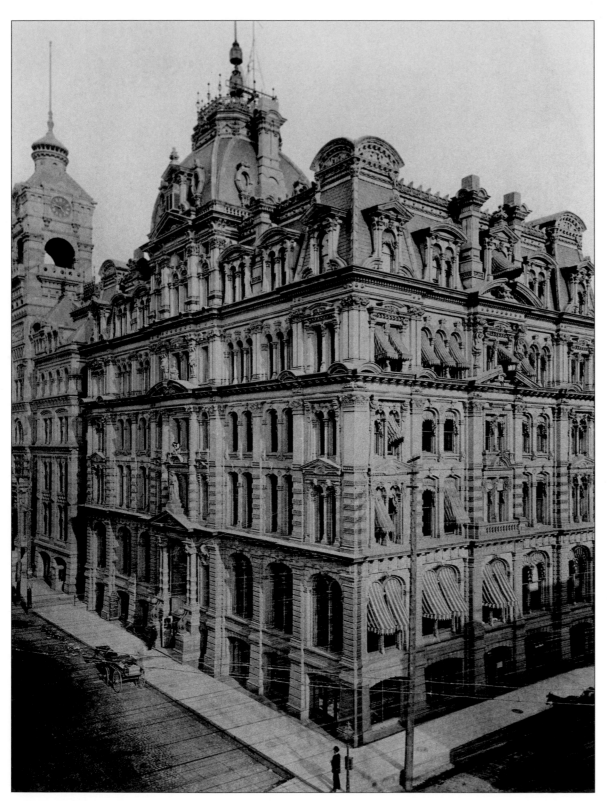

The Second Empire–style Mitchell Building was designed by E. T. Mix for Alexander Mitchell and completed in 1876. Alexander Mitchell came to Milwaukee in the midst of a banking crisis caused by banking scandals and the financial crash of 1837, which had made private banking illegal in Wisconsin. Mitchell and a partner founded the Wisconsin Marine & Fire Insurance Company in 1840. Daniel Wells Jr., a member of the Legislative Council in Madison, prepared a charter authorizing the company to become an insurance business, receiving deposits, issuing certificates, and lending money. To comply with the charter, the company issued a few policies, but most customers came to make deposits and receive bank certificates. In 1852, Wisconsin legalized banking and Mitchell obtained the first Milwaukee bank charter.

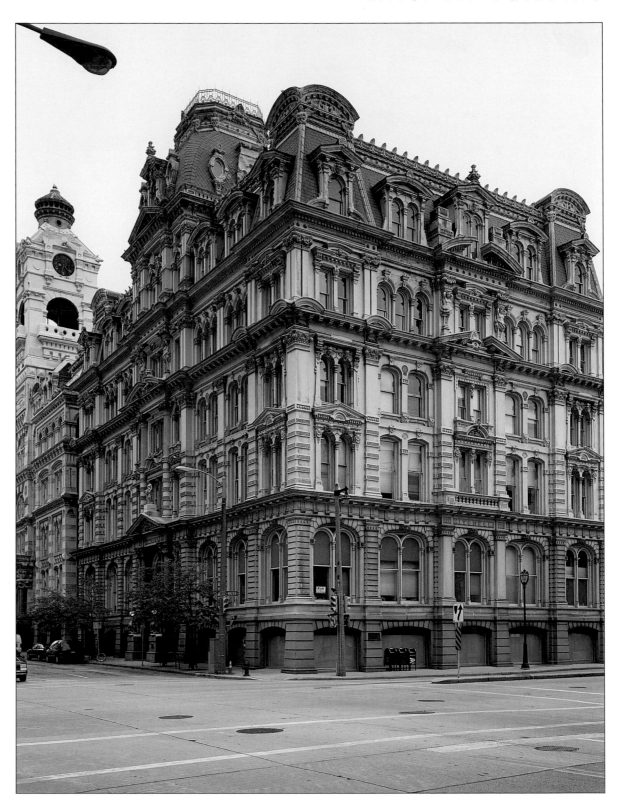

Charles Ashley purchased the Mitchell Building, as well as the Mackie Building next door, before the 1960s. The restored building, now used as office space, is a tribute to the legacy of Alexander Mitchell. Mitchell was instrumental in bringing major railroad services to Milwaukee, and by 1860, he was one of the sixteen early entrepreneurs who controlled most of the wealth in the city. The Second Empire–style exterior has not been changed and is elaborately decorated with sculptured images and a profusion of architectural ornament. The ornate central penthouse is an airy conference room for Laughlin & Constable, an advertising and public relations company.

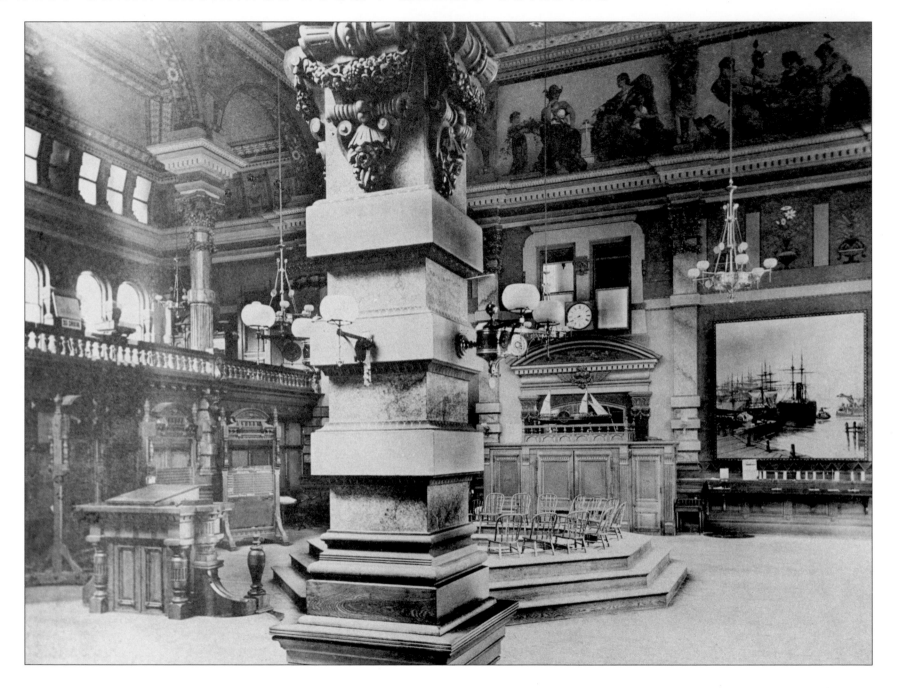

The Mackie Building, completed in 1879, was designed by E. T. Mix and built for Alexander Mitchell, who leased it to the chamber of commerce. The building housed the Midwest Grain Exchange, where grain crops were bought and sold. The octagonal grain pit shown in the picture was designed to permit traders to concentrate on the bidding. It is said to have served as a model for other grain exchanges. In 1862, Milwaukee was one of the primary wheat markets of the world. With the rise of Minneapolis as a production and milling center and the destruction caused by the cinch bugs of the mid-1800s, Milwaukee lost its dominance. Dairy production replaced wheat in the twentieth century.

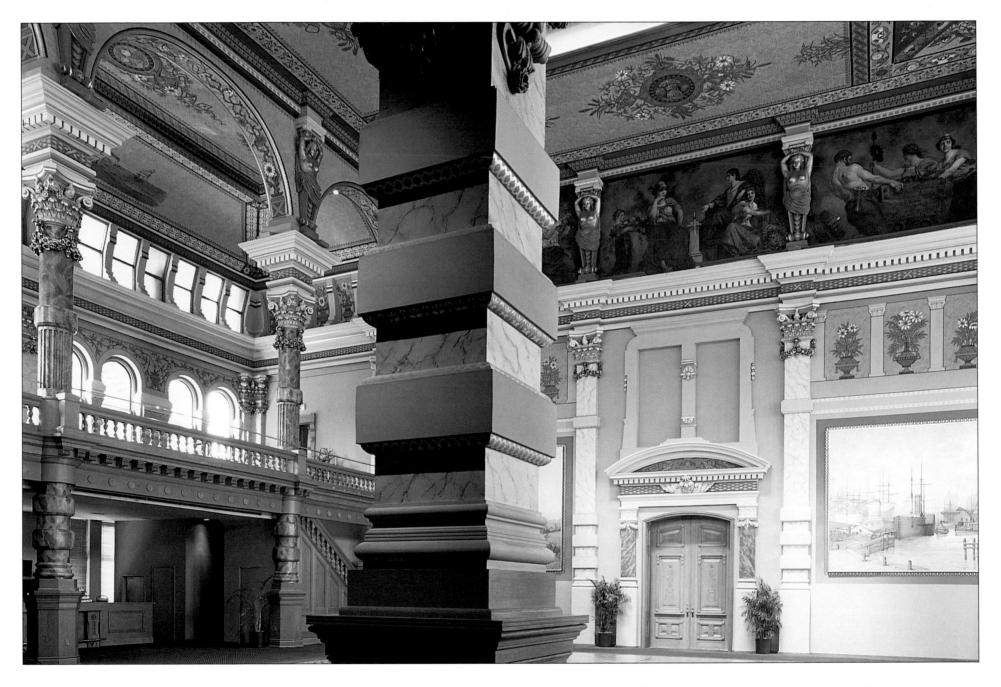

Due to diminished market activity, the Grain Exchange moved out of the building in the mid-1930s. After being vacant for several years, a suspended ceiling was installed and the large room was converted into several smaller, modern offices. In 1979, removal of the suspended ceiling and demolition of the offices began in preparation for restoration. Conrad Schmitt Studios performed the painstaking restoration of the room. A medallion in the floor marks the size and location of the trading pit. The three-year project was funded entirely by the owner, Mrs. Charles Ashley, and the room today is used for weddings, receptions, lectures, seminars, concerts, and much more.

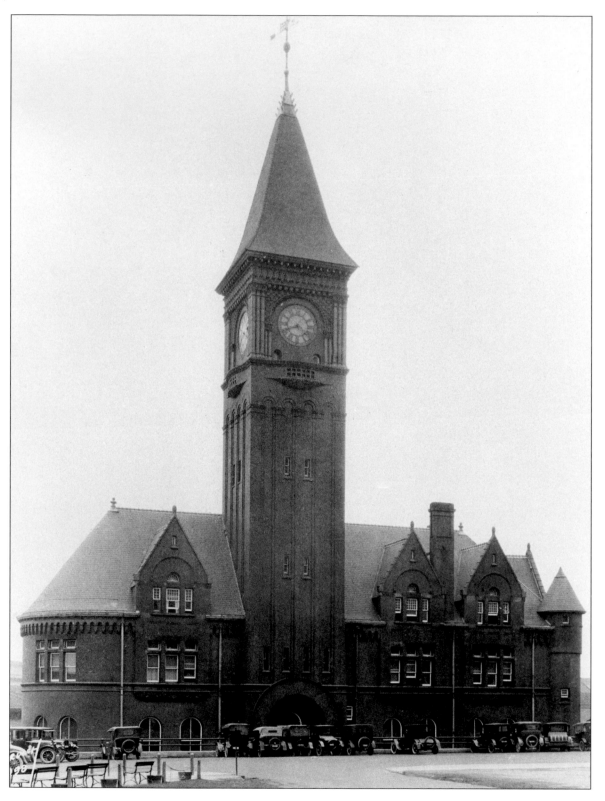

The Chicago and Northwestern Railroad built this imposing depot in 1889 on the lake bluff at the end of Wisconsin Street, where its Romanesque tower stood for more than seventy-five years. The railroad was organized in 1859 and was a conglomeration of older railroad lines that suffered failure in the Panic of 1857—when a series of financial scares caused widespread economic depression. The Northwestern moved into Wisconsin from Chicago. Banker Alexander Mitchell became a railroad magnate and his Milwaukee Road line competed with the Chicago and Northwestern for regional dominance.

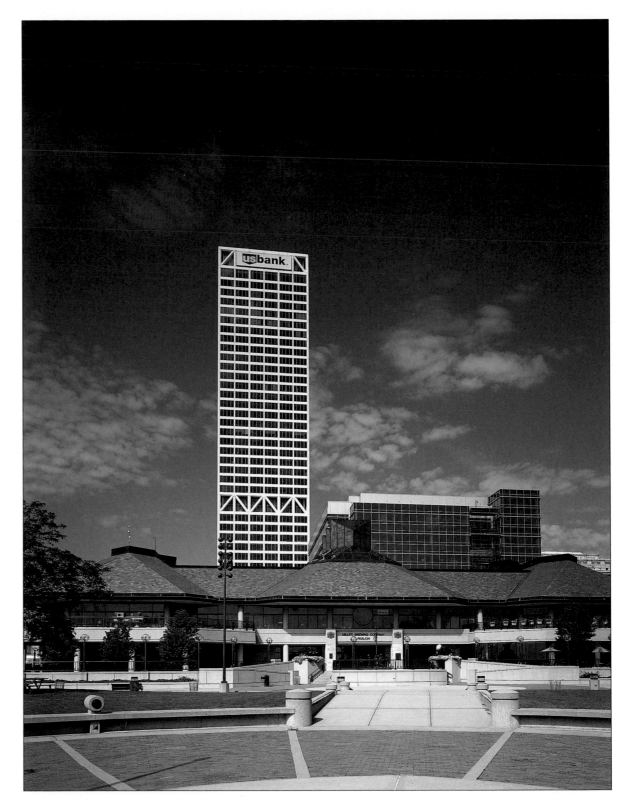

In 1968, despite efforts to save the depot, the structure succumbed to the wrecker's ball. After the depot was razed, Bluff Park was completed in 1983. The focus of the park is the monumental abstract steel sculpture *The Calling* by artist Mark Di Suvero, which is owned by the Milwaukee Art Museum. The park at one time had a display of a series of photo panels commemorating the Chicago and Northwestern Railway Station. In the early 1990s, construction began on the O'Donnell Park complex. In addition to a parking structure and large terraced area, there is the Miller Pavilion, shown here, that houses a restaurant and the Betty Brinn Children's Museum.

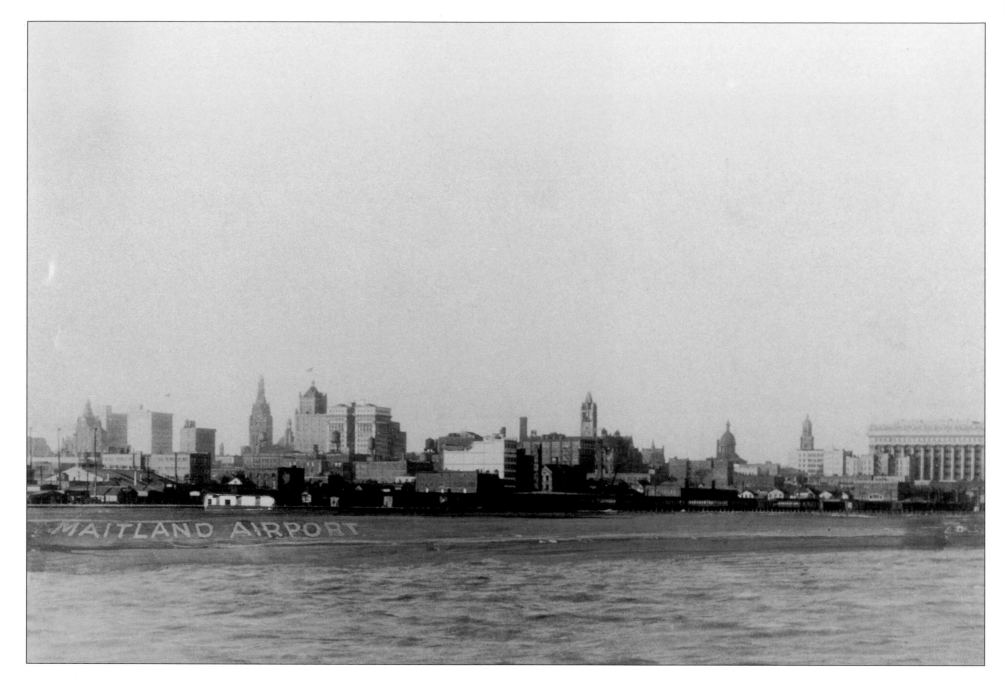

Maitland Airport (known as Maitland Field) was a lakefront airstrip for general aviation and was situated between the Chicago Northwestern railroad tracks and Lake Michigan. The field consisted of a landing strip and a sea ramp for pontoon planes that landed on the lake. During World War II, Maitland Field was shut down (as were all small airports) as a security measure against sabotage. In the early 1950s, a Nike missile base, built to protect Milwaukee from potential Russian bomber attacks, replaced it.

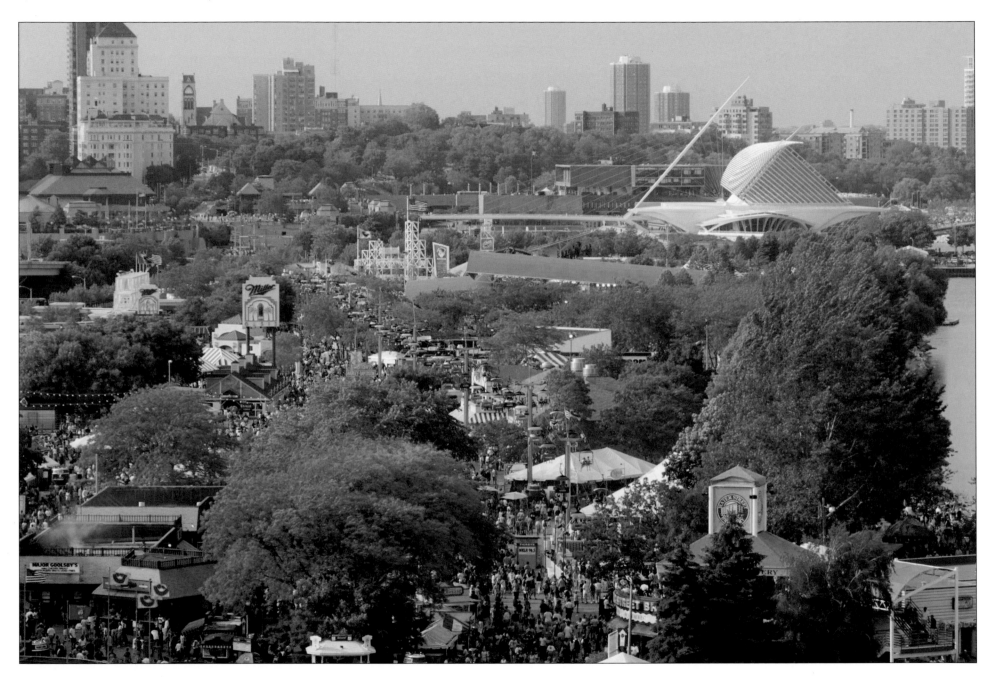

Milwaukee is known as "the City of Festivals"—most of which are held here at Maier Festival Park, the old site of Maitland Field. These include Asian Moon, Polish Fest, Festa Italiana, German Fest, African World Festival, Russian Fest, Irish Fest, Mexican Fiesta, Arabian Fest, Indian Summer Festival, and Milwaukee's premier music festival, Summerfest, which celebrated its thirty-sixth anniversary in 2003. The area alongside Lake Michigan will soon be the location of the new Lake Shore State Park. Lake Shore State Park will be built on a twenty-two-acre island just off the coast of the Maier Festival Park grounds. The park will include a picnic shelter, observation tower, and a walkway around the lake.

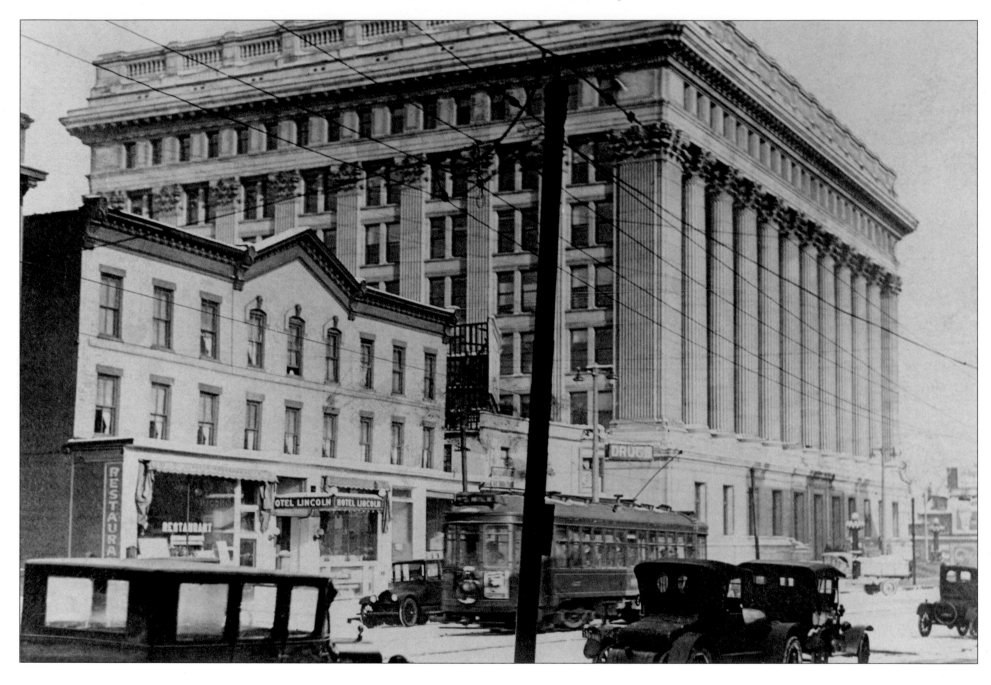

The Northwestern Mutual Life Insurance Company building was completed in 1912 in a Classical Revival style. This was their fourth home in Milwaukee as the company was chartered in Janesville, Wisconsin, and it moved to Milwaukee in 1859. This area was originally a ravine that drained into Lake Michigan. When Juneautown streets were laid, the drainage was dammed and formed a body of water named Lake Emily. During construction an extensive pool of water was discovered twelve feet below the surface and so six thousand fifty-foot-long cedar pilings were used to support the concrete base.

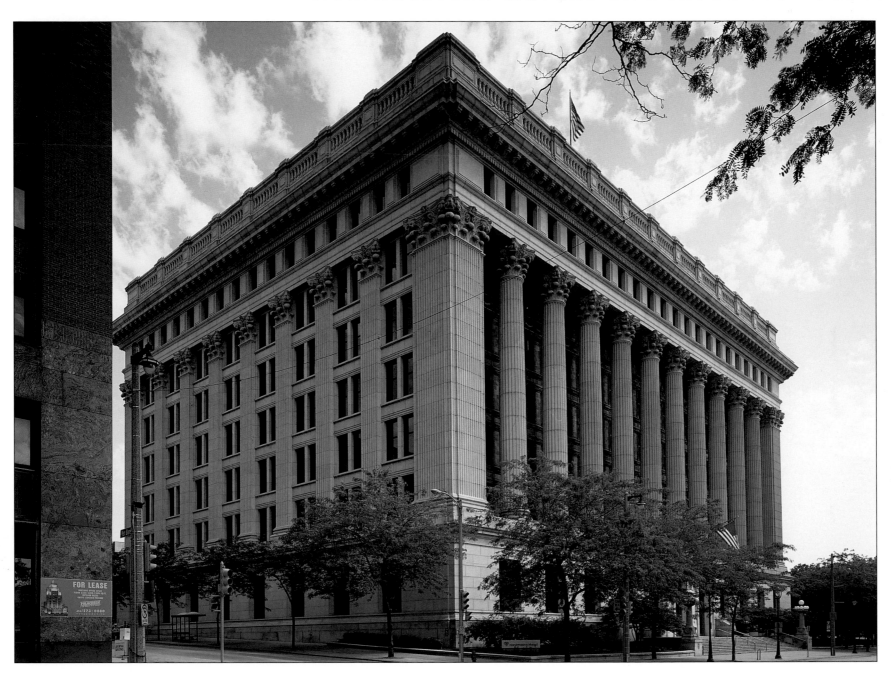

The taste for classicism on a grand scale dominated American building design for many years after the Chicago World's Fair (the Colombian Exposition) of 1893. This Classical Revival style building features monumental Corinthian columns and behind the columns, the building is faced with green granite to provide a contrast to the light granite columns. The Northwestern Mutual

Life Insurance Company displays the works of nearly one hundred of the state's outstanding artists in its home office collection. The company, a leader among the nation's 1,900 other insurance companies, celebrated its 125th anniversary in 1994.

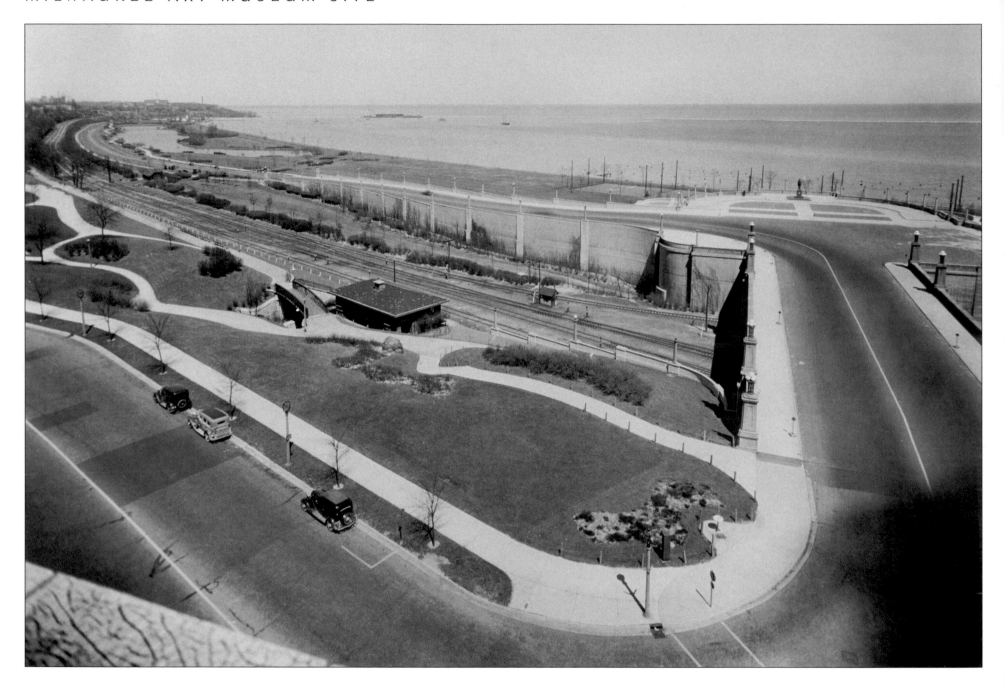

Lincoln Memorial Bridge spanned the Chicago and Northwestern Railroad tracks that ran below the bluffs along the lakefront. The bridge connected Mason Street and the newly completed Lincoln Memorial Drive of 1929 that was possible after years of landfill activities. On the bluffs above Lincoln

Memorial Drive is Juneau Park named for city founder Solomon Juneau. The walkway system leads people to the lakeshore and just to the west of the park is the Yankee Hill area where early settlers built their houses to take advantage of the cool lake breezes.

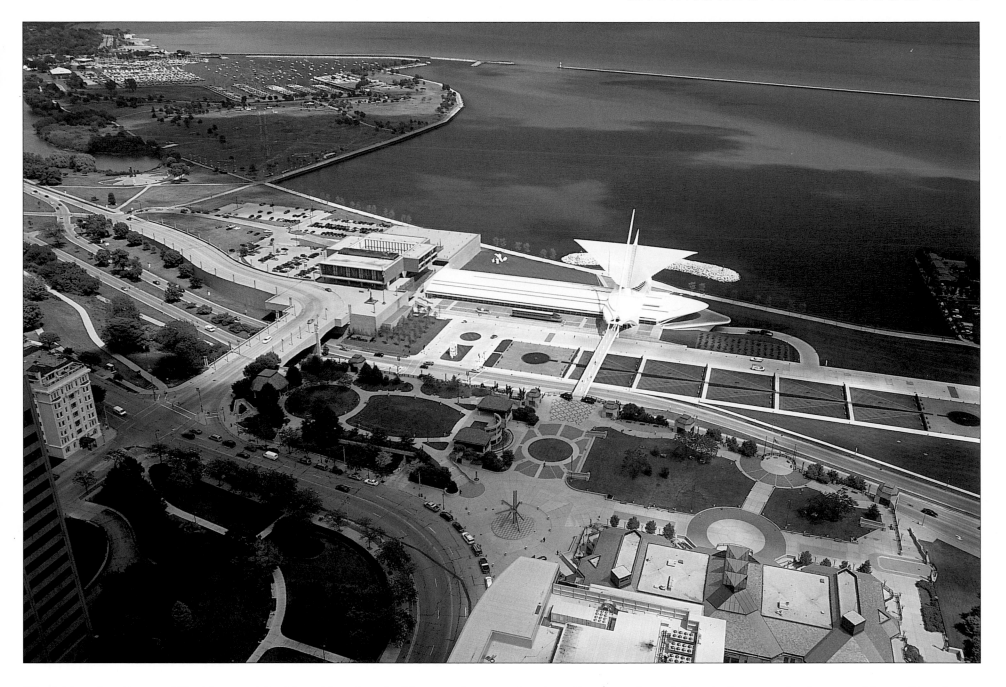

The Milwaukee County War Memorial Building (the white building on the lakefront) was designed by Eero Saarinen and was completed in 1957. Both the Layton Art Gallery and the Milwaukee Art Institute moved into the new building, where their collections and projects were merged. In 1969, Mrs. Harry Lynde Bradley offered her collection of modern art to the center and she also offered a million-dollar challenge to fund a new addition. David Kahler of Kahler, Slater, Fitzhugh Scott, Inc. designed the new addition that was completed in 1975. The Milwaukee Art Museum's collections continued to grow over the years, and, in 2000, the Santiago Calatrava addition with its *brise-soleil*, or sun baffle, was opened to the public.

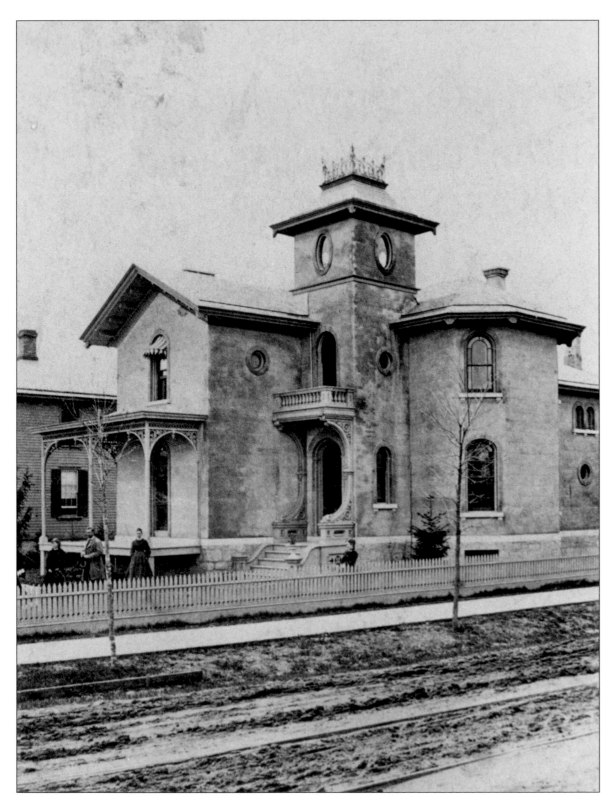

Edward Townsend Mix, an architect trained in Connecticut, single-handedly molded the appearance of Milwaukee through the patronage of an entire generation of leading businessmen, including such prominent Milwaukee names as Mitchell, Keenan, and Plankinton. Mix had commissions totaling $1 million or more during the 1880s, and some of those commissions included the Milwaukee Road Depot, the Layton Art Gallery, and the Industrial Exposition Building. This photograph shows the Mix residence on Waverly Place. Mix designed most of the houses on this block, including the Italianate Peck House, which was just south of the Mix House.

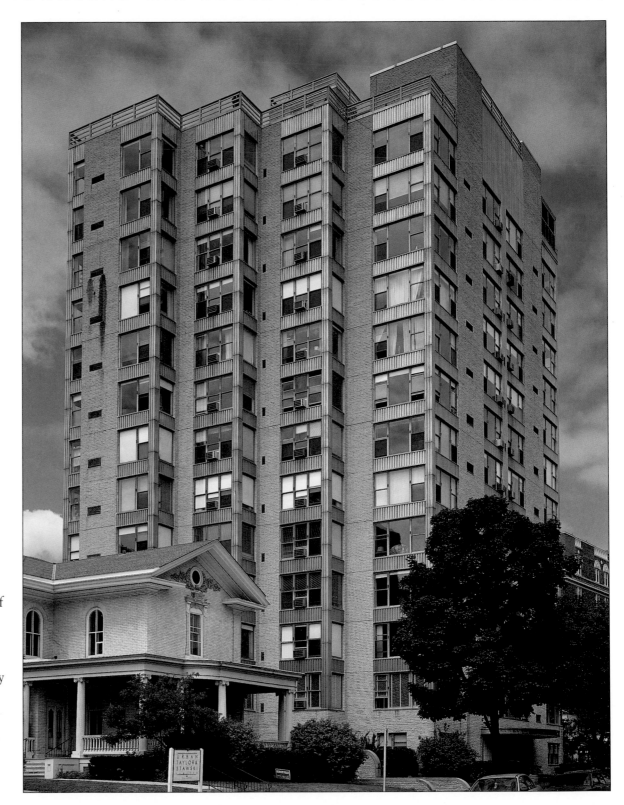

An 1877 Milwaukee souvenir book noted, "Here on Waverly Place was first put into practice the pretty idea of removing all fences, thus throwing the beautiful grounds into one immense and beautiful park." This area, known as Yankee Hill, saw decline as an exclusive residential neighborhood over the years. Over the years, single-family houses gave way to apartment buildings such as the Lodgewood Apartments (*right*), where Mix's house once stood. The Peck House still stands (*left*) and provides a contrast to the modern surroundings. It now houses a law firm.

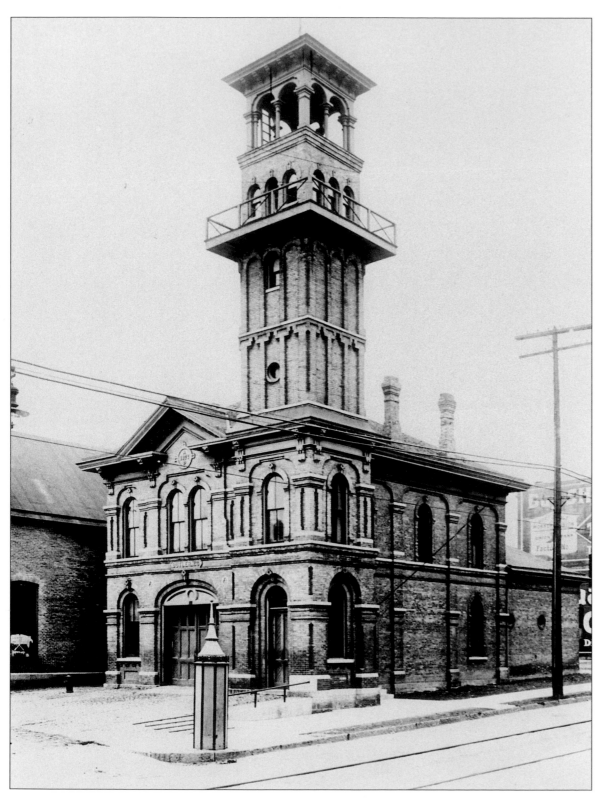

The Butler Fire Station was built in 1875 in a High Victorian Italianate–style featuring extensive ornamental brickwork and massive wooden brackets under the eaves of the hipped roof. The spindly brick seven-story corner watchtower was capped with a pyramidal roof. The watchtower, which rivaled St. Hedwig's Church steeple across the street in visual prominence, was used to spot fires in the area. The station was named for one of Milwaukee's early mayors, Ammi Butler. The tower was probably removed during the 1920s or early 1930s, as by that time the city's fire alarm box system and telephones had eliminated the need for fire watchtowers.

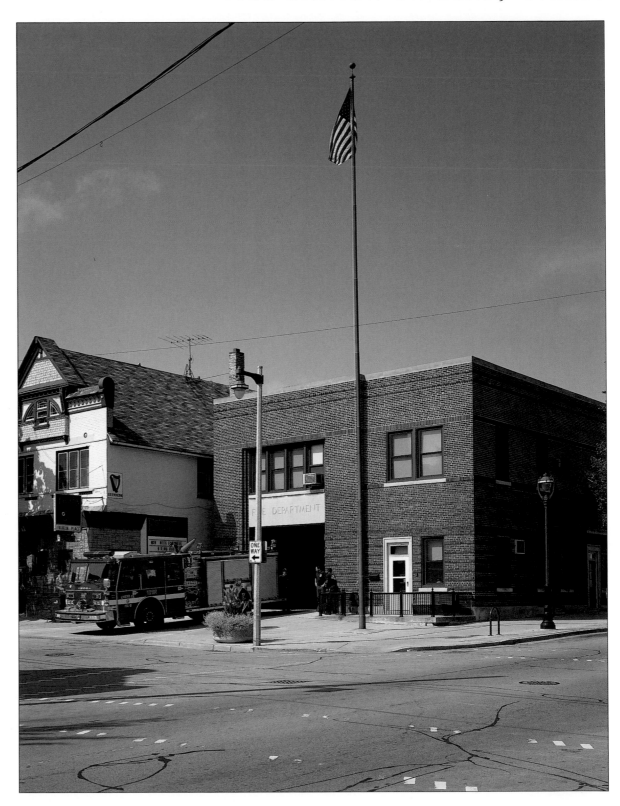

During the 1960s and 1970s, Brady Street was the center of Milwaukee's counterculture. Now called Engine Company 6, the station building was rebuilt in 1946, and at that time all the historic architectural features that remained were removed. The station is still an integral part of the Brady Street neighborhood, but like many other urban neighborhoods, hard times caused many of the small businesses to close. In the last ten years, Brady Street has once again come to life as urban entrepreneurs restored the facades of the buildings and brought in new enterprises—from restaurants to art galleries—that found a home alongside the old established businesses.

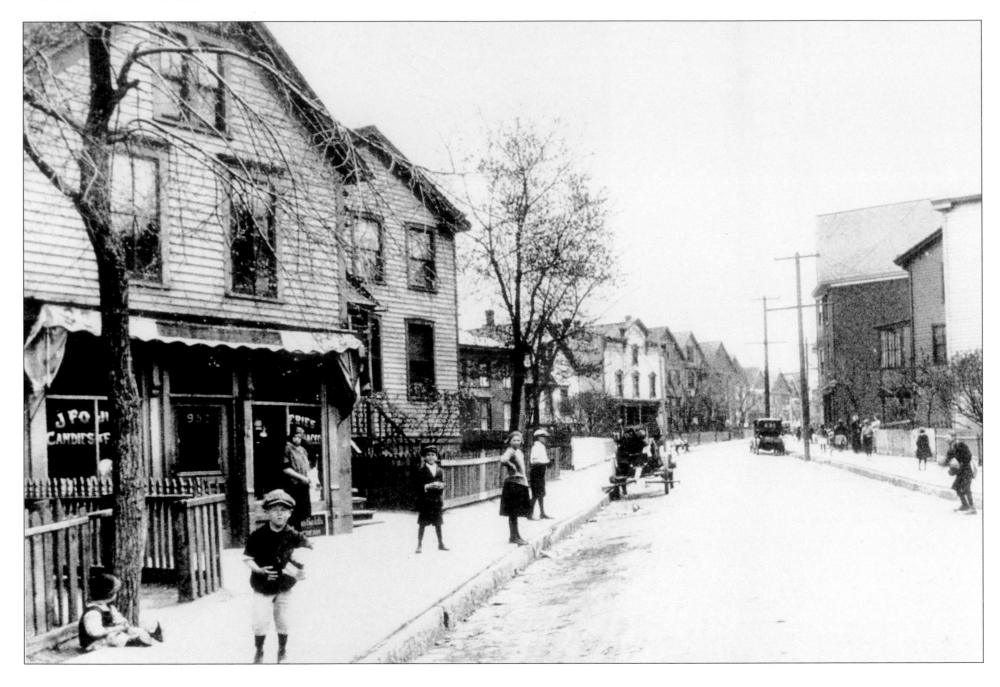

Pulaski Street, in the Brady Street neighborhood, actually started as a ravine with a small stream that branched off of the Milwaukee River. When the city did its first sewer excavations, it simply laid pipe in the ravine and filled it in. Locals took advantage of the flat, well-packed fill and proceeded to build houses here. They named their street for Casimir Pulaski, a Revolutionary War hero of Polish decent. The Brady Street area was first settled by poor Polish immigrants who came for work in the tanneries and other factories located just west of the area along the Milwaukee River.

The neighborhood was poor and very overcrowded until a push by a local alderman forced the razing of several homes to create the Pulaski Street playground. Italians began to migrate here from the Third Ward after the fire in 1892. Pulaski Street's claim to fame today is that it is home to the popular Wolski's Tavern. For years, cars have sported bumper stickers stating "I Closed Wolski's." This section of the Brady Street area is known as East Village and the neighborhood association has applied to the National Trust for it to be named a Historic District.

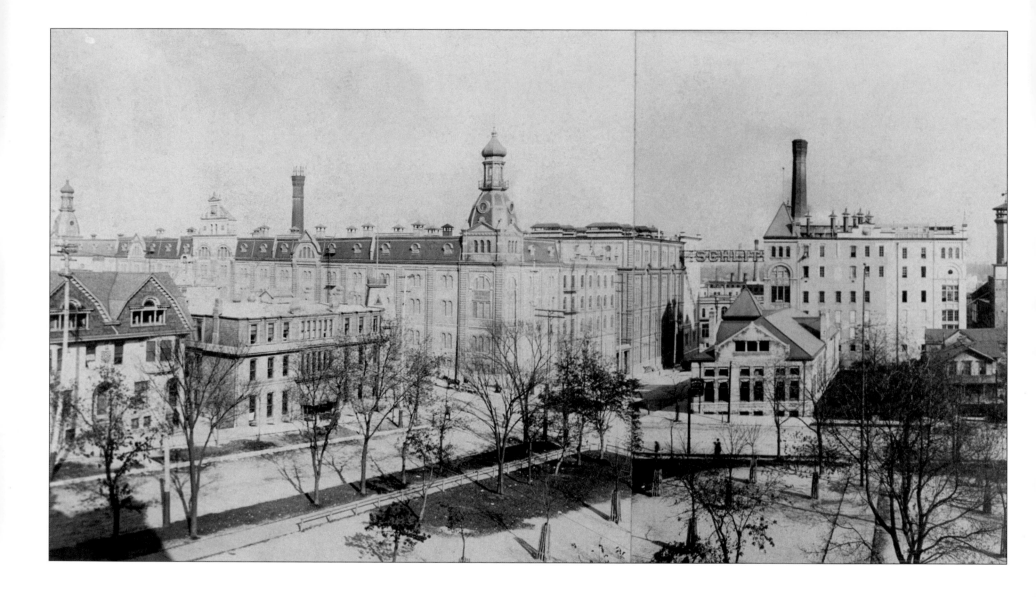

Joseph Schlitz arrived in Milwaukee in 1855 and gained employment as a bookkeeper with August Krug, the owner of a small brewery. When Krug died three years later, Schlitz bought the brewery from Krug's widow. He then married her and named the brewery after himself. After the Chicago fire of 1871, Schlitz capitalized on their water shortage and sent several shipments of beer, a gesture that was well received and which created new beer drinkers. It also resulted in the slogan "Schlitz, the Beer That Made Milwaukee Famous." In 1875, Schlitz was killed when he sailed for Germany on the steamer *Schiller*, which tragically sank. This led to his nephews, Henry, Alfred, August, and Edward Uihlein, taking over the brewery.

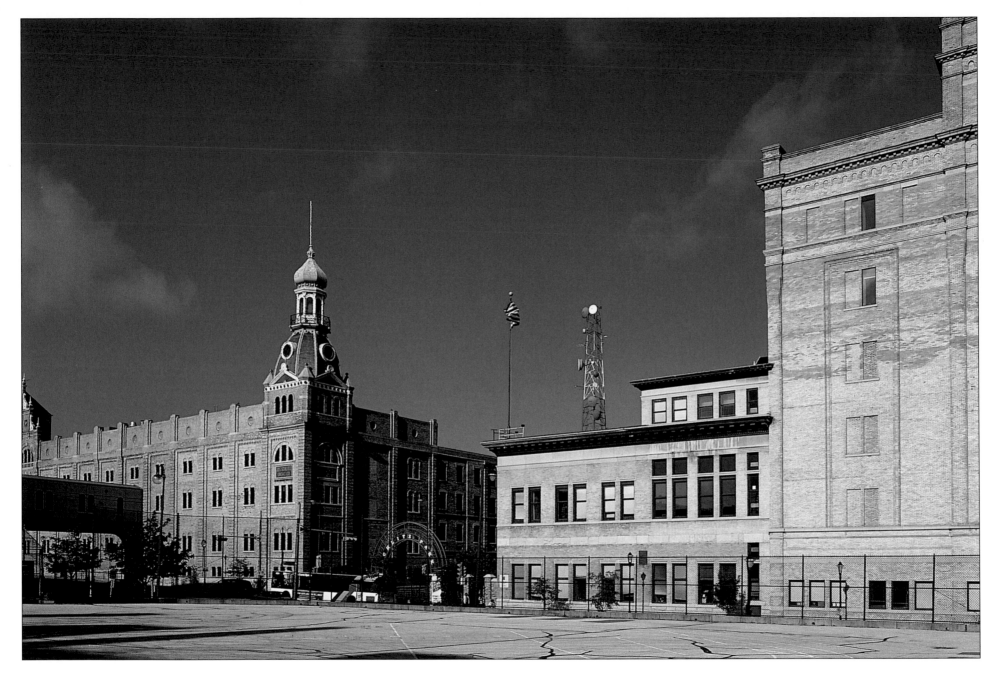

The company expanded after World War II, and in the 1950s, they opened plants in Tampa and Los Angeles and purchased a brewery in Kansas City. In 1963, Schlitz introduced the pop-top can that boosted sales. International expansion under Robert Uihlein resulted in new breweries in Turkey, Puerto Rico, Spain, and Brussels. The downfall of Schlitz occurred in the late 1960s and '70s when they unsuccessfully tried to diversify their business, buying into a winery and a feed business. In 1982, Stroh Brewery made an offer to purchase the brewery. The buildings now house the Milwaukee Education Center, a middle school for the Milwaukee Public School system, the United Way, and several other businesses—a good example of adaptive reuse.

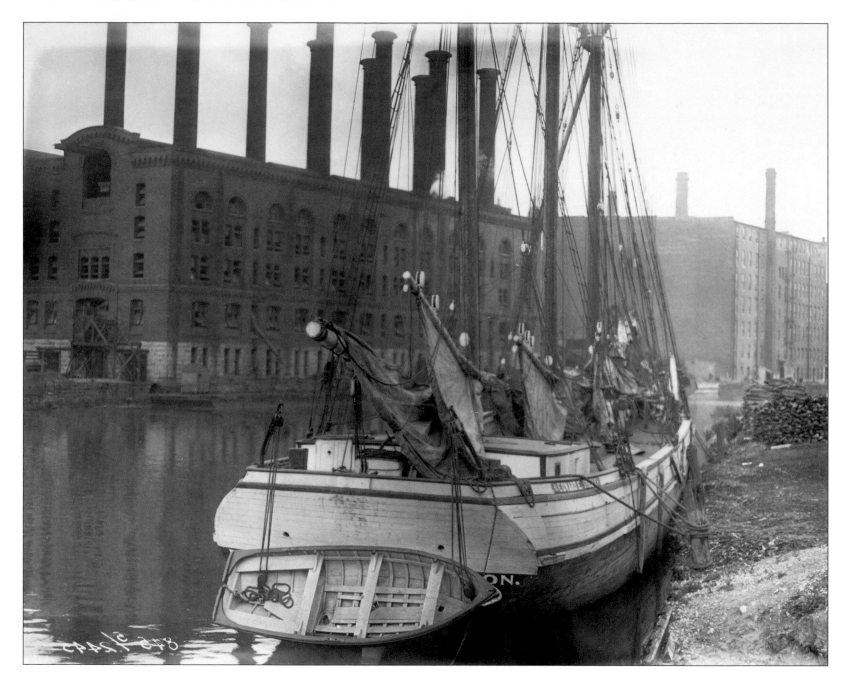

The Commerce Street Power Plant was completed in 1903 as a "transitional" powerhouse, with direct current being produced in its north half and alternating current in its south half. The generators were driven by both old-fashioned steam engines and newfangled steam turbines. It was once the electricity supplier for the Milwaukee Electric Railway and Light Company.

The company installed a steam tunnel in 1917 that connected the Commerce Street Plant with the Oneida Power Plant. By 1925, the new Lakeside facility in St. Francis, Wisconsin, was producing 86 percent of the company's electricity and the Commerce Street Plant was left to produce only steam heat and provide standby power.

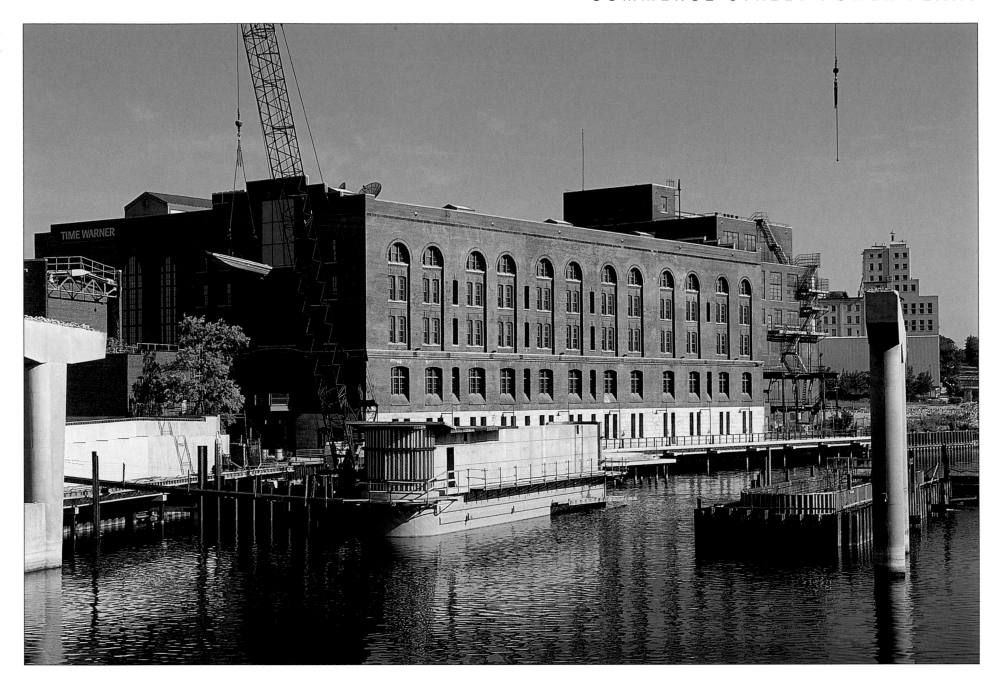

A new power plant in the Menomonee Valley in the 1960s took over the steam heating load handled by the aging Commerce Street and Oneida Power plants. After years of standby status, the Commerce Street Plant was formally retired in 1988. Still owned by We Energies, the building was gutted in 2001 and fitted with five floors of offices for Time Warner Cable's new state-of-the-art headquarters. The space includes an employee cafeteria with direct access to the riverwalk and a veranda overlooking the Milwaukee River. At the time work was going on to carve out space for Time Warner, a tunnel was discovered under the building that was used to divert water from the river for cooling the large turbine engines in the power plant.

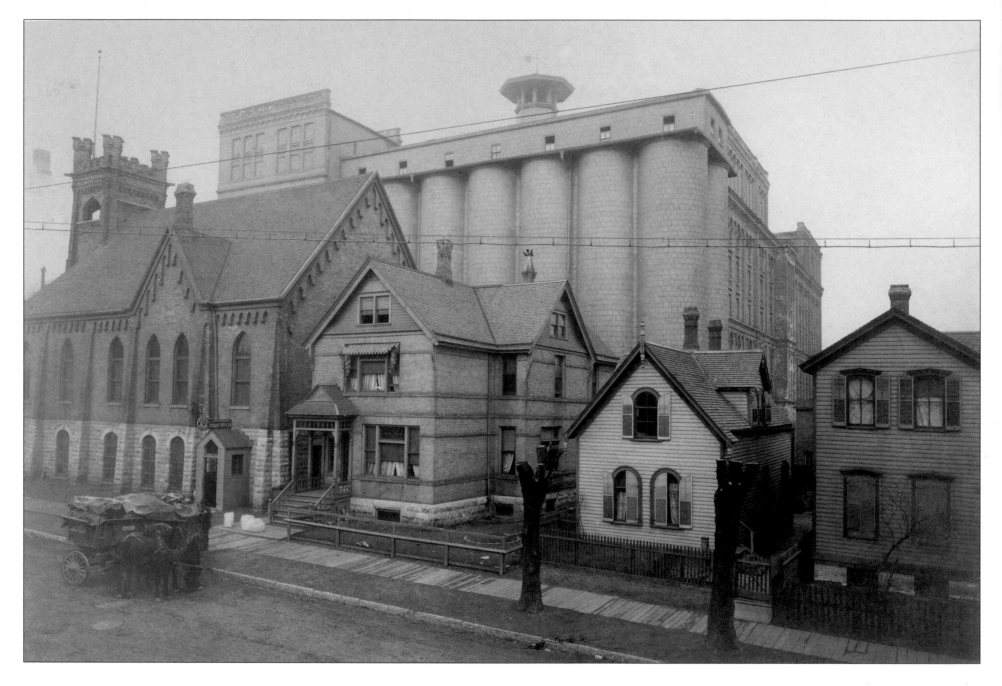

In the 1830s, German brewery owner Jacob Best emigrated to Milwaukee and built a brewery in his new town. His son Phillip took control of the brewery in 1859 and after Phillip's daughter, Maria, married the ship captain Frederick Pabst in 1862, he became a partner in the successful Best and Company. Best and Company was the second largest brewery in the United States by 1872 and was renamed the Pabst Brewing Company in 1889. "He drinks Best who drinks Pabst" became the new Pabst Brewing slogan. The imposing brewery building dominates the background of this photograph. In the foreground is the German Methodist Church that Pabst purchased in the late 1890s.

At the Philadelphia Centennial Exposition in 1876, Best competed with other breweries for the honor of best beer in the country and won first prize. To celebrate, in 1882, they tied a blue ribbon around the neck of each bottle and people began asking for "blue ribbon" beer. In 1985, Paul Kalmanovitz of California bought Pabst and, after being in business for 152 years, the brewery finally closed in 1996. The complex has since been purchased by a local investment group including We Energies. Pabst City—a multiuse complex— is being planned.

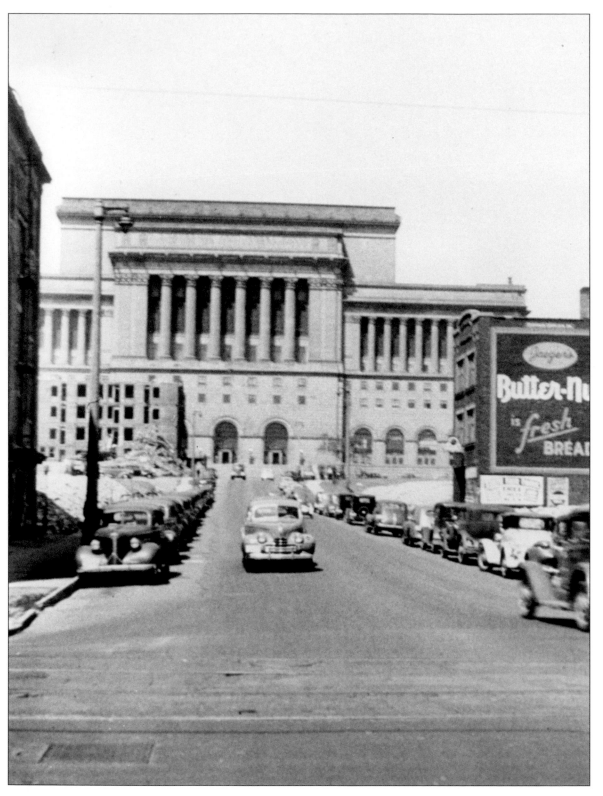

Left: In 1929, Milwaukee County held an architectural competition for the design of a new courthouse. The competition attracted thirty-three entries from across the country and the commission was given to the New York architect Albert Randolph Ross and his Classical Revival–style building. The courthouse was completed in 1931 and was the first courthouse located west of the Milwaukee River (the first two were located in what is now Cathedral Park). A Civic Center was also created due to the pressure from city planners, which consisted of a corridor of government buildings stretching west from City Hall to the Courthouse.

Right: The open area in front of the courthouse is MacArthur Square, which was created above an underground parking structure. MacArthur Square is dedicated to General Douglas MacArthur, as both MacArthur's father, General Arthur MacArthur, and his grandfather Judge Arthur MacArthur had been Milwaukee residents. Douglas himself attended West Division High School during his stay in Milwaukee. To the left of the courthouse is Clas Park, named for the Milwaukee architect and city planner Alfred Clas.

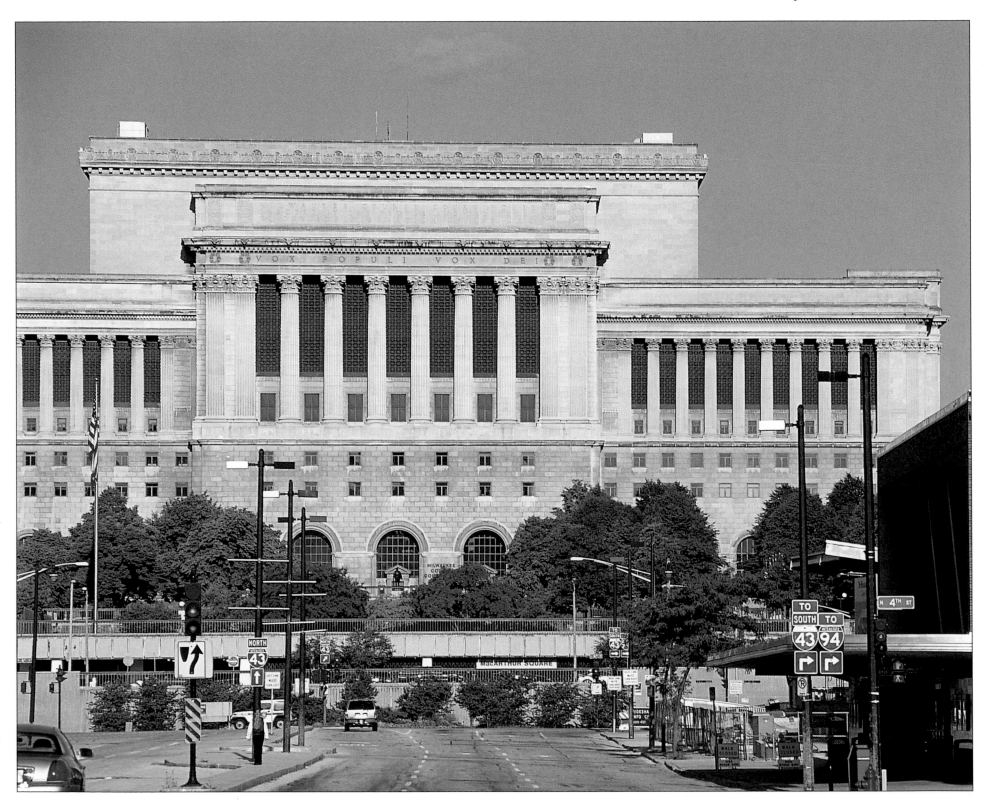

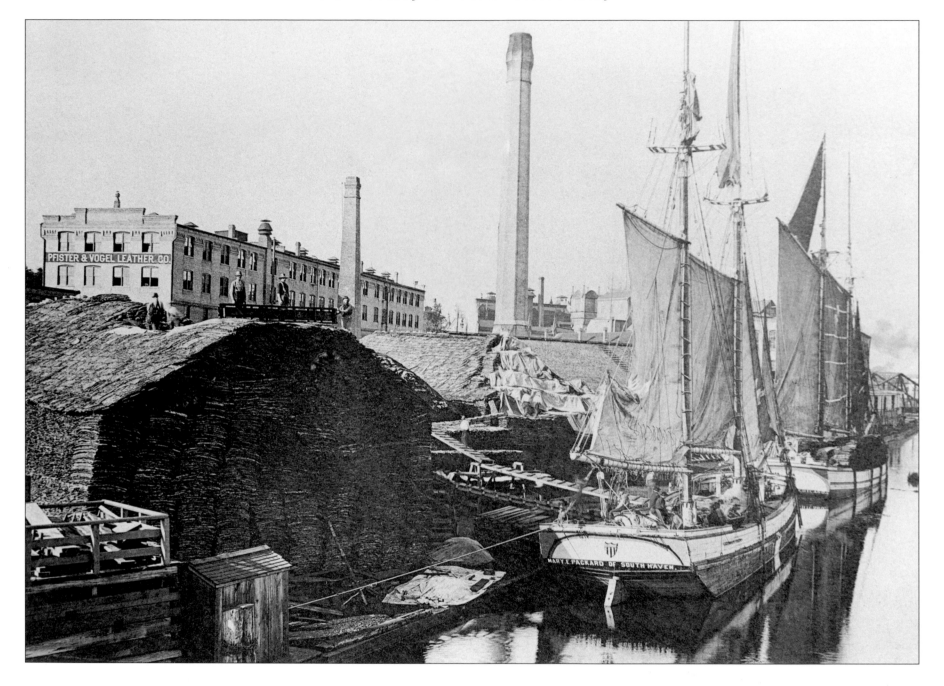

The meatpacking business was one of the earliest businesses to develop in Milwaukee and the tanning industry soon followed as a result. The industry relied on the natural resources of water and hemlock trees found in the area, but also on the abundant animal hides from the meatpackers. By 1872 Milwaukee had become the largest tanning center in the West, with over thirty tanneries. The German immigrants Frederich Vogel and Guido Pfister started separate tanning companies that merged in 1857 to become the Pfister & Vogel Leather Company, which was located here in the valley on the Menomonee River.

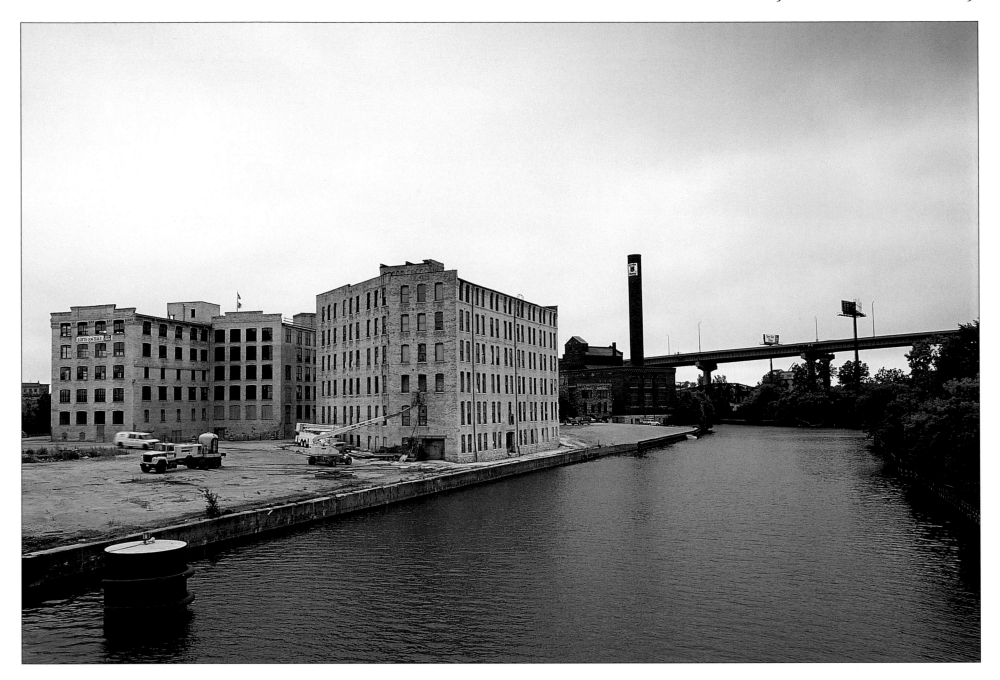

In the early 1930s, the tannery operations at this location were discontinued and the company created the P&V Atlas Industrial Center to lease out space in the buildings. Over the years many businesses used the buildings either for storage or for manufacturing—one of the businesses was Sprecher Brewing Company, a microbrewery. Although no longer at this location, their logo is still visible on the smokestack. The complex is now called the Tannery and is an urban business park. The buildings are being renovated, and in many cases, the original brick walls and thick support timbers are left uncovered, adding to the ambience of the interior office spaces.

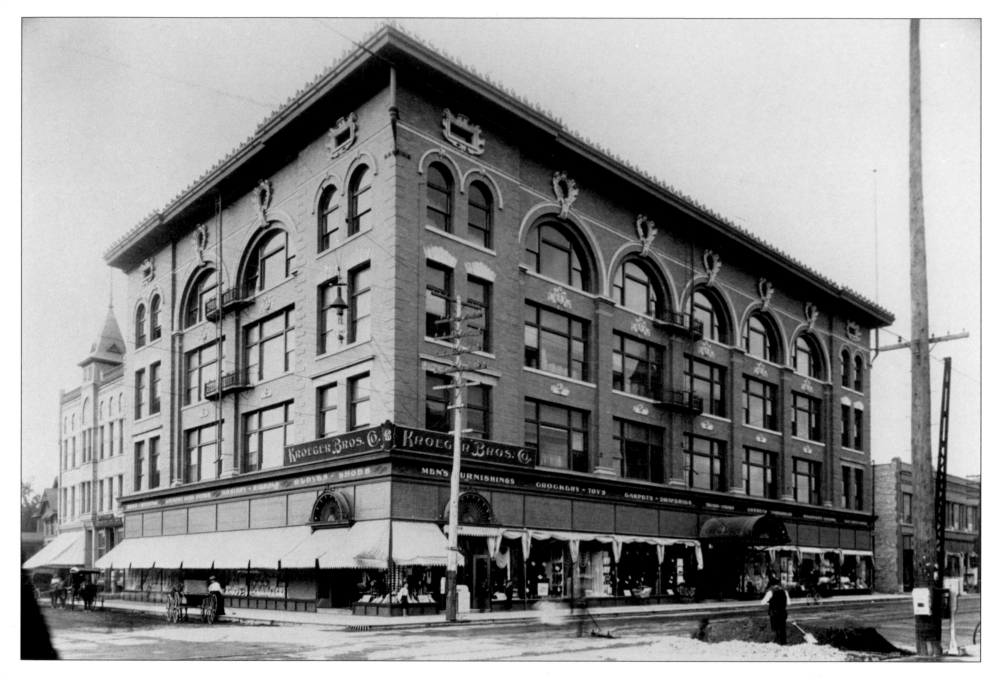

In 1901, Kroeger Bros. Company moved to their new building at Sixth and National, where they sold everything from clothing to groceries, toys, and carpeting. Their motto was "The store that tries to please." Poet Carl Sandburg worked as a copywriter in the store's advertising department when he lived in the area. Kroeger's had the longest expanse of display windows in Milwaukee at the time it was built. Later Clum Manufacturing occupied the building until it was abandoned in the late 1970s, turned into a symbol of urban decay.

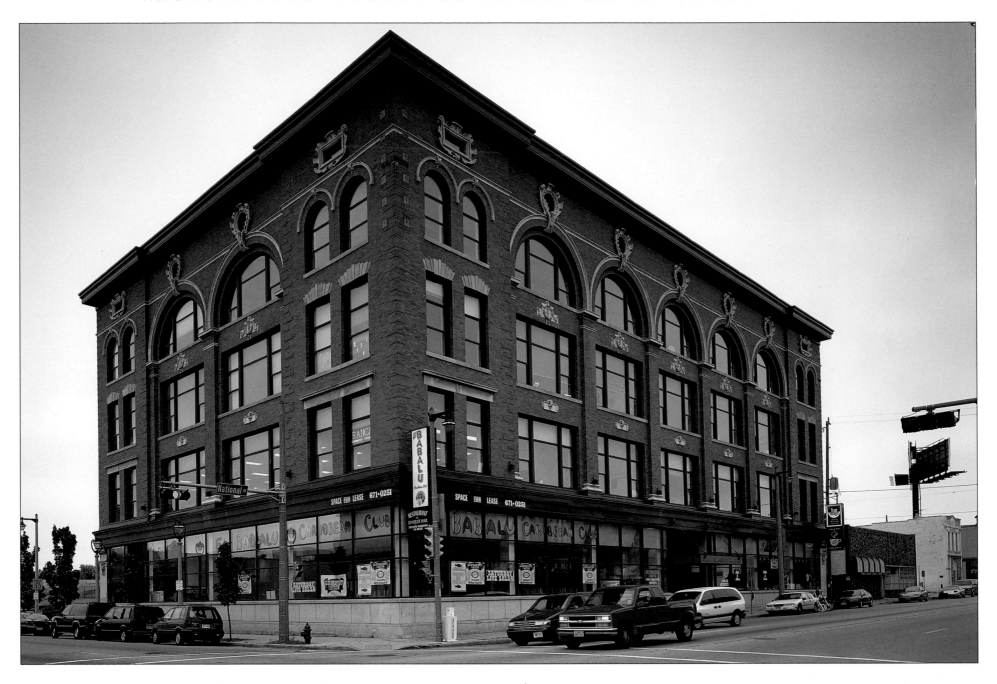

Over the years, heavy cement walls have been added in front of the first-floor windows. In 1991, Esperanza Unida Inc. acquired the building, and in partnership with public and private supporters, rehabilitation of the entire building was completed. The Esperanza Unida International Building was developed to house economic development, educational, and social service programs, which serve residents of Milwaukee. The building is also home to the El Babalu restaurant and nightclub and the Que Pasa? bilingual bookstore.

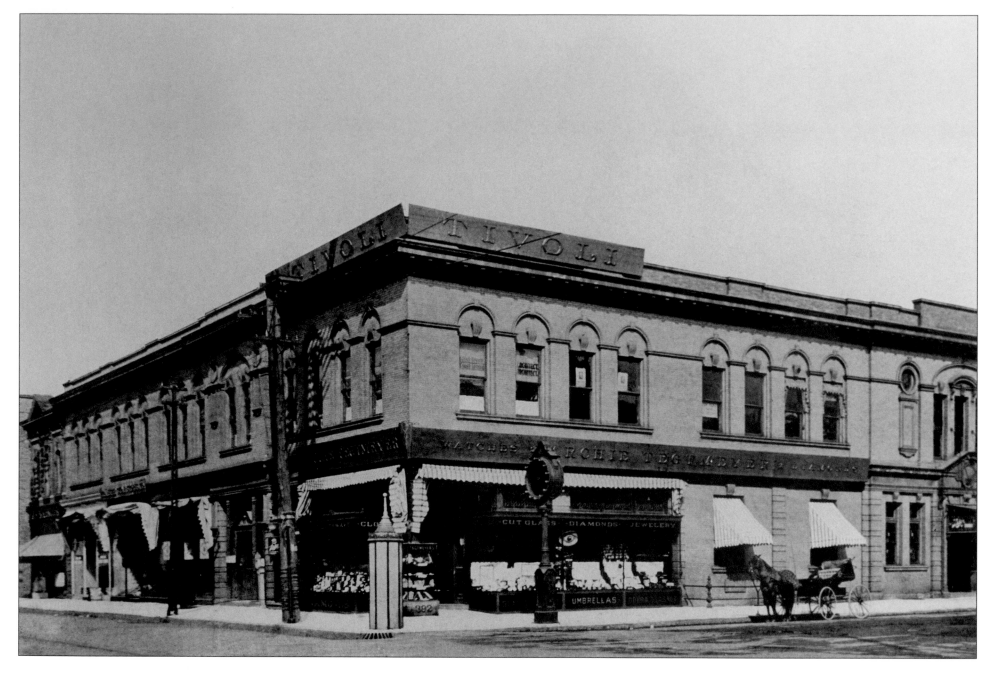

In an effort to move their product, Pabst, Miller, and Schlitz built taverns all over the city that sold their beer exclusively. Many of these taverns still exist—often across the street from each other. In addition to the taverns, Schlitz built Tivoli Palm Garden in 1901—it housed a bar, café, barbershop, dance hall, and bowling alley. The Schlitz Brewing Company's emblem was over the entrance at the rear of this Classical Revival building. The rest of the building was office space. Tivoli Palm Garden was a companion to the Schlitz Palm Garden at Third & Grand Ave that opened in 1886 and which also had a dance hall and served beer. Although no longer used as a beer garden, Tivoli Palm Garden continued to house offices into the 1970s.

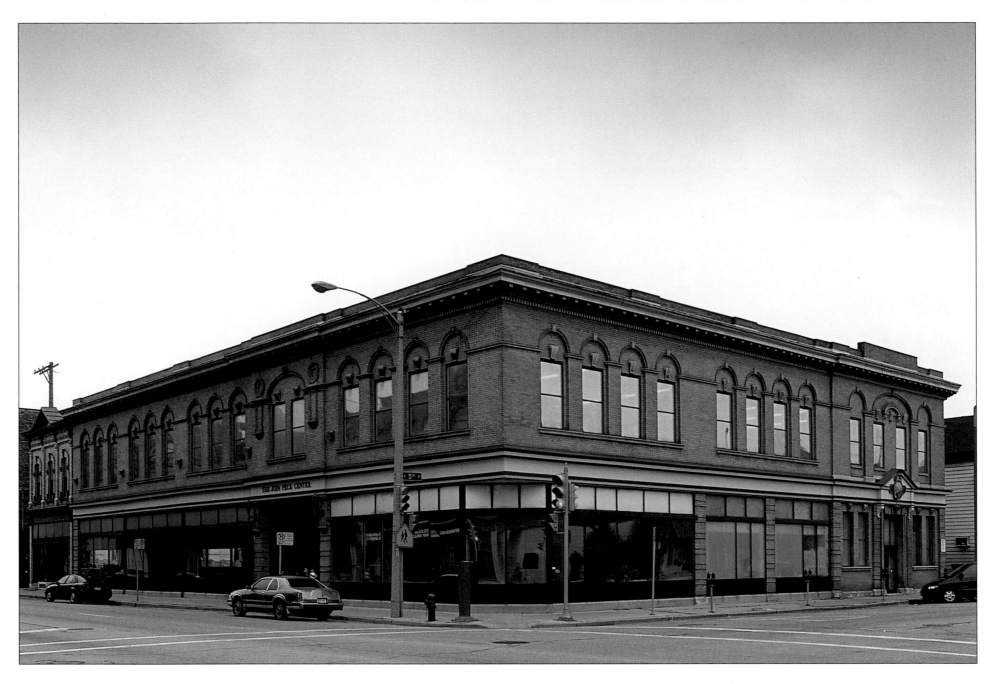

In 1978, fire swept through the building and only the exterior walls remained. The Historic Walker's Point organization—the forerunner of Historic Milwaukee—were watchdogs over the burned building because of several close calls with the wrecking ball. The Carley Group was hired to carry out the rehab work and the architectural firm of Kahler, Slater & Scott conducted a study to figure out uses for the building. The Milwaukee Ballet agreed to rent the building, and the interior was designed to include practice rooms, a dance studio, and space for costume making and scenery design. Jodi Peck, who came from a philanthropic family, donated money to the Milwaukee Ballet so that they could purchase the building, and they named it for her. The building is one of the few surviving Palm Gardens, and with the Milwaukee Ballet using it as a dance hall again, it has come full circle.

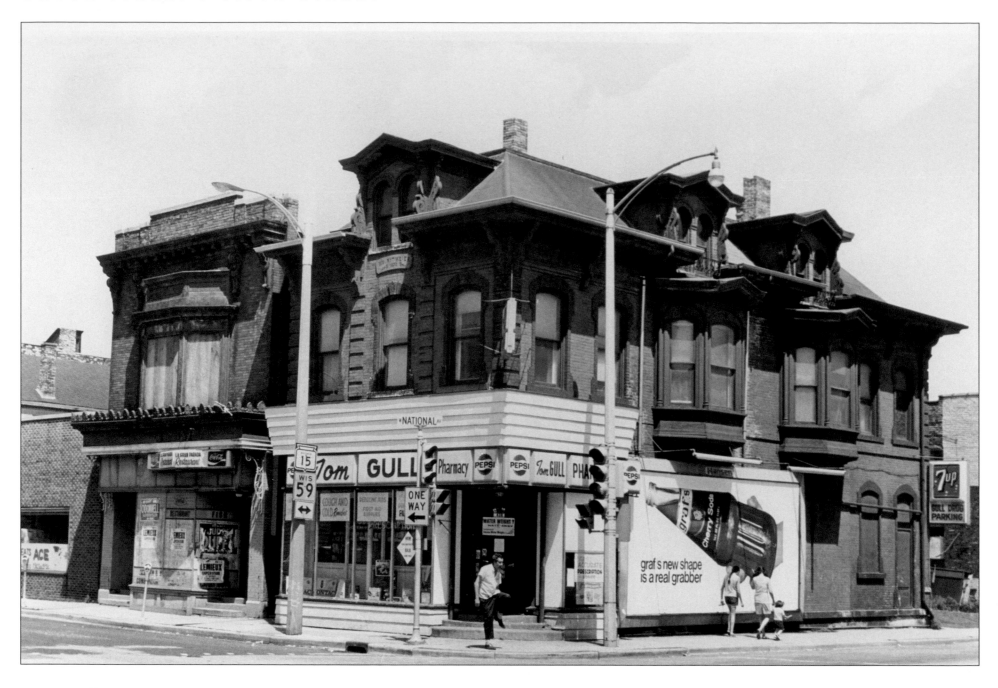

George Walker, one of Milwaukee's founders, bought land south of the Menomonee River and sold lots in what became known as Walker's Point. Grove Street (now Fifth Street) was the major shopping area for the Walker's Point neighborhood. In 1877, a veneer of "Cream City" brick was added to an existing wood frame building of the 1850s that stands on the corner of what was Grove Street and Elizabeth Street (now National Avenue). William Ritmeier ran a pharmacy out of this building for many years. To the left of the Ritmeier Building is the Schmidt/Ritmeier Building built in 1852. The brick front was added in 1907, with Charles L. Lesser listed as the architect of the brick-front addition.

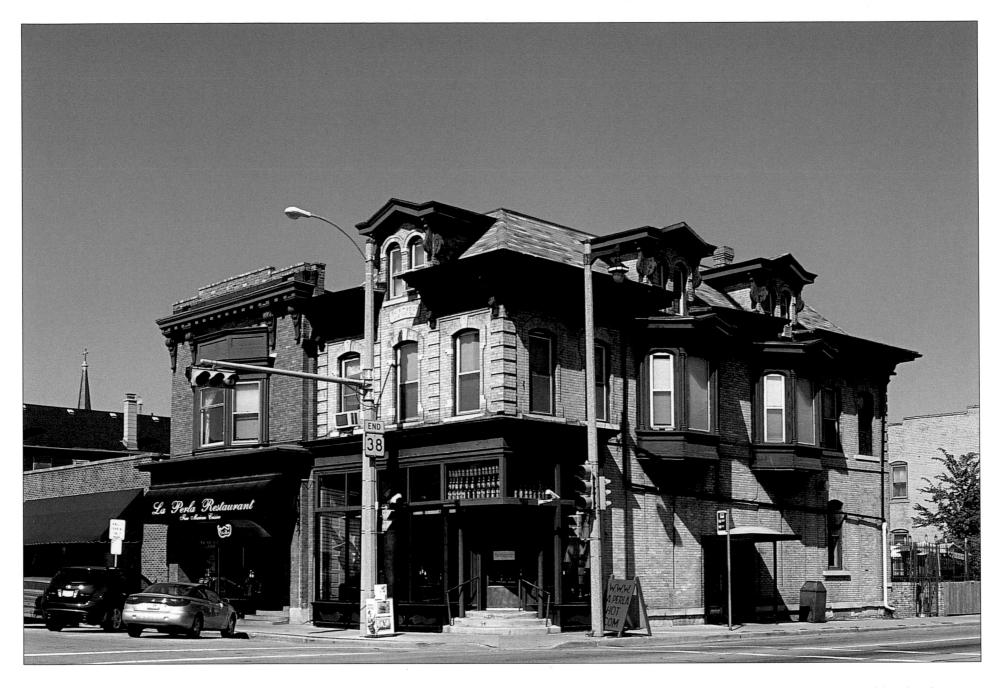

In 1973, a preservation group, Land Ethics, and the Junior League joined forces on a new project here in Walker's Point. In addition to getting the district on the National Register, they bought buildings and houses and educated area residents on how to rehabilitate the area for themselves.

After the buildings and houses were renovated, they were sold to local residents. Today the La Perla Restaurant operates out of both buildings. Walker's Point has a large population of Hispanic people and is home to many popular Mexican restaurants.

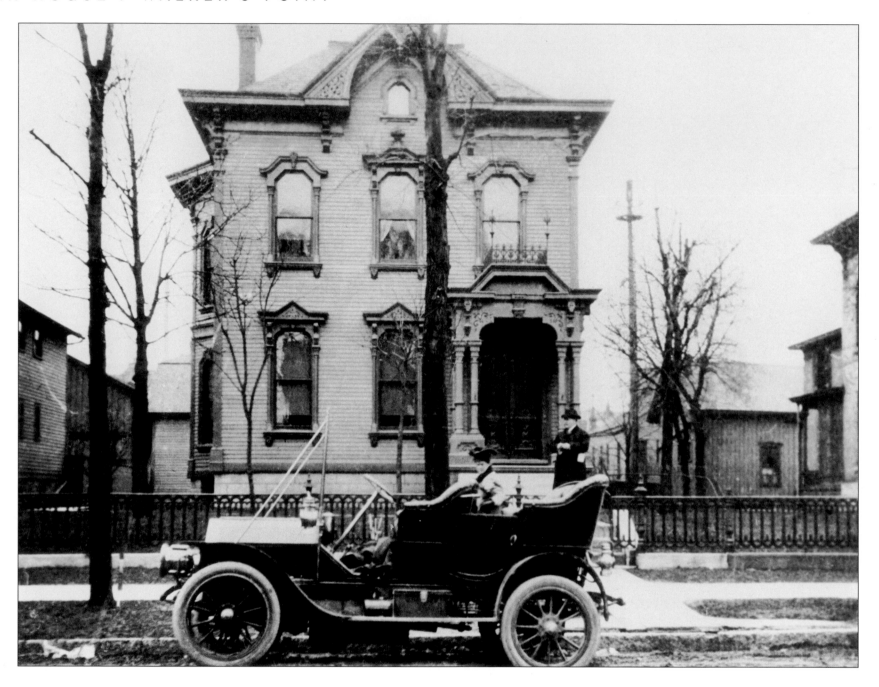

This 1875 Italianate-style house was constructed for Emil Durr, a part owner of Durr and Ruggee Lumber Company, a prosperous lumber company located in Walker's Point. One of three mansions located on what was then Hanover Street, Durr House was highly ornamented with decorated window hoods, an elaborate porch, and iron cresting at the roof. Durr was a native Milwaukeean of German extraction and lived here with his wife until his death in 1915. Houses in Walker's Point belonged to either the workers, the owners, or the managers of businesses in the area.

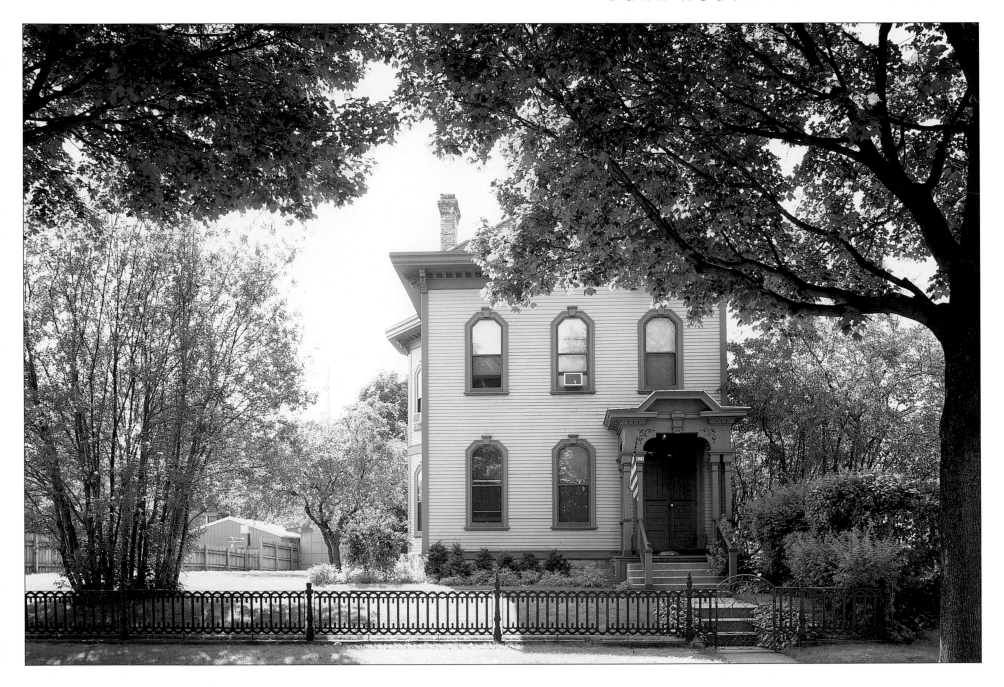

At some point, most of the decorative elements were removed from the house when the asphalt siding was added. However, the current owners have done much restoration work both to the interior and exterior of the house. Walker's Point was the smallest of the three pioneer communities that merged in 1846 to form Milwaukee. The other two were Juneautown, east of the Milwaukee River downtown, and Kilbourntown, west of the river. Walker's Point developed slowly over the years and remains an intact example of a nineteenth-century neighborhood. In 1978, Walker's Point was the first district in Milwaukee to be designated as a National Register Historic District.

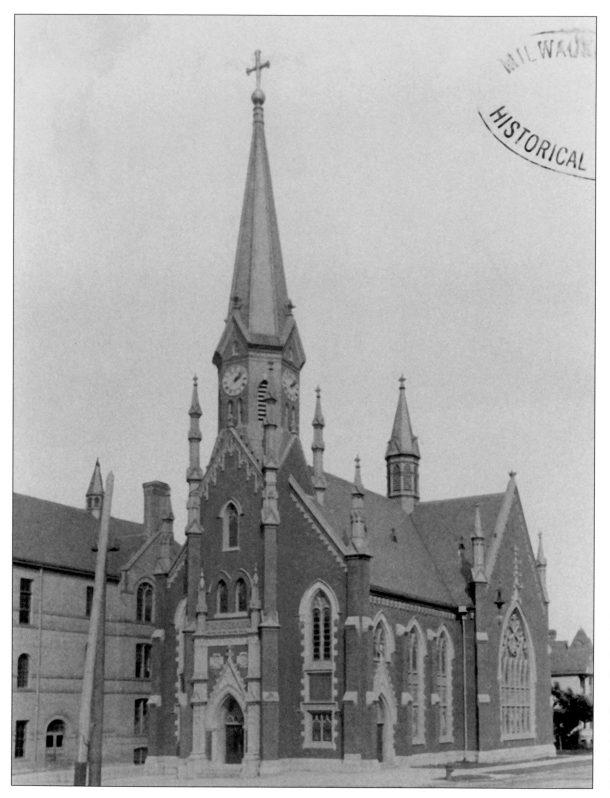

German immigrants formed St. Stephen's Evangelical Lutheran congregation in 1854, and by 1866 they had built a small church at this site. The tower and steeple were added in 1879, a common practice to hold down costs. In 1901 that building was razed, except for the tower and steeple, and the present church was actually constructed around the remaining tower and steeple. Until World War I, services were held in German. St. Stephen's School began in 1853 and was housed in the building to the left of the church, constructed in 1892.

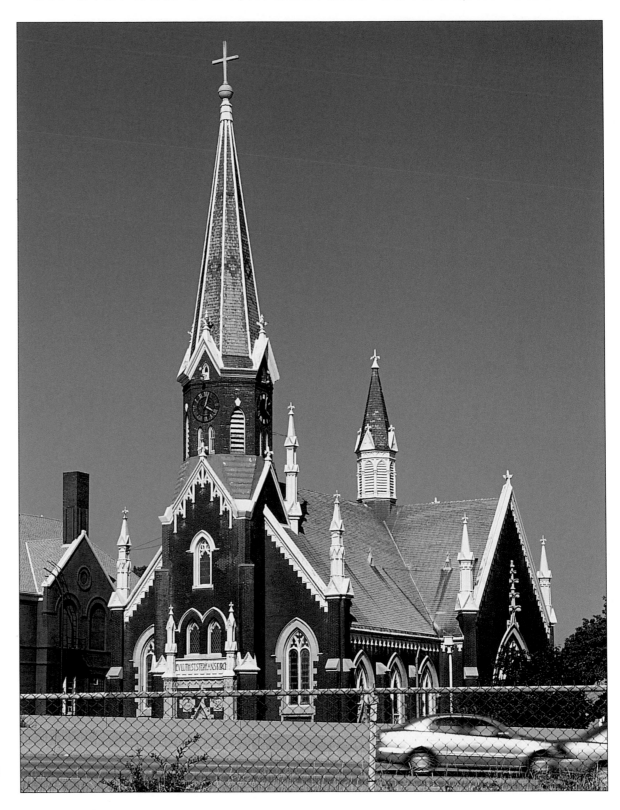

St. Stephen's was spared during the construction of the freeway. The many stained-glass windows in the church are extraordinary and include the two large windows on the north and south facades that depict the four evangelists. Until recently, the chimes of the clock rang out the hour, but they are no longer rung because of complaints from the neighbors about the noise. Today, services are held in English and Spanish, reflecting the changing nature of the Walker's Point neighborhood. The school closed in 1971 because of rising education costs.

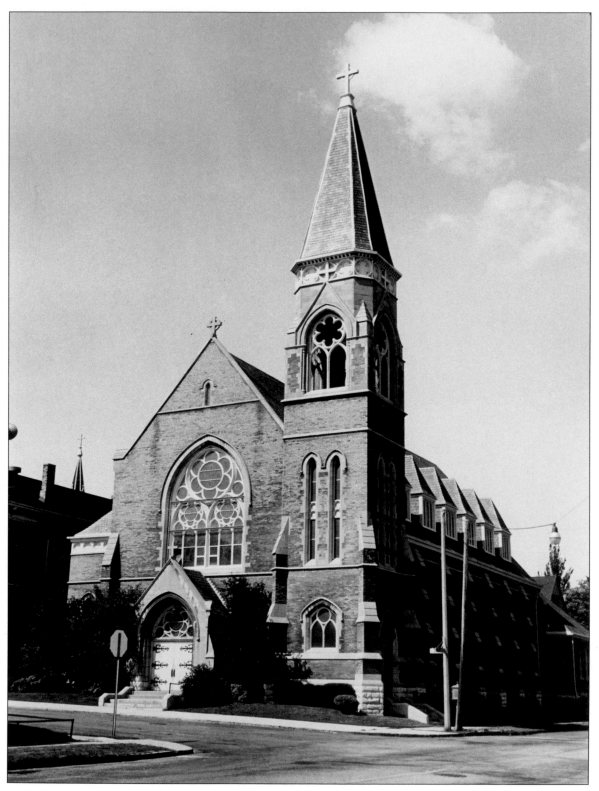

St. Patrick's Roman Catholic Church was established in 1876 to serve the growing number of Irish and English Catholics who resided on the south side, but had previously worshiped at St. Gall's in the central business district. Their first building consisted of a two-story brick structure with classrooms and a nun's residence on the first floor and a church auditorium on the second. When this Gothic Revival church was built, the original building became the school. The steeple behind the school building in this photo is St. Peter's Evangelical Lutheran Church, which was built in 1885.

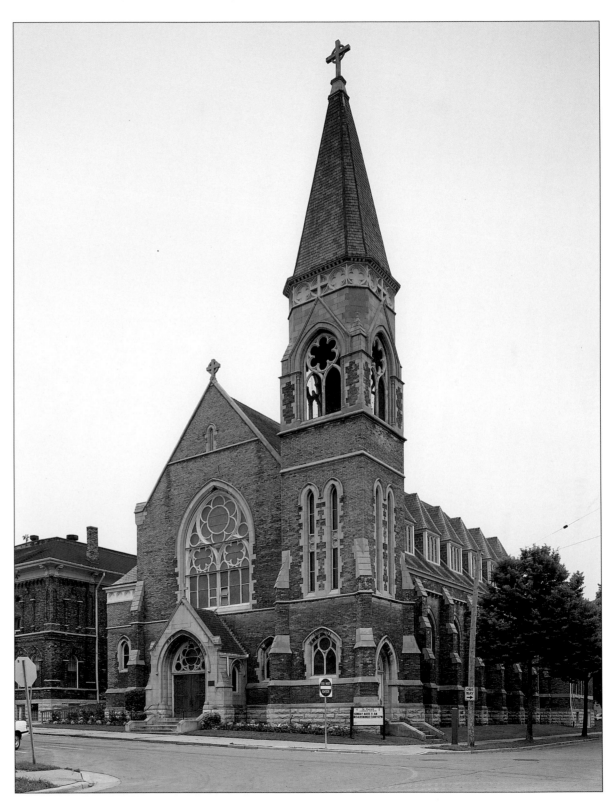

Jesuit priests now serve the mostly Hispanic congregation, again reflecting the changing demographics of the Walker's Point neighborhood. The parish has a Social Concerns Committee that visits families to assess their needs and to provide any help where needed. They have a food and clothing pantry for poor families and also run an English-as-a-second-language course.

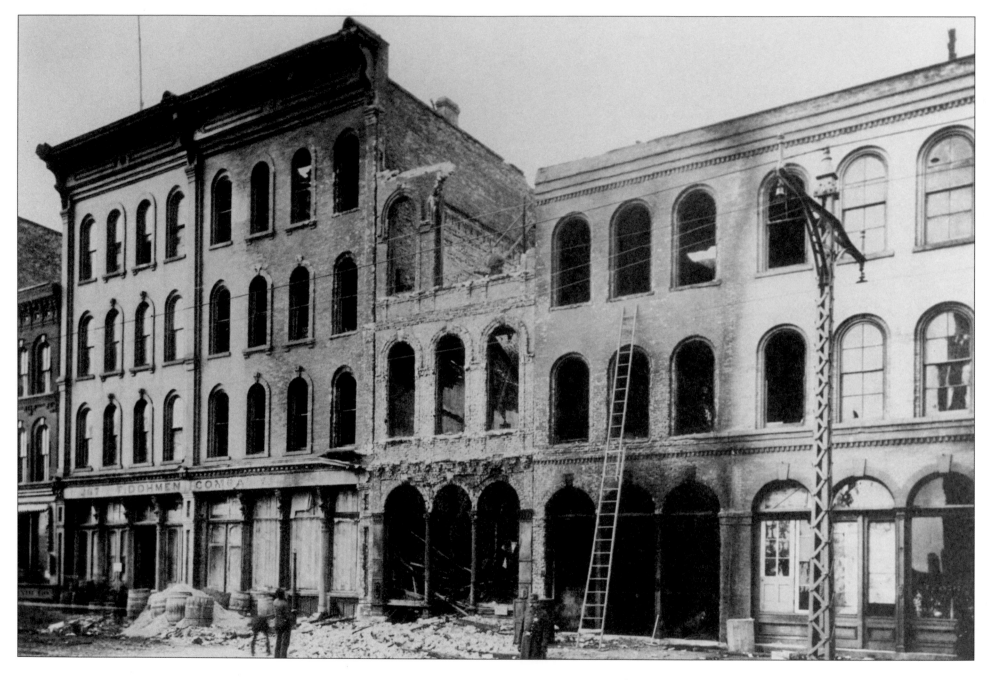

The Third Ward's Great Fire of 1892 started here in the Union Oil and Paint Company building. Fire officials claimed the fire was under control, however flames later erupted at the Bub & Kipp Furniture Factory a block away. The fire was fanned by fifty-mile-an-hour winds and for nearly six hours firefighters battled the blaze. The fire burned three hundred buildings, including commercial buildings and dwellings, four hundred families were left homeless, and four people were killed, including two firefighters. Freight cars that stood on the tracks to the east were also destroyed.

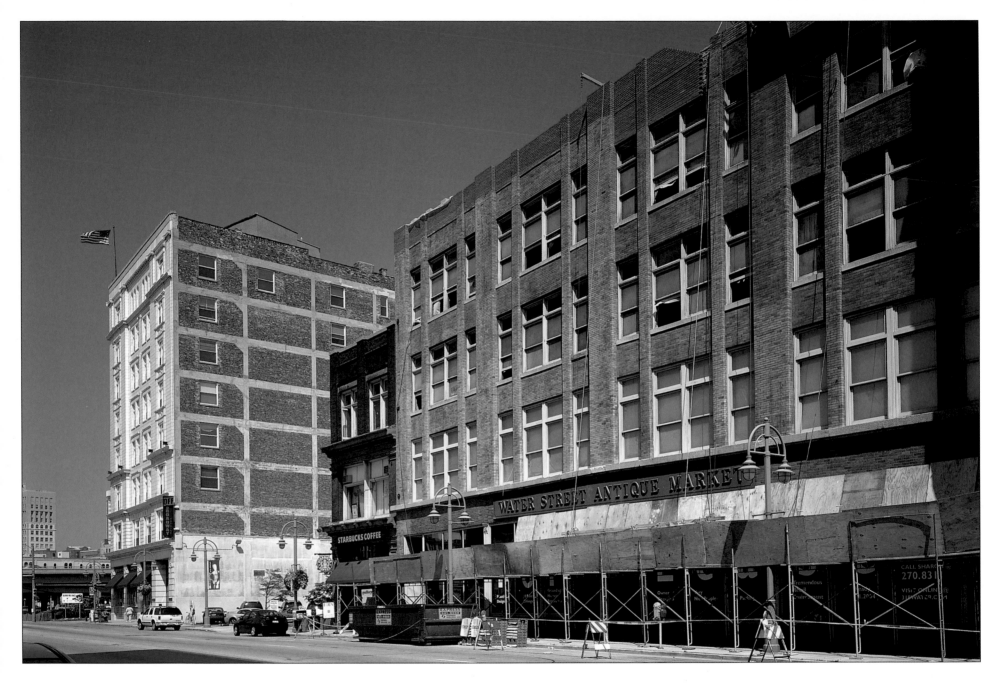

After the fire, rebuilding began almost immediately and many of the buildings that were damaged or destroyed in the fire were rebuilt. Warehouses and factories again appeared along the banks of the Milwaukee River and for several blocks east. The houses and small shops of the Italians moving into the area soon appeared east of the commercial district, such as the market and coffee shop seen here. In 1984, a portion of the old Third Ward was put on the National Register of Historic Places. Arches reading "Historic Third Ward" serves as entrances into the district.

The historic Third Ward was originally an Irish neighborhood, as the docks along the lakefront and the rivers offered the immigrants plenty of jobs associated with the maritime business conducted there. The area flourished as both a commercial area and a neighborhood for the immigrants. As the Irish who settled here first moved further west, the Italians started to move into the area, followed by merchants with goods and services. Frank Vitucci operated this saloon and, during prohibition, a soda fountain here. Frank and his family lived above the saloon.

A major fire in 1892 leveled over 300 buildings in the Third Ward but rebuilding began immediately. With the construction of the freeway in the 1960s and the demolition of many buildings by the city so the area could be put to industrial use, many of the Italians were displaced. In the late 1970s, a Milwaukee alderman proposed relocating adult stores, peep shows, and red-light activities to the Third Ward but building owners unified and resisted that proposal. In recent years, many of those warehouses have been converted into condominiums and apartment complexes. Today's historic Third Ward is once again a mixture of warehouses, factories, homes, retail businesses, and office blocks, such as the building featured here.

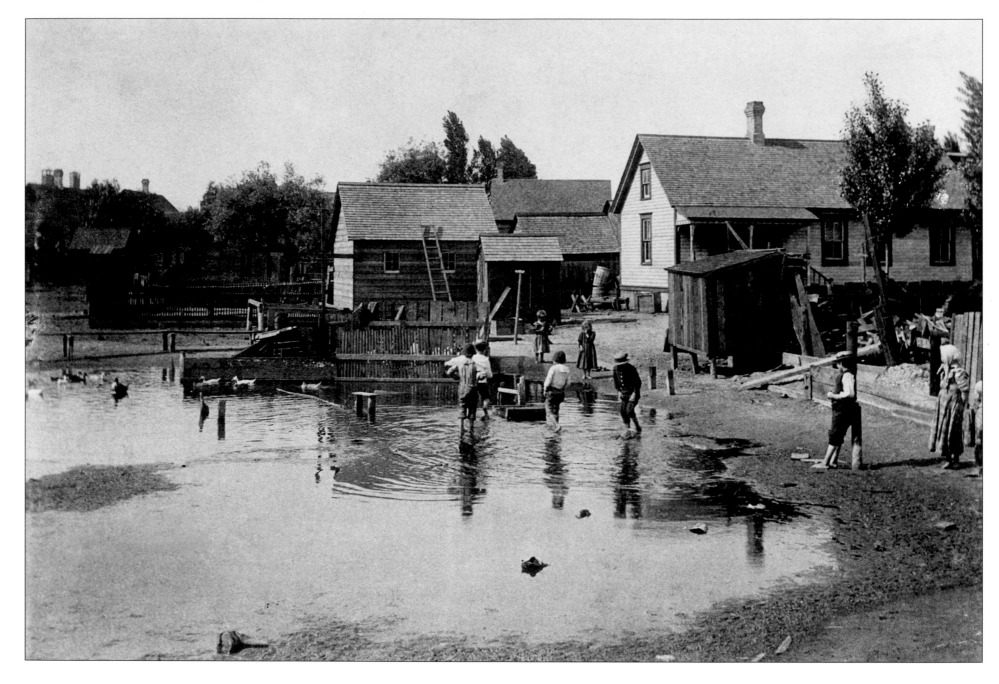

In the 1870s, Polish immigrants from the Kasuby region on the Baltic seacoast settled on a wind-swept peninsula along Lake Michigan, just south of the harbor entrance. Jones Island became the center of commercial fishing in southeastern Wisconsin. The village, whose population peaked at nearly 1,600, was a picturesque jumble of homes, saloons, fish sheds, and net reels. Many early Milwaukeeans came to Jones Island on Friday nights for the fish and fries offered at taverns operated by the locals. The Kashubians never obtained a land title and were evicted from the area in 1925.

Most of the former village was demolished when the Milwaukee sewage treatment plant was built, but the last of the fish shanties was not torn down until 1961. The Board of Harbor Commissioners was created in the 1920s and they still function today. When the St. Lawrence Seaway system opened in June of 1959, Milwaukee became an international port with marine terminals, and it is also home to the Seafarer's Mission (*see above*). Milwaukee has become a destination for German cruise ships, because of the city's German roots.

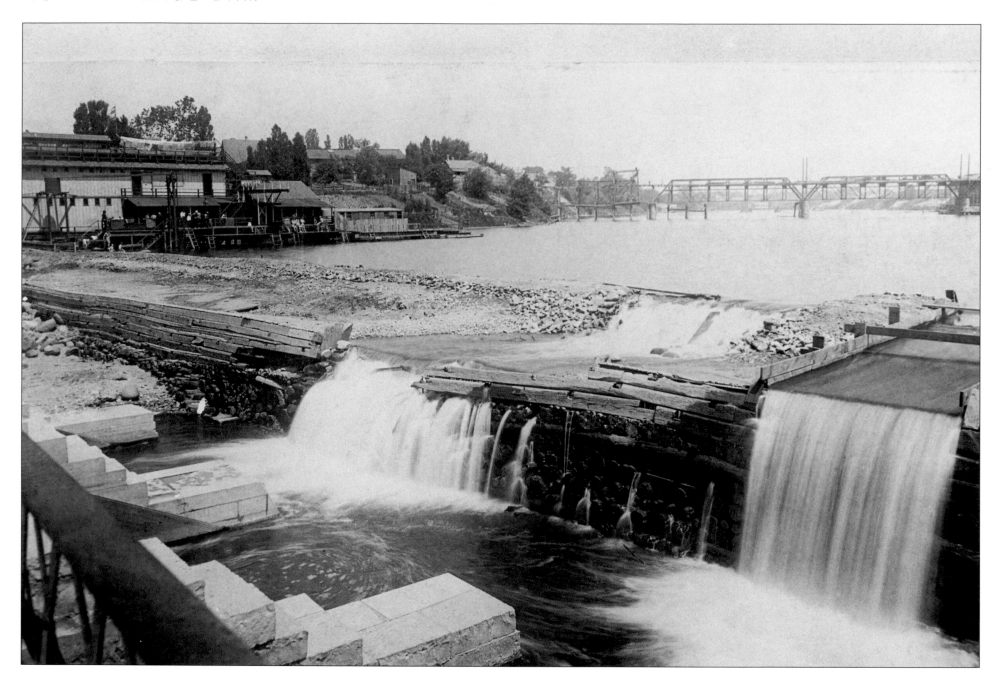

Byron Kilbourn envisioned a canal running from Lake Michigan to the Mississippi River, and by 1840, he had hired men to start building a dam on the Milwaukee River. They also dug a 1.25-mile-long ditch along the west bank of the river below the dam as the first link of the Grand Western Canal. The canal was never finished and the ditch became a millrace. By 1843, there were sawmills, flour mills, woodworking plants, and other businesses located there. The buildings on the west bank of the river belonged to Rohn's Swimming School, one of the many located on the banks of the Milwaukee River above the dam. Visible in the distance is the North Avenue Bridge.

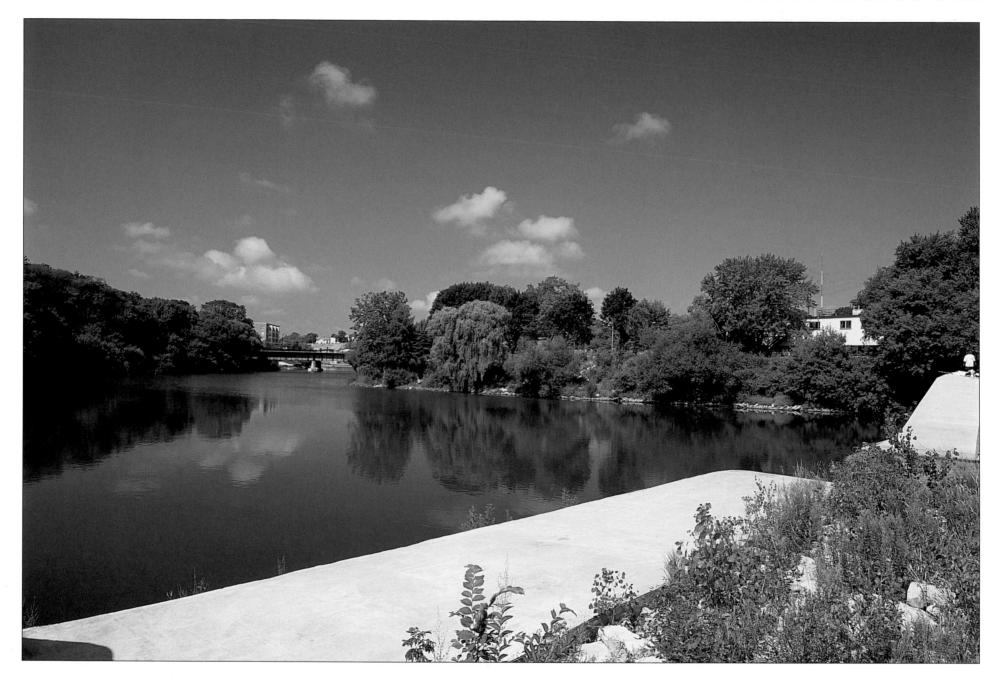

For years, industries dumped toxic by-products directly into the river, nearly killing it. Thanks to conservation efforts, including the passage of the Federal Clean Water Act in 1972 and the state's Milwaukee River Basin Priority Watershed program in 1984, the river has bounced back. The dam at North Avenue posed the biggest hurdle in recovery. Its gates were opened in 1990 and the dam was removed in 1997. As a result of the removal of this and other dams further north, the quality of the water has improved and now fishermen are finding a greater variety of fish in the shallow, fast-flowing water.

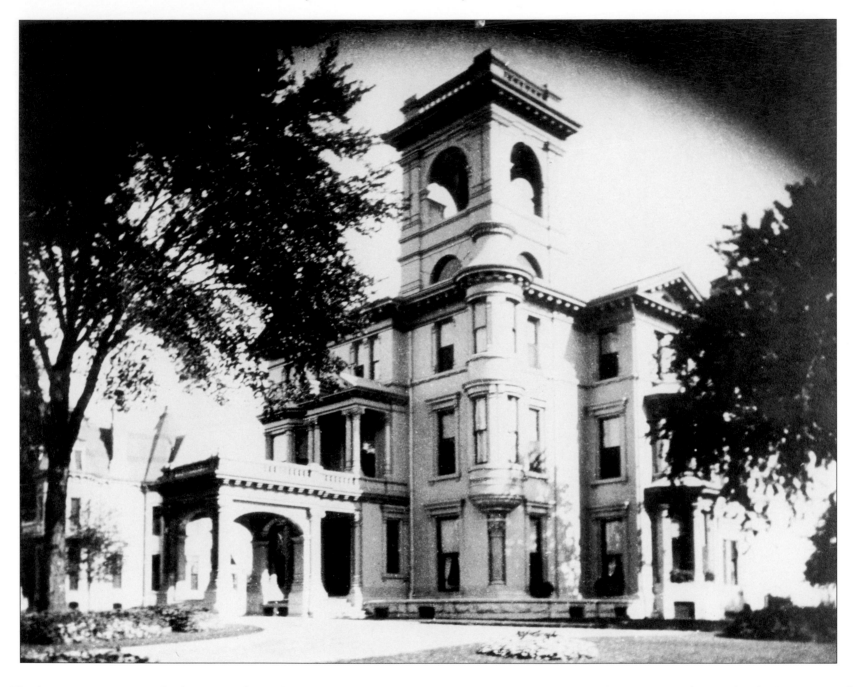

The John Plankinton Mansion was built in 1857 by real estate developer James H. Rodgers, and after his death, it became the residence of meatpacker John Plankinton. E. T. Mix significantly remodeled the house for Plankinton, who lived here until his death in 1891. In 1918, the building was purchased by Marquette University and was first used as a school of music. By the 1940s, the College of Engineering occupied the building. The mansion had been housing the university speech school in the 1970s when it was razed.

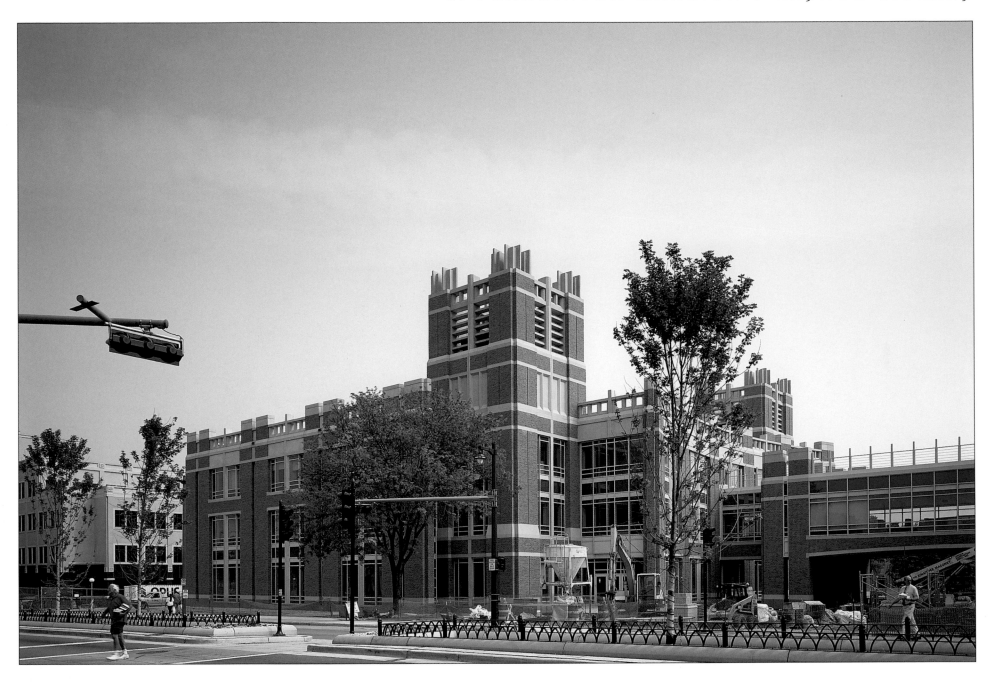

Marquette University's new library was dedicated on September 19, 2003. Actor Martin Sheen attended the dedication, and because of his support of Catholic social efforts, he received an honorary doctor of letters degree. The $55 million facility, named for Jesuit and former Marquette president John P. Raynor, is devoted to the technology of information gathering. The library is just one of the many new projects undertaken by Marquette in the last few years. Streetscaping along Wisconsin Avenue, which runs through the middle of the campus, has helped to define the university's borders in its downtown location.

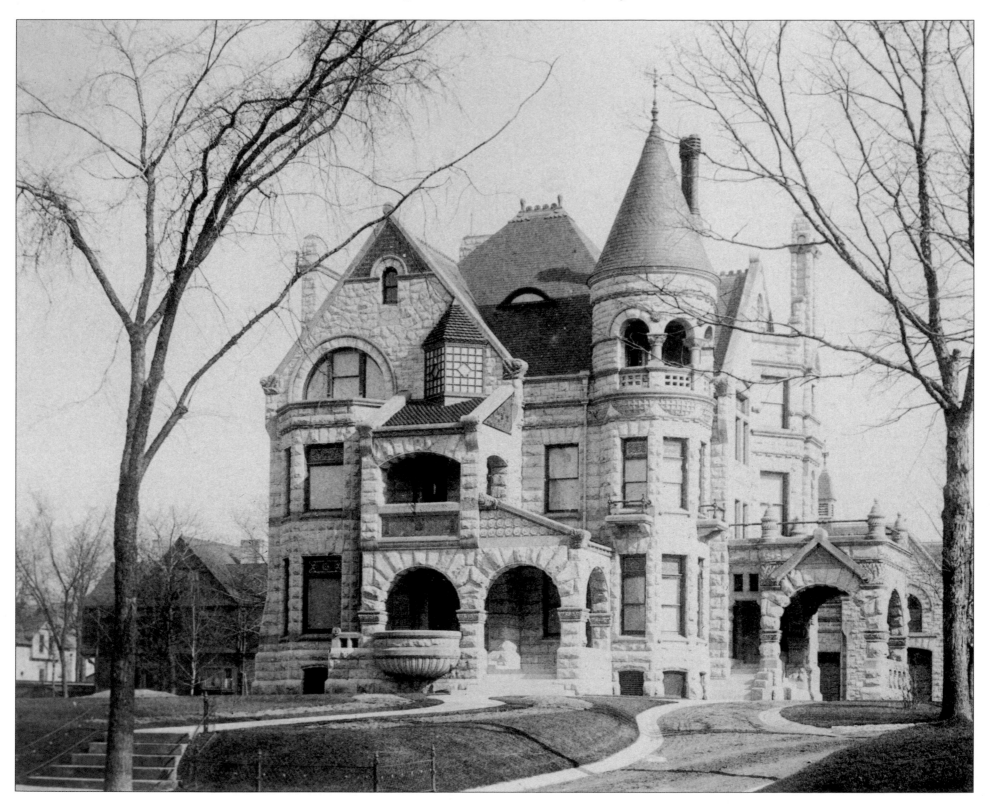

Left: The Richardsonian Romanesque–style Elizabeth Plankinton Mansion stood almost directly opposite the family home. John Plankinton conceived this mansion as a wedding present for his daughter, Elizabeth, and her groom-to-be Richard Hamilton Park, a sculptor living in Florence, Italy. When it was discovered that Park was already married, Elizabeth was so shaken that she left for an extended European vacation. Once back, Elizabeth took her one and only look at what was to be her home. After sitting empty for eight years, the mansion was finally sold to Mrs. Hugh L. Johnston, the widow of a partner in the Robert A. Johnston Cookie Company.

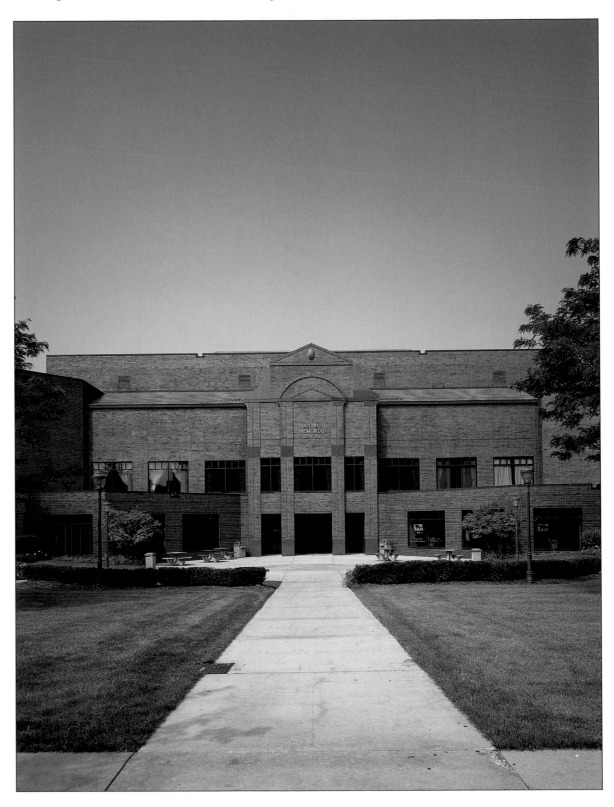

Right: Mrs. Johnston was the only one to ever live in the house. In 1910, the Knights of Columbus bought the home that was designed by architect E. T. Mix. Throughout the years, the Columbus members took pride in their Wisconsin Avenue home and the interior was left almost intact. In the 1960s, the group was told that the building stood in the path of Marquette University's redevelopment project. The building was listed on the National Register and there were several attempts to save it. However, in 1980, the building was razed. The new building on the site houses the Alumni Memorial Union.

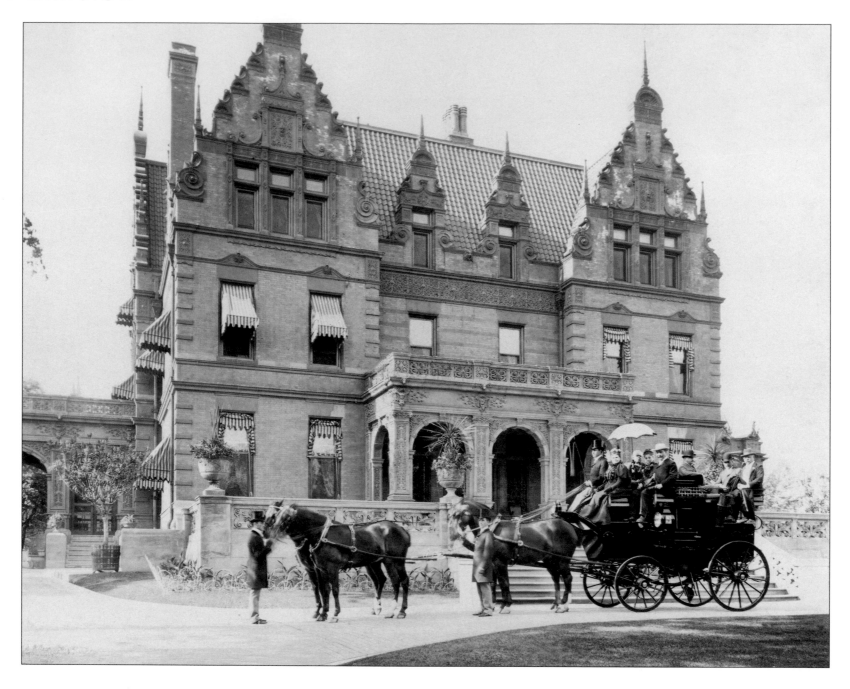

This early view shows the Captain Frederick Pabst (of the Pabst Brewery) Mansion. Built between 1890 and 1892, the mansion was one of many along Grand Avenue—a beautiful boulevard that was lined with elm trees and the turreted mansions of Milwaukee's premier families. Architect George Bowman Ferry, of the firm Ferry and Clas, designed the Flemish Renaissance Revival–style mansion. The Pabst family occupied the house until 1906, and in 1908, the mansion was sold to the Roman Catholic Archdiocese for the archbishop's official residence.

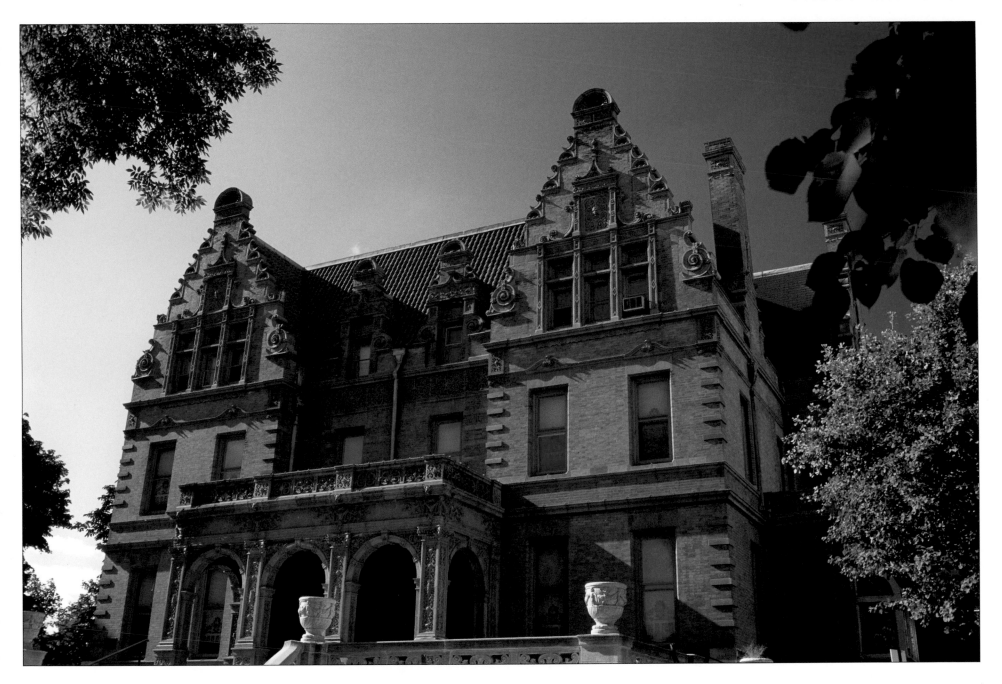

The estate was sold to a local developer in 1976 who subdivided the grounds and demolished the carriage house. The house was sold to Wisconsin Heritages, a private nonprofit corporation that was charted in 1975 to save Wisconsin's architectural landmarks. Money came from a $100,000 grant from the National Park Service and a mortgage (from twenty-three local savings and loan associations) for the balance of the purchase price. The mansion was listed on the National Register of Historic Places and work on restoration began. The mansion has been open to the public for tours since 1978.

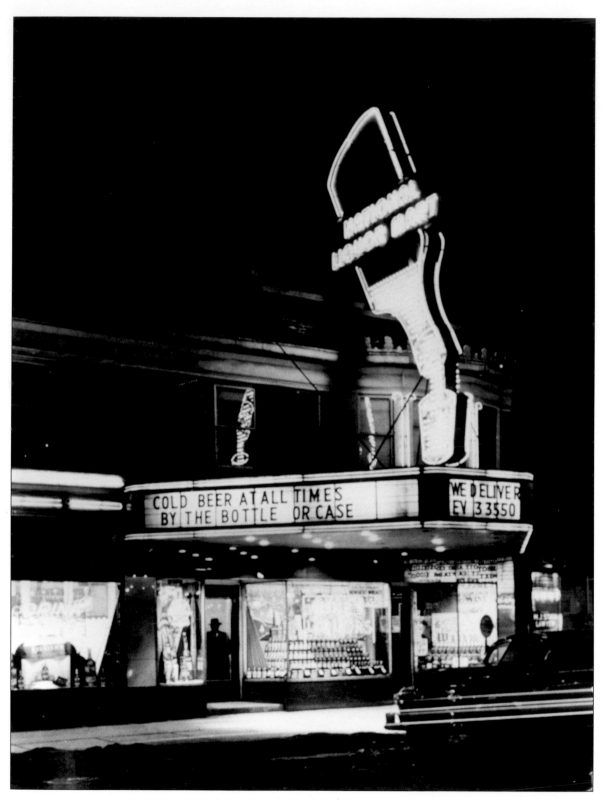

Milwaukee has been home to some of America's largest brewers—Pabst, Schlitz, Miller, and Blatz—and is known as the "brewing capital of the world." Although it sounds more like a federal agency than a local bar, the National Liquor Bar has been one of Milwaukee's classic no-frills venues for about sixty years, a place where regulars can enjoy for themselves some of the locally brewed beers. It was built in 1939, but with wood paneling on most of its walls and an old-fashioned tin ceiling, it gives the impression of a saloon of old Milwaukee.

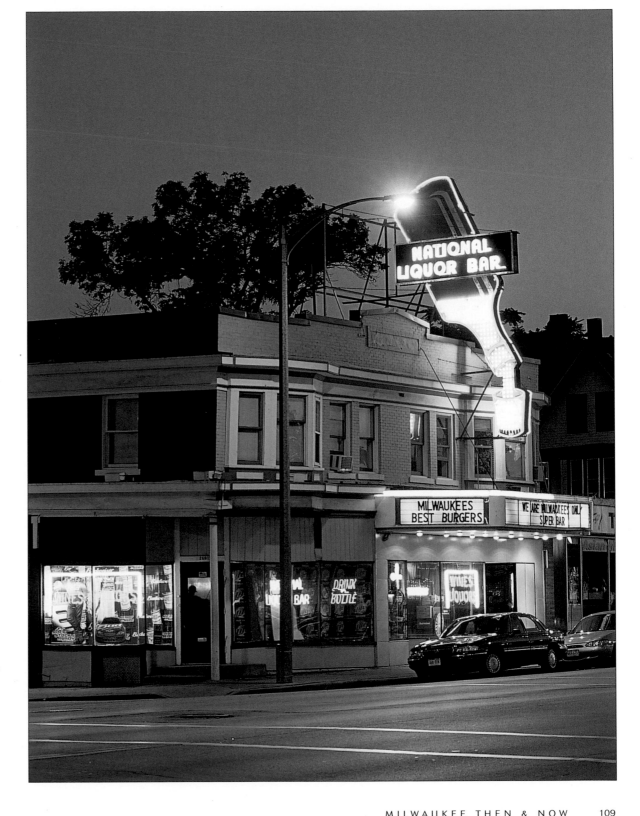

Located on National Avenue in the shadow of the Mitchell Park domes, the bar remains a typical neighborhood meeting place where patrons can relax around a circular bar while enjoying the food and beer, or buy from the liquor store contained within. The giant, neon-trimmed bottle—a fine example of retro Americana—up on the roof still pours psychedelic booze by way of sequential lightbulbs into a shot glass below, and the spacious bar inside maintains the down-to-earth hospitality it was known for sixty years ago. Although the bar is threatened with closure, it still has its loyal supporters who wouldn't want to see this familiar landmark go away.

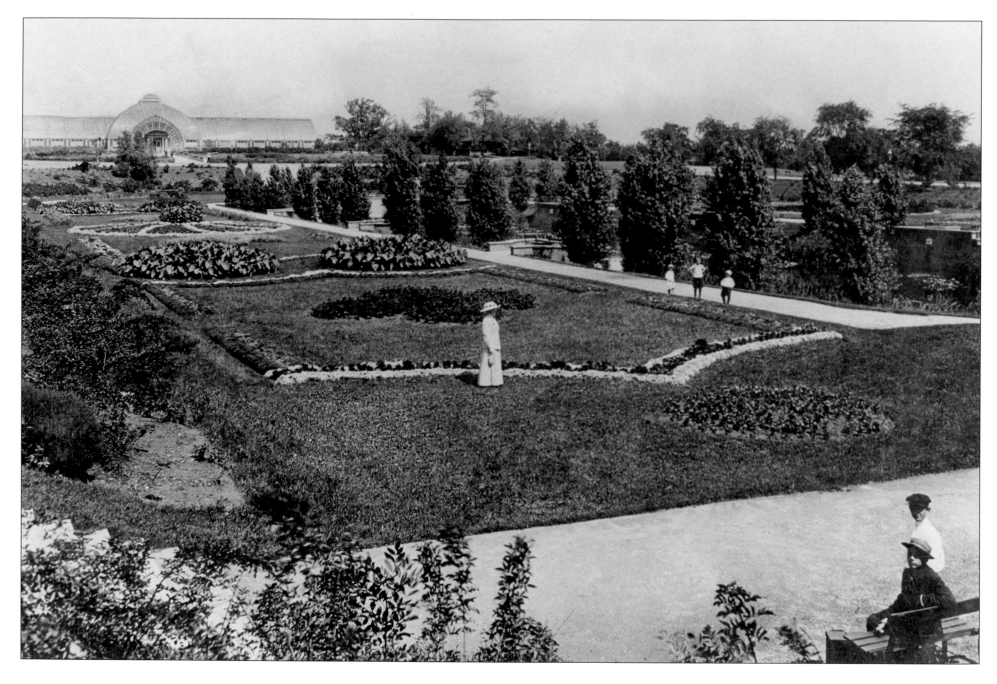

In 1889, the Milwaukee Park Commission was established. Their first report stated, "Without regards to sides, they have chosen tracts of land so located that in the course of time the city will be completely surrounded by breathing places where all classes from the highest to the lowest, may rest their tired brains and weary limbs." Mitchell Park was one of those six original park sites chosen. In 1898, construction began on the first conservatory that contained traditional plantings, which became one of the most elegant park buildings of its age. In 1904, the sunken gardens were added.

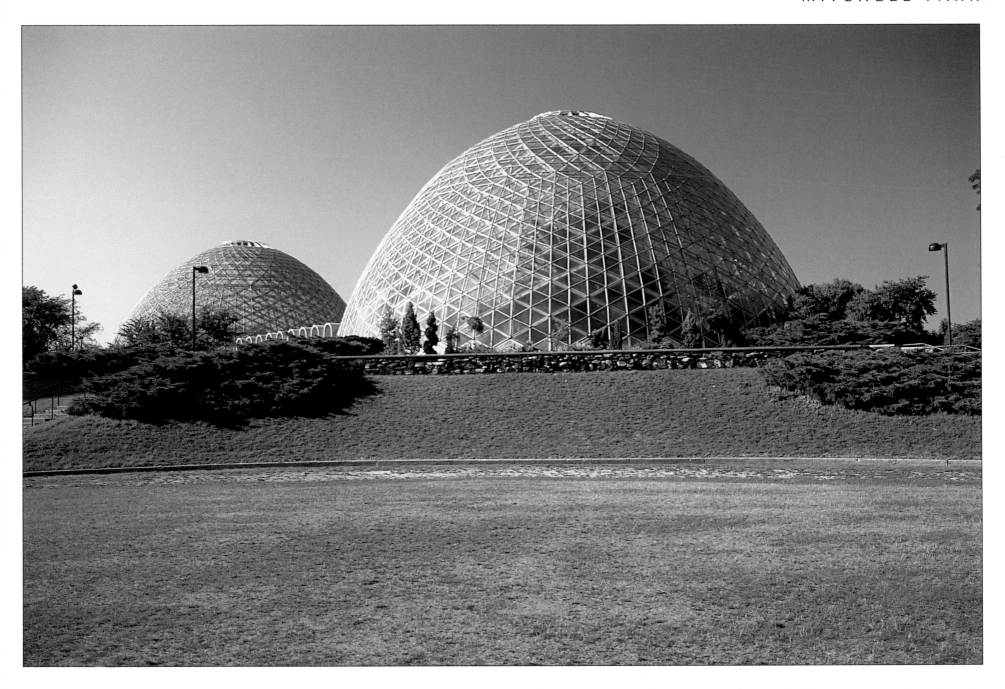

The elegant conservatory was removed in 1955, and between 1959 and 1967, the present three geodesic domes were constructed. Each dome houses a naturalistic display of plants, flowers, and trees in different climatic conditions: desert, rain forest, and a changing seasonal display. The filling in of the sunken gardens began in 1994 because budget cuts meant that the park could no longer provide for their upkeep. The bluff at the north end of the park once held the trading post of Jacques Vieau, an early fur trader in the area and Solomon Juneau's father-in-law; it is now marked by a plaque.

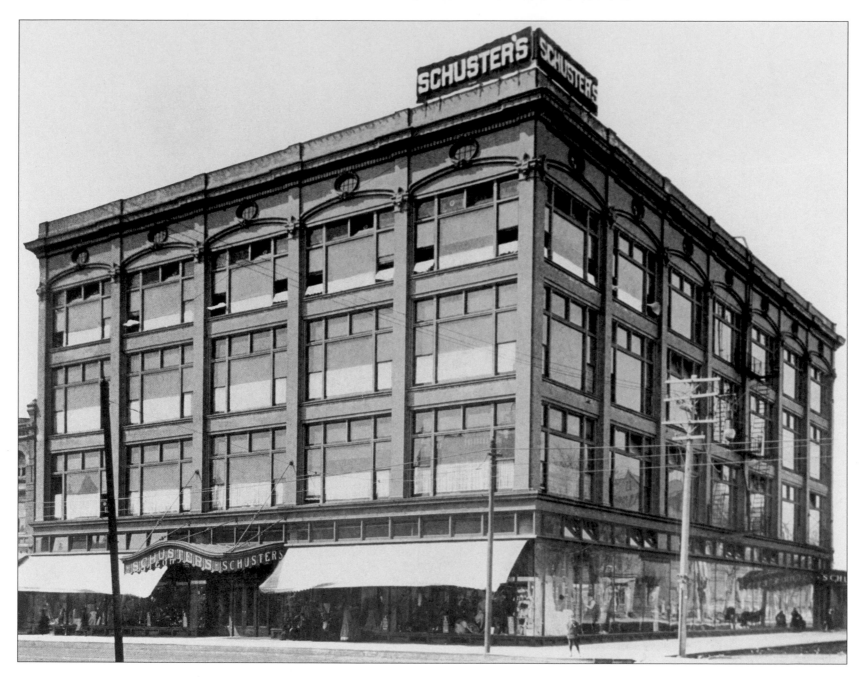

The Schuster Dry Goods Company building on Third Street and Garfield was one of three Schuster stores in Milwaukee. The others were located at Twelfth and Vliet and at Eleventh and Mitchell. Schuster's was the largest department store chain in the state. In 1927, Schuster's decided to do something special for the children of Milwaukee. Schuster's decorators and carpenters constructed floats, and on the first Saturday of December, a Christmas parade rolled through the streets of Milwaukee. The parade became a family tradition over the years and the last parade was held in the late 1950s. Schuster's opened their last store in Capitol Court in the late 1950s, but they and other business owners on Third Street saw sales fall significantly as shoppers started going to the new outlying malls.

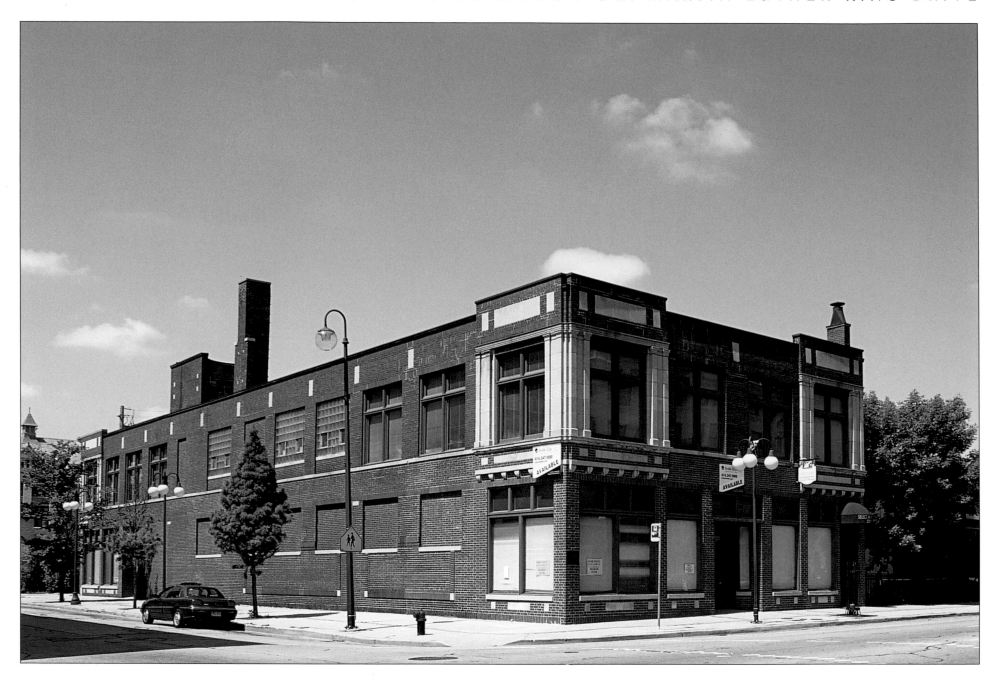

The civil unrest along Third Street in the 1960s and the opening of suburban shopping malls in the 1950s and '60s caused many businesses in this area to close. For several decades after that the street declined as more and more buildings were boarded up or used for storefront churches. In the last ten years, new life has come to the street now named for civil rights activist Dr. Martin Luther King Jr. The old buildings are being restored to their former glory and new infill buildings mirror the decorative elements of their neighbors. Restaurants, cafés, bookstores, and other businesses are once again calling this area home.

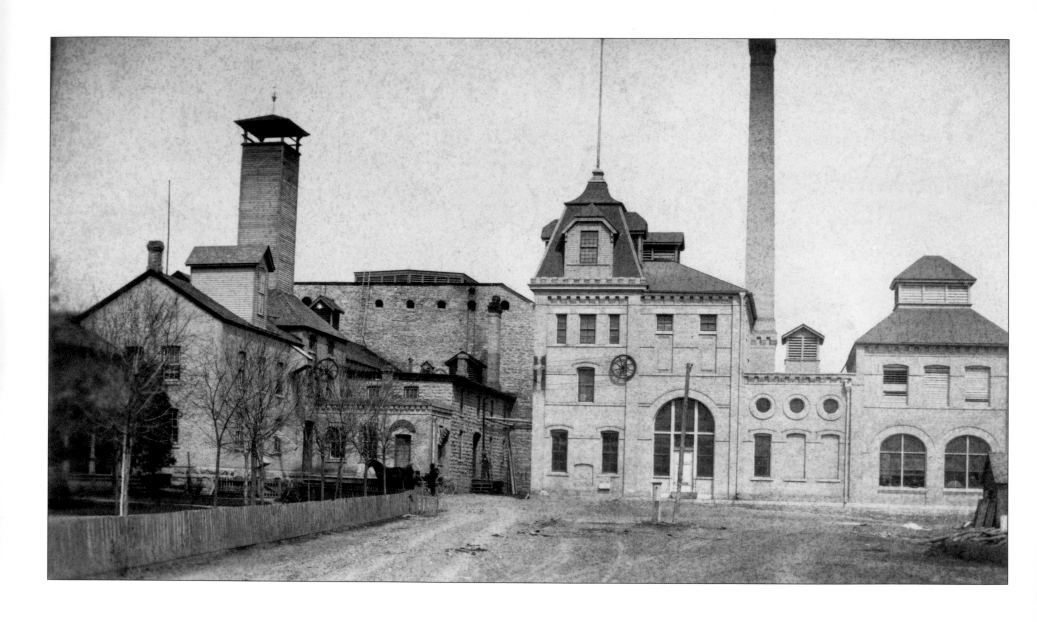

In 1856, George Schweickhardt, an immigrant brewer from Alsace, bought some abandoned brewery buildings and established the Schweickhardt Brewery. The brewery was located outside the city limits but the nearby Menomonee River provided ice for production and storage. George's daughter Magdalena married Adam Gettelman, who became the owner in 1876 and changed the name to Gettelman Brewery. Adam's son Frederick—known to all as Fritz—was known for his improved brewing practices and advanced brewing equipment and "Get, Get, Gettelman" became a well-known slogan in Milwaukee. In 1949, Gettelman invented the six-pack of nonreturnable bottles which were known as a "Basket O' Beer."

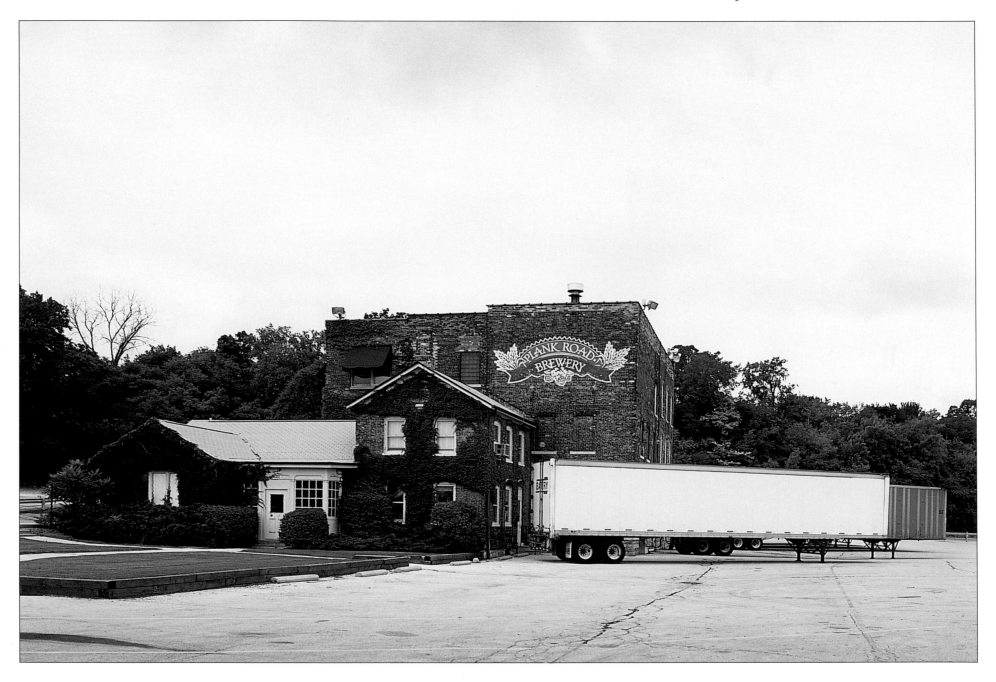

In 1961, Gettelman sold out to its friendly neighbor on State Street—Miller Brewing. This remained an ideal spot for a brewery, as in addition to the ice taken from the Menomonee River, good water also flowed from the wells. The site is still known as Plank Road Brewery, although it is owned by Miller.

Today Miller is the only one of the large breweries still in operation in Milwaukee. It is the second largest brewer in the United States and has branches in over eighty countries worldwide. Miller still has contracts to produce Pabst and Schlitz beers.

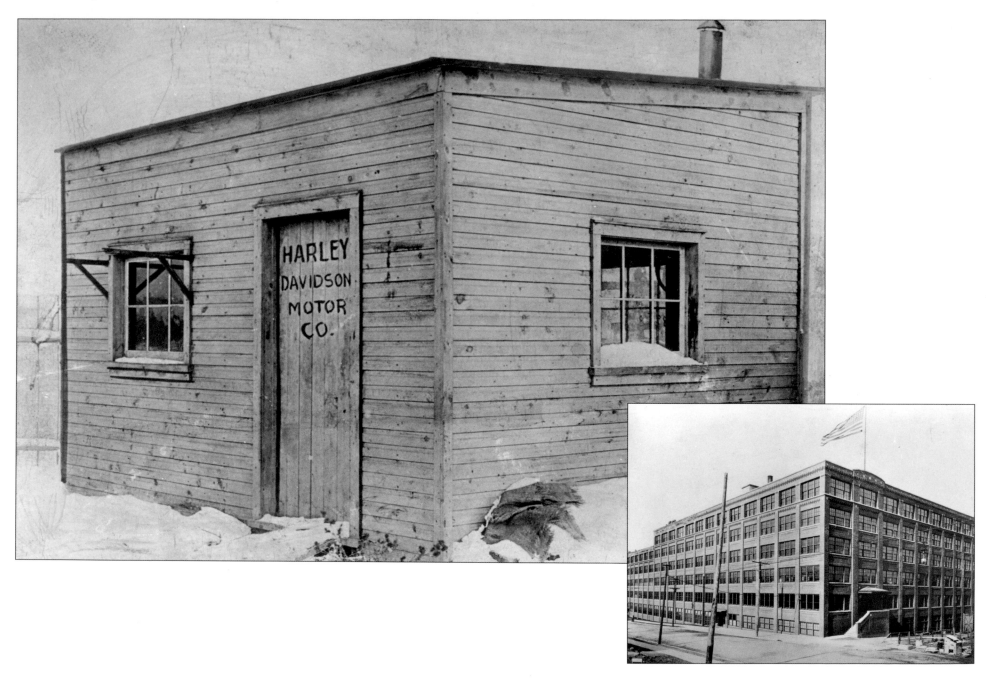

William Harley met Arthur Davidson when they were both working for a metal fabrication company in Milwaukee; William was a draftsman and Arthur was a pattern maker, and in 1901 they set about making a motorcycle after their plans to build an outboard motor for fishing trips fell through. From a humble, ten-by-fifteen-foot wooden shed emerged what would become the world's most charismatic motorcycle marque. With the help of Arthur's two brothers, William and Walter, three machines were produced in 1903 and again in 1904, until in 1906 they bought a site in Chester Street, (later to be renamed Juneau Avenue) and built their first factory. The first year's production was fifty "silent gray fellows" retailing at $200. The inset shows a later factory that was built in 1918. All photographs courtesy of Harley-Davidson Photography & Imaging, copyright Harley-Davidson.

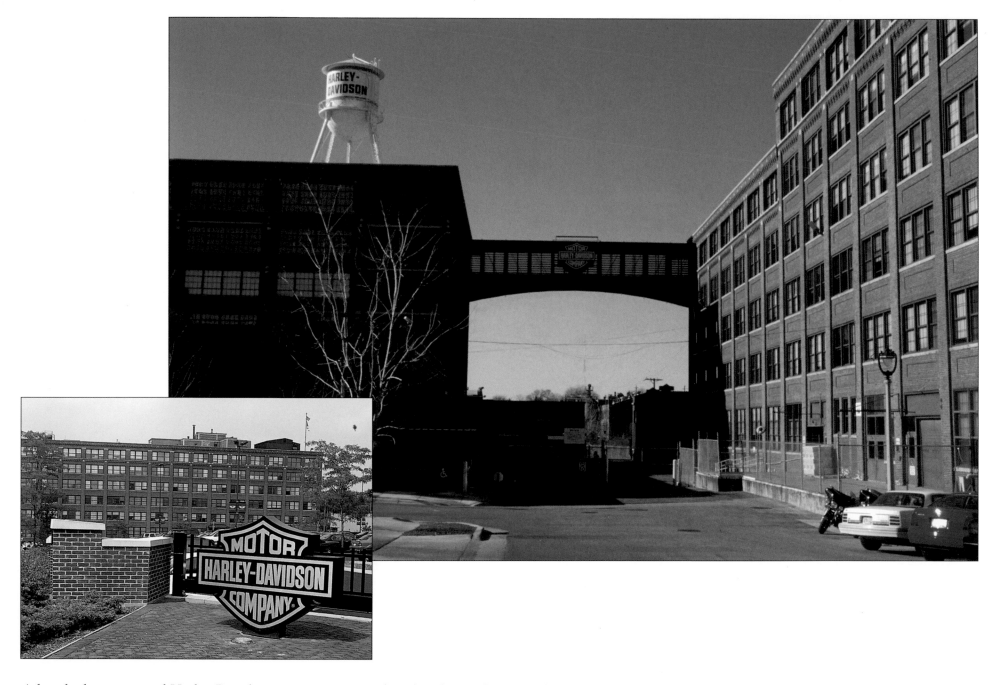

A hundred years on and Harley-Davidson is synonymous with Milwaukee and quality motorcycles. Though the assembly of machines and the production of engines and transmissions has been spread further afield in the United States, the Juneau Avenue site is still the world headquarters of Harley-Davidson Motor Company. World War I had transformed the fortunes of the company, which built its early reputation on producing durable, reliable machines. In 1918 half of all Harley-Davidsons were sold to the U.S. military. Through the 1920s and '30s the company built on its reputation for innovation and engineering excellence, and during the 1960s and '70s, it fought off the "Japanese invasion" that was to see many leading European manufacturers go to the wall. In 2003 Milwaukee played host to 200,000 Harley-Davidson fans who descended on the city for the company's centennial celebrations.

Washington Park, or West Park, as it was originally called, was another of the six original park sites chosen by the Milwaukee Park Commission. Landscape architect Frederick Law Olmsted designed Washington Park, which featured carriage drives, a horse-racing track, an observation platform, a band shell, and the Milwaukee Zoo. There had been a display of small animals and birds in the park barn as early as 1892, and by 1907, the zoo was the sixth largest in the country. With the addition of an elephant in 1907, the zoo began to develop as a major tourist attraction.

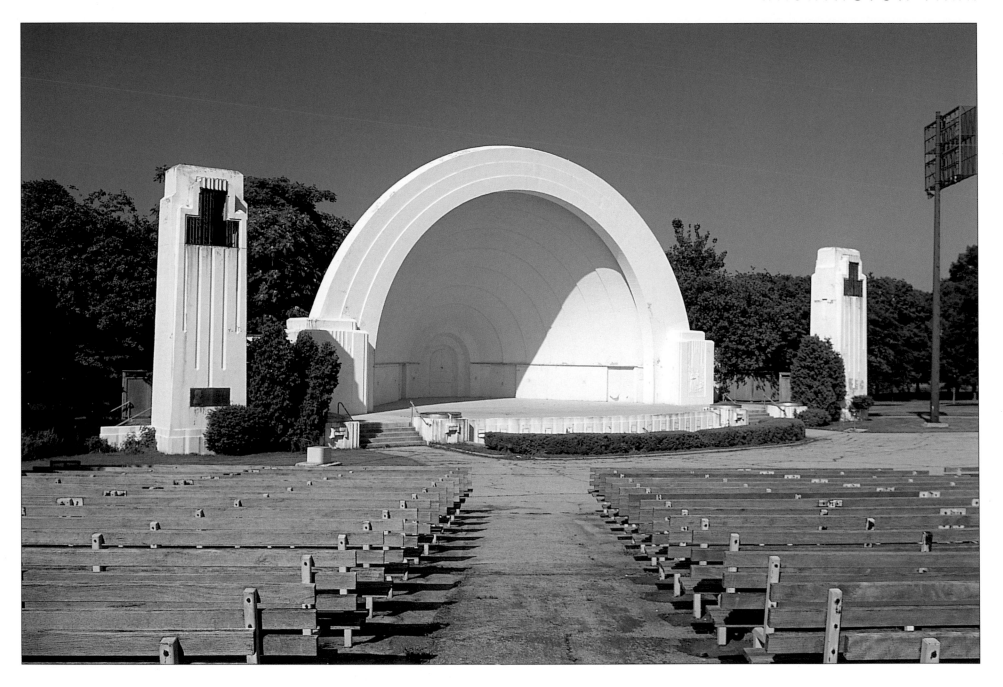

The zoo was moved in 1958 to its present location on Blue Mound Road to make way for the freeway. Today's zoo is considered one of the best in the world. Washington Park now contains a large lagoon, spacious picnic areas, a ball field where the racing track had been located, tennis courts, and a swimming pool. There is a replica of a statue from Saxony, Germany, honoring the two celebrated German poets Fredrich von Schiller and Johann Wolfgang von Goethe, located atop the hill behind the seating section of the Blatz Temple of Music, which is shown above.

Calvary Cemetery, founded in 1854 by Bishop John Henni (Milwaukee's first Catholic bishop), is the oldest Catholic cemetery in Milwaukee. This, the third site of Calvary Cemetery, is located in what had been the town of Wauwatosa. The land was consecrated on November 2, 1857. This view shows the Milwaukee Electric Railway and Light Company's Wells Street streetcar line that headed south at Fifty-second Street and then west past Calvary Cemetery on its way to West Allis. The line was in existence until the 1950s.

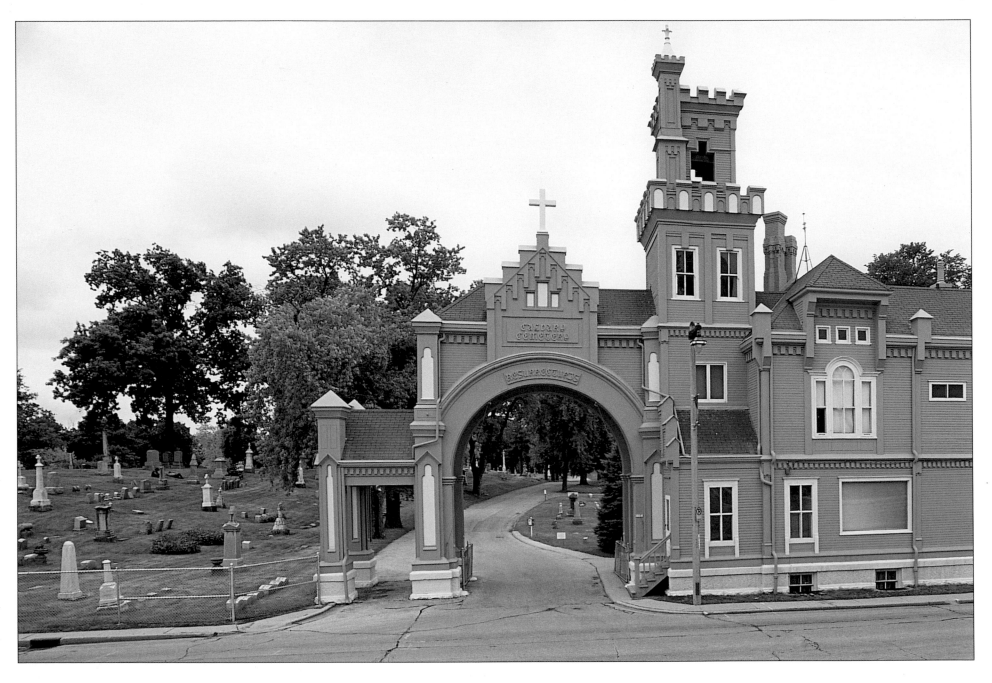

Many of Milwaukee's early Catholic businessmen are buried here including meatpacker Patrick Cudahy, architect Victor Schulte, and brewer Fred Miller. Calvary is also the final resting place of city founder Solomon Juneau. In 1958, the Milwaukee Electric Railway and Light Company's Wells-West Allis Branch trackage was abandoned. Today the Interstate Highway 94 runs parallel to the old streetcar lines. Historic Milwaukee offers tours at both Calvary and Forest Home Cemeteries during the summer months. The tours for Calvary meet at this impressive gate house, the entrance to the cemetery.

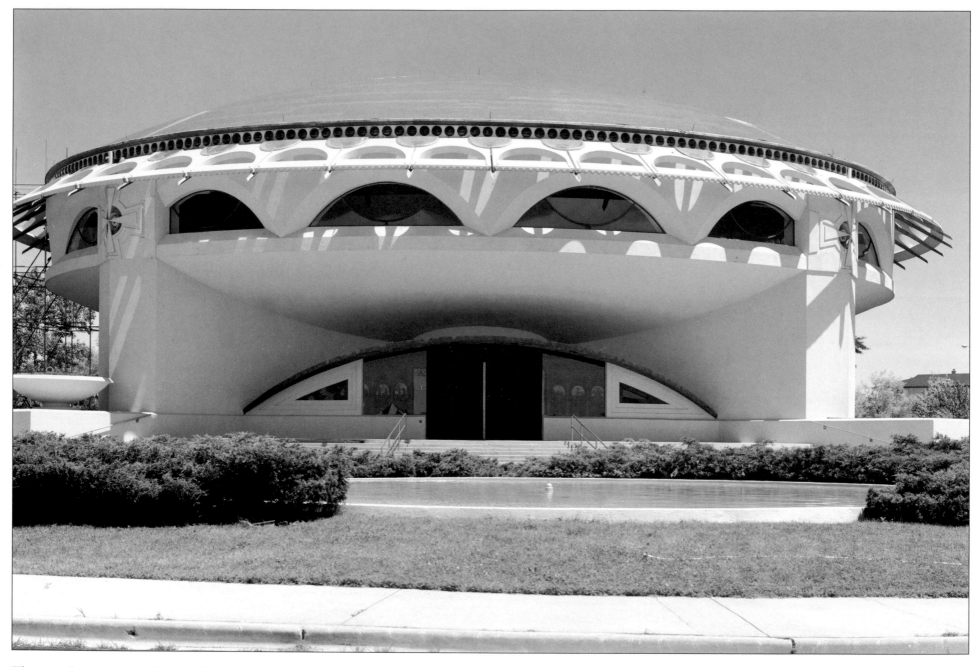

The award-winning building of the Annunciation Greek Orthodox Church, designed by the renowned architect Frank Lloyd Wright, has been given the nickname of "Flying Saucer" by many local people. The Greek community of Milwaukee, while small, was very cohesive and the idea for a new church was the dream of one Stasinos Papastasinou (later to take the Americanized name Stanley Stacy), who organized the building committee in 1952. This masterpiece of form and structure, hardly recognizable by traditional Greek Orthodox standards, is a concrete shell and the dome is supported on thousands of ball bearings that allow it to expand and contract in extreme temperature changes without cracking. The roof was originally surfaced with a blue ceramic mosaic tile, which was later replaced by a synthetic plastic resin. The building is shown here in 1959 just three years after it was completed.

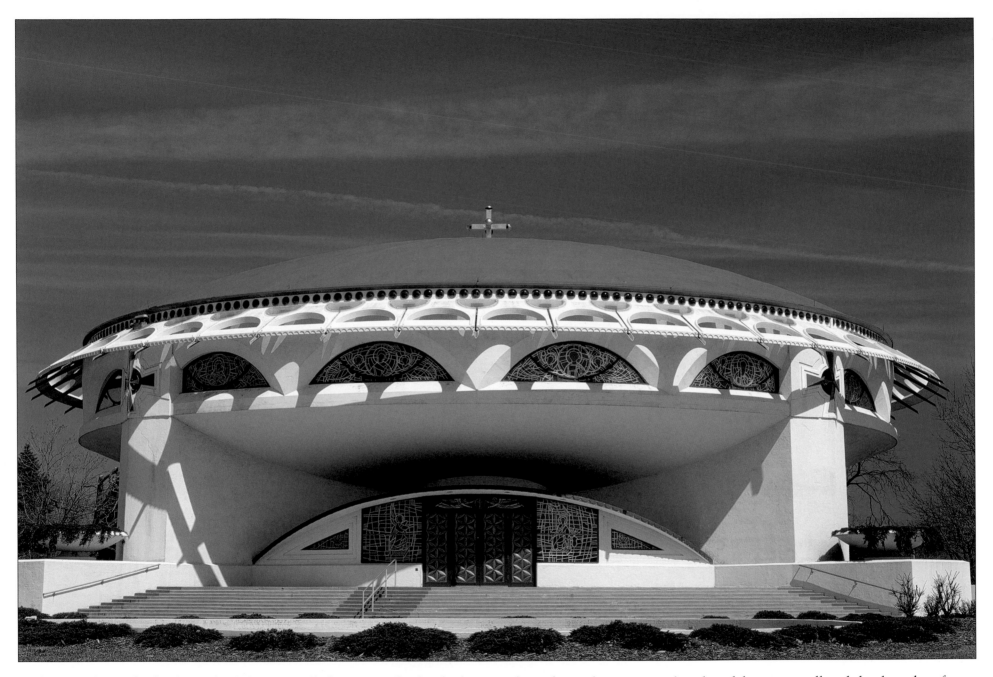

Unfortunately Frank Lloyd Wright did not actually live to see the finished result, as he died in 1959. The symbols of the Greek Orthodox faith that Wright incorporated into the plan of the church are translated into the decorative elements of the building and appear throughout the sanctuary. Light enters the building through semicircular windows and 325 transparent glass spheres that separate the edge of the upper wall and the domed roof. The art-glass windows shown in the contemporary photograph were installed many years after the building's completion and were not designed by Wright. It is open today both for religious services and for tours.

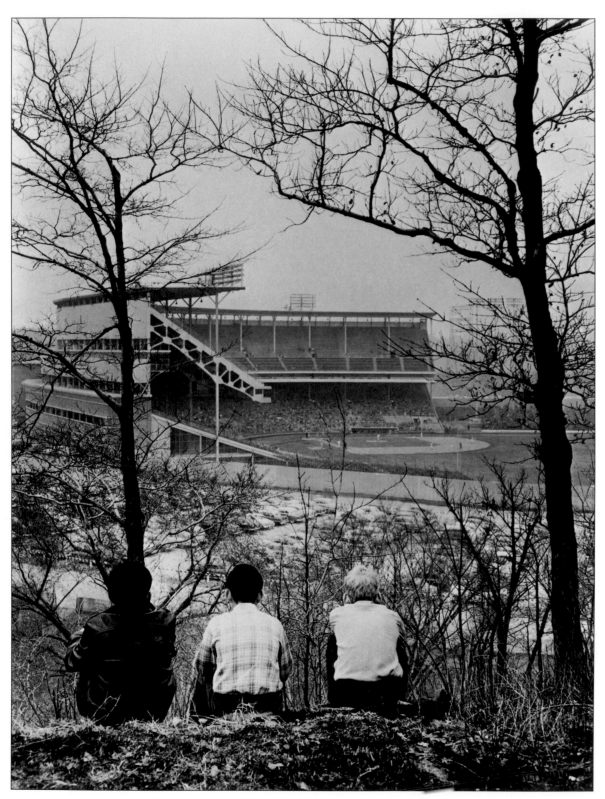

Lou Perini brought the Boston Braves to Milwaukee in 1953 and built Milwaukee County Stadium to house them. It was the first time a team had moved in modern league history. The stadium had 36,000 seats—a National League record—and before the stadium's upper level was expanded, veterans from the National Soldiers Home would sit on the top of the bluff and watch the games. The Braves won the World Series in 1957, but by 1965 they had moved again, this time to Atlanta. In 1970, the Seattle Pilots of the American League moved to Milwaukee and became the Milwaukee Brewers.

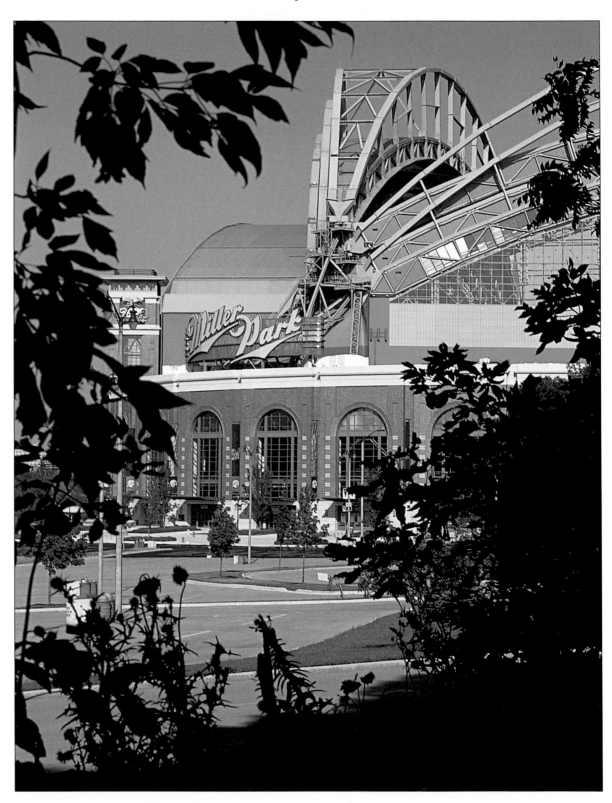

The Milwaukee Brewers, now a National League team, needed a larger stadium in order to stay competitive. There was a lengthy debate about whether to build the new stadium downtown or next to the old stadium at the west end of the Menomonee River Valley. The valley location won out and construction on Miller Park began. On July 14, 1999, Big Blue, a large crane, collapsed, causing the deaths of three construction workers and delaying the opening of the park by a year. The new stadium, with its retractable roof and old world features, is a commanding presence in the valley.

In 1864, Grand Avenue Congregational Church member Lydia Hewett led a major effort to obtain a charter and funding for a permanent soldiers home. After holding a gigantic fair in 1865, the churchwomen purchased twenty-six acres of land on Wisconsin Avenue. At the same time, there was a move by Congress to develop a larger system of care for veterans, and Milwaukee founder George Walker was influential in getting the home established. The women's group was persuaded to donate its land and resources, and in January 1867, 382 acres were purchased west of the city. The main building was designed by E. T. Mix and used to house the veterans.

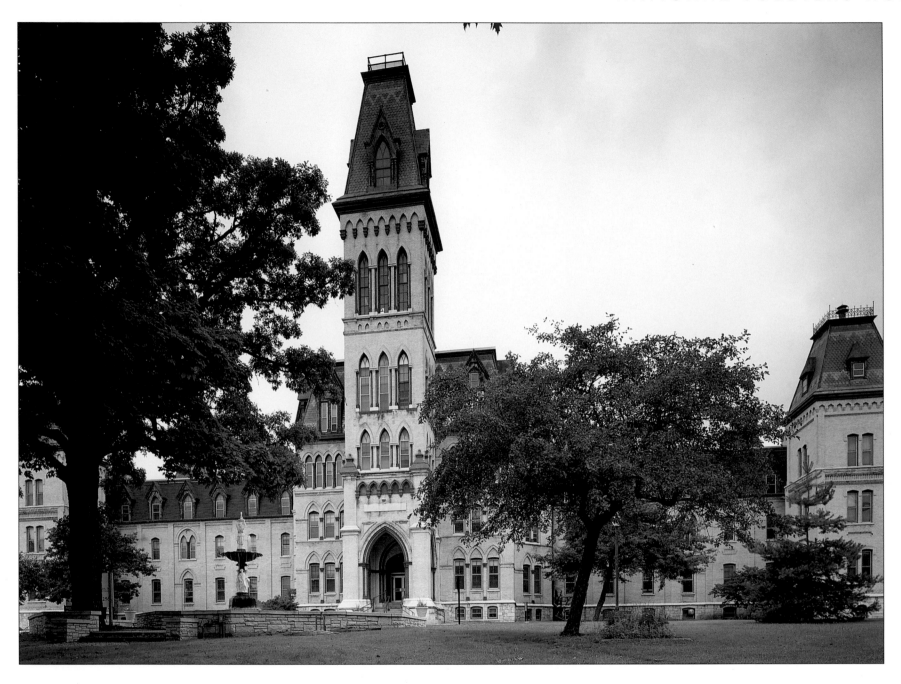

The main building of the National Soldiers Home is still in use as a domiciliary and had one of the first operating elevators in the state. The main part of the building looks the same now as it did in 1876 when the corner towers were added. In 1989, the building's exterior was cleaned and the window casings were painted. The tower, with its striking roof design, is visible from the freeway, and the cast iron fountain features a female figure holding an urn above her head. Previously the fountain had been torn down, and it was remodeled using parts from the original fountain from the 1870s.

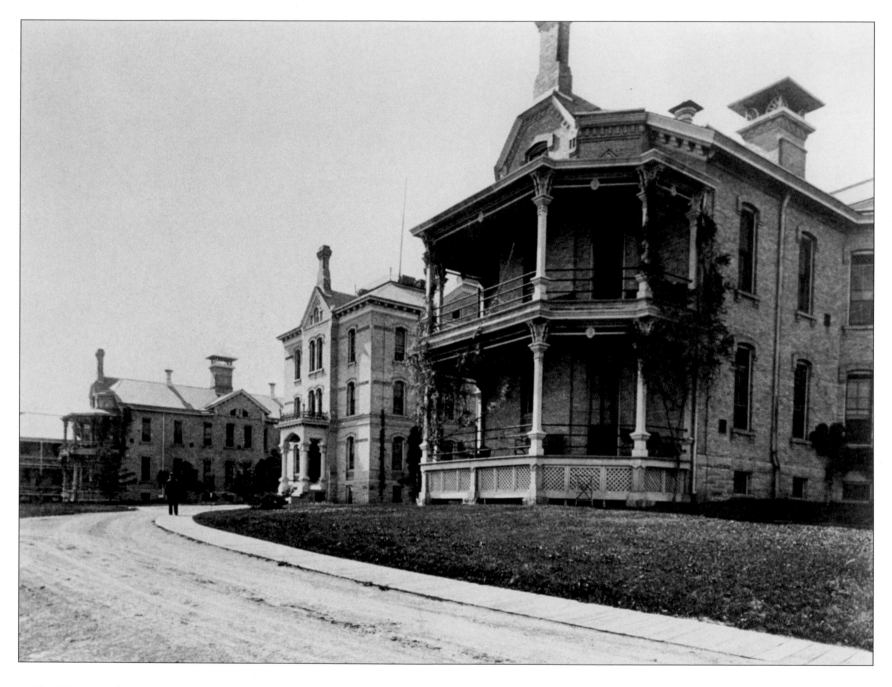

The second building on the right was built on the grounds of the National Soldiers Home in 1879 as the third hospital and convalescent ward for Civil War veterans. The building on the far left was built in 1898 and was a "TB camp." Until 1884, admission to the Soldiers Home was limited to men injured or chronically ill from conditions related to army service. In 1884, admission was opened to all disabled veterans and the Soldiers Home was totally unprepared for the rush. As a result, other buildings flanking the hospital were added in 1886.

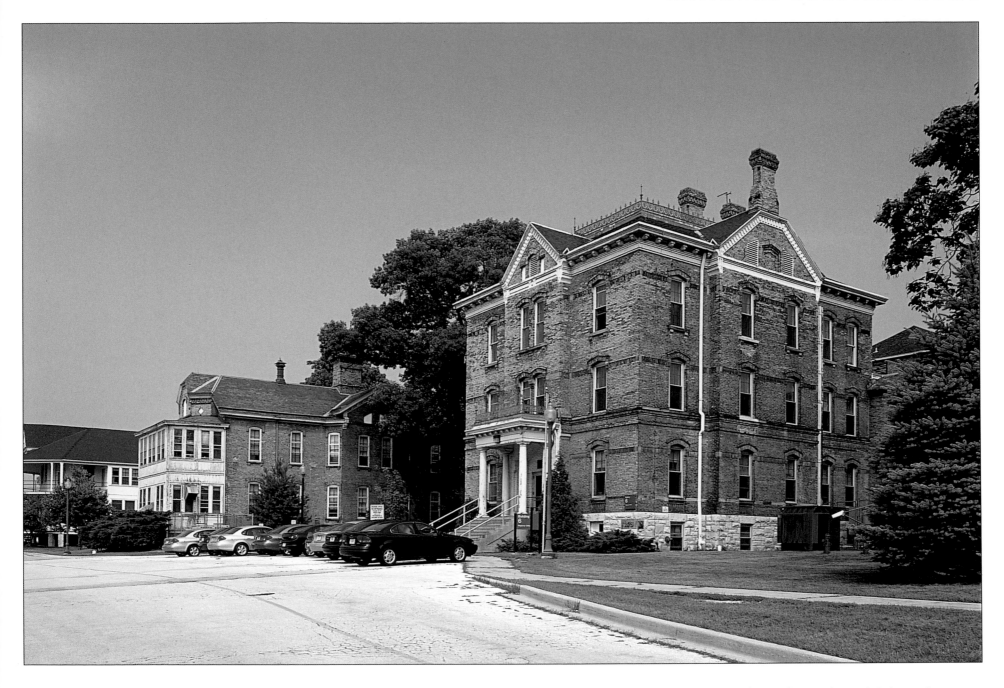

These buildings are now referred to as Building No. 6 and are used as the regional office of the Veterans' Affairs Department of Veterans Benefits. Today's veterans are treated at the modern Zablocki Medical Center located on the south end of the grounds. Across the street from Building No. 6 is the recreation hall, built in 1894, with a bowling alley, pool tables, and a clinical area for recreation therapists. Next to this is the Wadsworth Library from 1891 that serves patients and medical center employees. Beyond the old "TB camp" is Woods National Cemetery, which opened in 1871. The headstones bear the veteran's name, date of death, and dates of military service.

St. Paul's Episcopal Church was formed in 1838 and this progressive church featured many prominent citizens as its members. In time, St. Paul's would become one of the wealthiest and most influential Episcopal congregations in Wisconsin. In 1847, they appointed a cemetery committee to see if a suitable site for a burial ground for the church could be found. Their plan soon expanded and they envisioned the need for a "cemetery for the city." In 1850, land was purchased that lay nearly two miles beyond the settled portion of the city, but was within easy reach of city dwellers because of the newly built Janesville Plank Road. Forest Home is the resting place of city founders Byron Kilbourn and George Walker.

In 2000, Forest Home Cemetery celebrated its 150th anniversary. Its good condition can be attributed to the wisdom and vision of the people of St. Paul's, who founded the cemetery as a permanent, nonprofit public trust. From every purchase of a plot, money goes into a perpetual care fund for the upkeep and protection of the cemetery. The large monument is the Newhall House Fire Monument. Newhall House was one of the premier hotels of the Midwest that was destroyed by fire in 1883. The coroner officially listed seventy-one dead, with forty-three unidentifiable bodies. Forest Home Cemetery trustees donated this plot to the city for a mass grave for sixty-four of these victims.

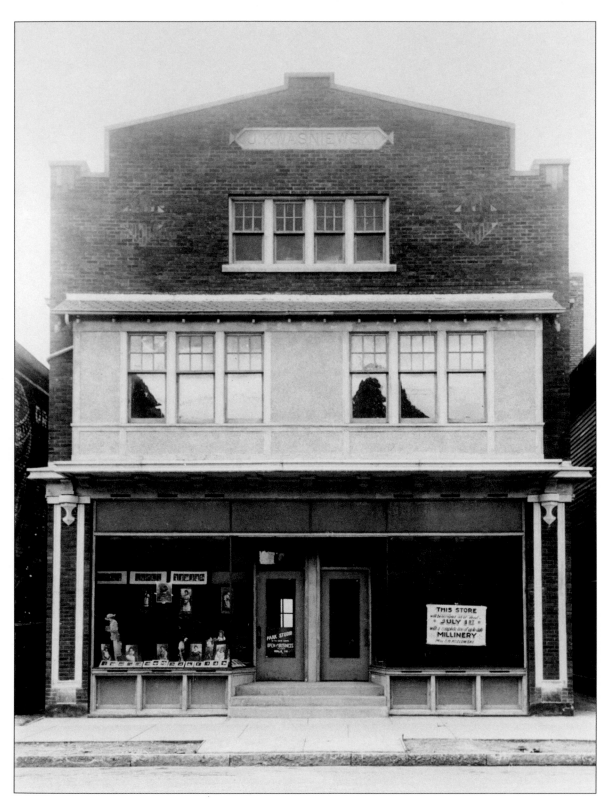

Lincoln Avenue's businesses catered to the Polish immigrants who were settling on the south side of Milwaukee. By 1915, Milwaukee County's Polish population had grown to over 100,000, with the majority of them settling south of Greenfield Avenue. Joseph Kwasniewski took out a permit to construct this building in 1916, and in 1924, he and his wife opened the Art Flower Shop. Their son Roman opened a photography studio at Tenth and Lincoln and later moved the business to this location. The photography business closed in 1952, but Kwasniewski's photographs and negatives, over 20,000 in number, were donated to the University of Wisconsin-Milwaukee archives. They serve as an important historical resource of Milwaukee's Polish neighborhoods and cultural life.

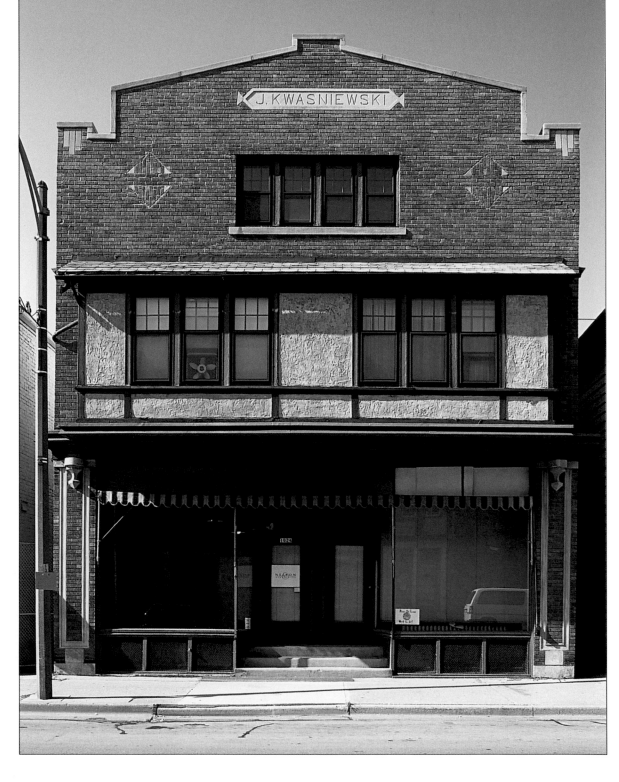

Lincoln Avenue was the heart of the Polish community for many years. Anchored by St. Josaphat's on the east and Forest Home Cemetery on the west, Lincoln Avenue merchants catered to the immigrants' needs. Kosciuszko Park was a popular gathering place, with its lagoon, tennis courts, and swimming pool. Lincoln State Bank at Thirteenth Street had the first drive-up banking windows in Milwaukee. Over the last decade, new businesses have taken up residence along Lincoln Avenue including a pottery shop in the old photo studio at Tenth and Lincoln. Nelson & Associates is now located in the Kwasniewski building. They do digital photography and digital printing, so the building once again functions as a photo shop—albeit using new technology.

St. Josaphat's congregation, founded by immigrant Poles, was an offshoot of St. Stanislaus and was formed in 1888. When the parish's second church proved to be too small, Pastor William Grutza conceived the idea of a new magnificent church. Architect Erhard Brielmaier was hired to draw up the plans that were virtually completed when Grutza learned that the old Federal Building of Chicago was being razed and the materials were for sale. The materials were purchased and brought to Milwaukee on about 500 railroad flatcars. Parishioners did all the work for the building, from digging for the foundation to capping the dome. St. Josaphat's was dedicated in 1901 and 4,000 people attended the ceremony. The church's interior was decorated in 1926. The parish church was granted basilica status in 1929 and was only the third basilica in the United States.

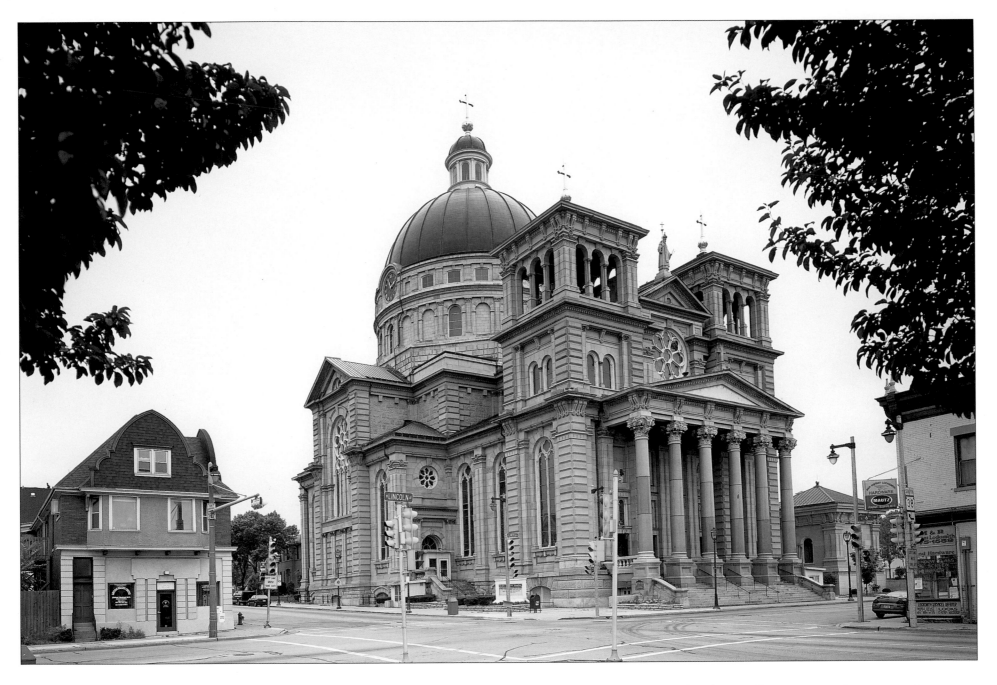

Maintenance of the basilica was always an ongoing process. A fire in 1944 caused smoke damage to the murals, and a severe summer storm in 1984 ripped off a copper sheet on the dome, causing water damage to the interior. In 1990, the St. Josaphat's Basilica Foundation was established and they embarked on a $2.5 million city-wide campaign to raise money to restore the exterior of the church. A further $2.3 million was raised to restore the interior. Both projects were completed by 1997, and in 2000, a $2.2 million visitors' center was also completed. The basilica was given historic designation by the City of Milwaukee in 1987.

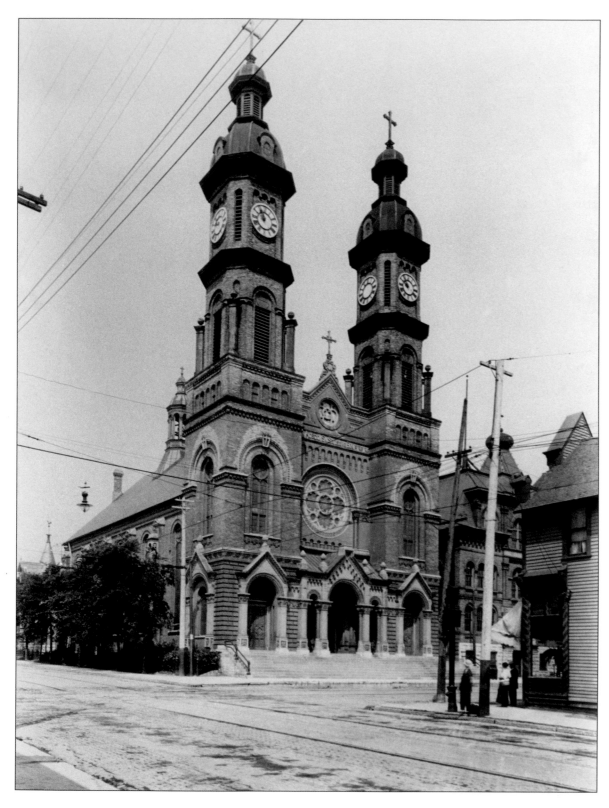

St. Stanislaus was the third Polish Roman Catholic church in the United States, the first in an urban area, and the first to establish a parochial school with Polish nuns. After worshipping in several other spaces, the need for their own church became evident, and each member of the congregation agreed to pay thirty dollars for the new building—a sum greater than a month's wages in those days. St. Stanislaus was completed in 1873 and the twin-towered church is based on middle-European styles. The school building to the right was constructed in 1889.

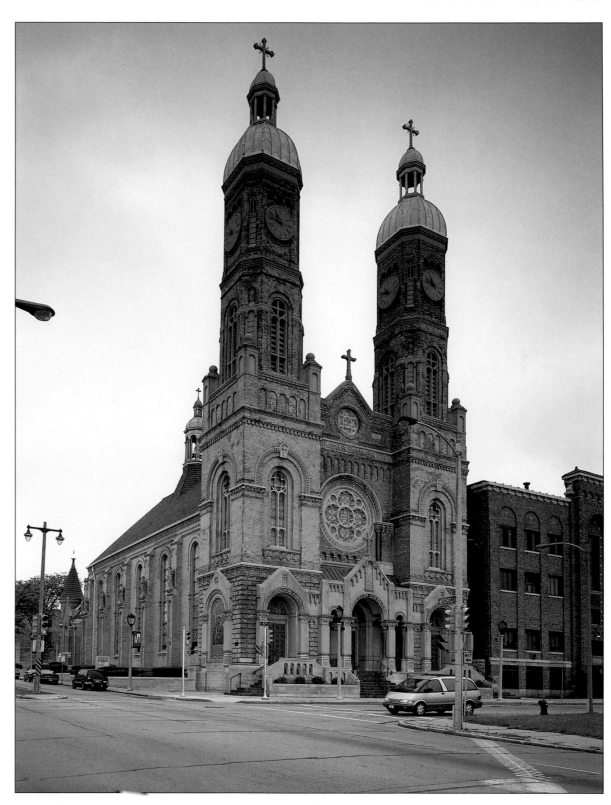

There were major alterations to the church in 1966 when the original sheet copper domes were replaced and covered with twenty-three-karat gold leaf and the stained-glass windows were replaced with contemporary ones. The Mitchell Street facade's mosaic of Our Lady of Czestachowa, the Black Madonna, was also added then. The school was expanded in 1926 and a new facade was added to the old building. Like St. Josaphat's, St. Stanislaus remains a vital part of this changing neighborhood.

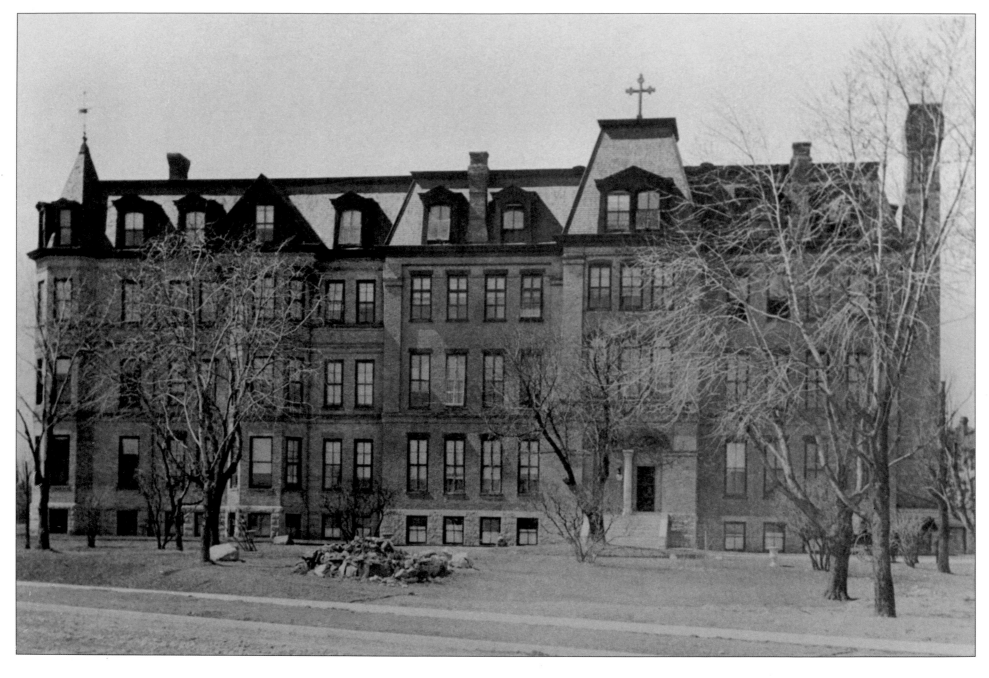

The land for St. Mary's Hospital was given to the Daughters of Charity of St. Vincent de Paul in 1859, in return for the services they had rendered to Milwaukee during a cholera epidemic. Prior to this, the three-acre site was occupied by an almshouse, a potter's field, and a city-owned poor farm (that later moved to the Milwaukee County grounds in Wauwatosa).

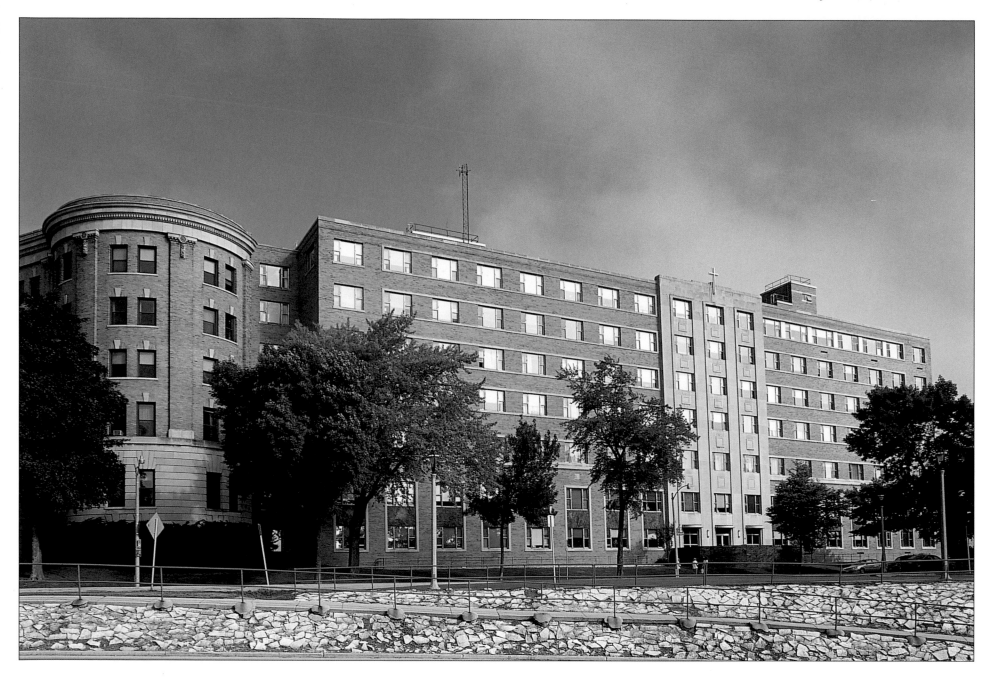

A hospital has been on this site ever since. The present St. Mary's Hospital was built in 1910. The Beaux Arts–style building, designed by Esenwein & Johnson of Buffalo, New York, suited the grand civic schemes of the "City Beautiful" movement that was occurring throughout the country at the time. With the recent merger of Columbia and St. Mary's hospitals, plans are underway to expand the campus. The Water Tower Landmark Trust, a neighborhood group dedicated to preserving the historic character of the area, has been working with the hospital on those plans so that the magnificent views of Lake Michigan are preserved.

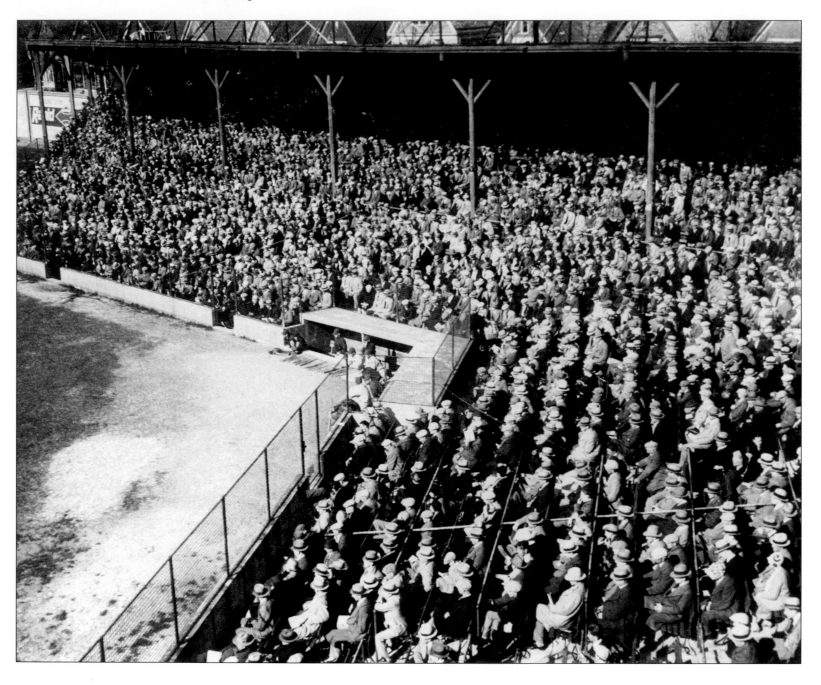

Borchert Field, from 1902 until 1952, was the home of the minor league Milwaukee Brewers. Milwaukee was always involved in sports and from the beginning there was bowling, curling clubs, rowing clubs, and, most especially, baseball. It is said that the first professional baseball team was organized here in 1860. Milwaukee clubs played in the American Association and the Northwestern and Western leagues and used four different fenced-in playing fields. Borchert Field lasted the longest. The first night game there in June of 1935 drew 4,747 fans to see baseball played under the new electric lights.

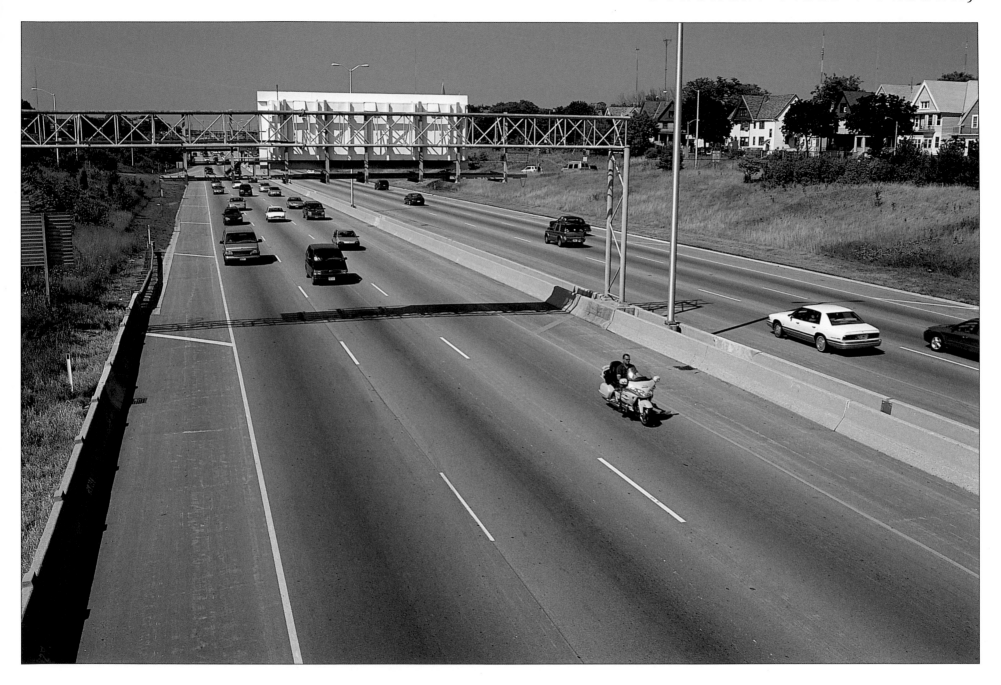

As in most cities, while the freeway systems initially allowed for freer flow of traffic, their construction was devastating to neighborhoods—especially in the poorer sections of town where they tended to be built. In this area on the north side of town, the freeway displaced 613 households and over four hundred businesses were demolished, which decimated the old close-knit African American Bronzeville neighborhood completely. Borchert Field was also lost during the construction. A wide area was also cleared from North Avenue to Sherman Boulevard in order to build the Park West Freeway, but this was never completed. While much of that land is still vacant, new construction is beginning to add affordable housing options for area residents.

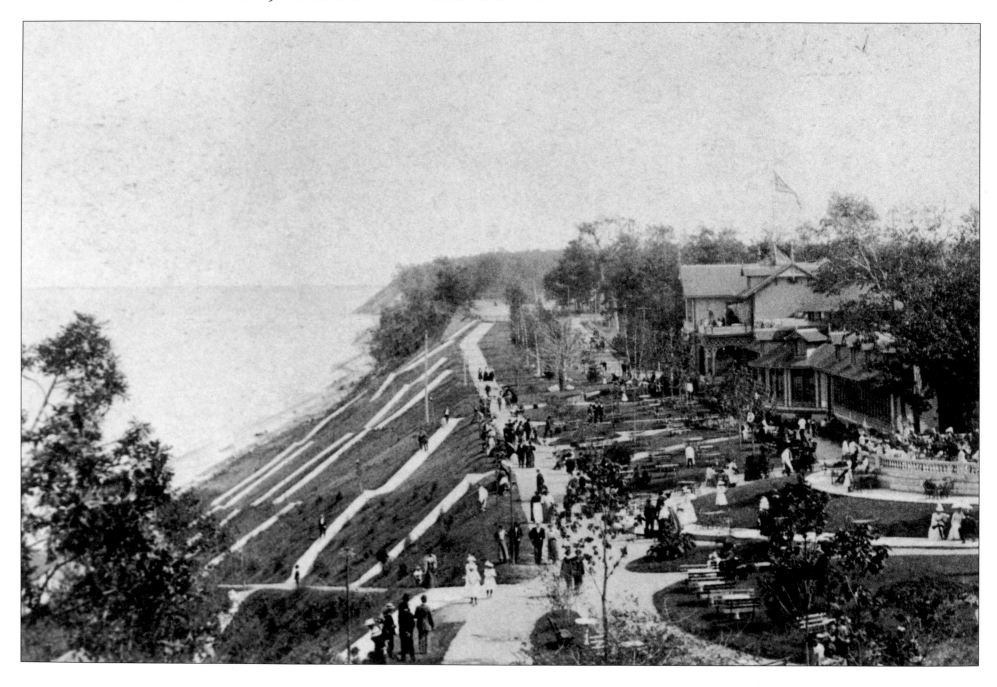

Captain Frederick Pabst established the Pabst Whitefish Bay Resort in 1889 on a narrow strip of Lake Bluff property. Until 1914, people flocked to the resort to sip Pabst Blue Ribbon beer, eat planked whitefish dinners, attend concerts, and later to ride on the Ferris wheels that were installed at the northern end of the resort. People came by horse and carriage along the Lake Avenue Turnpike, on steamboats such as the Chequamaque, or on the "Dummy Line" railroad. The lakeside setting provided cooling winds during hot summer days.

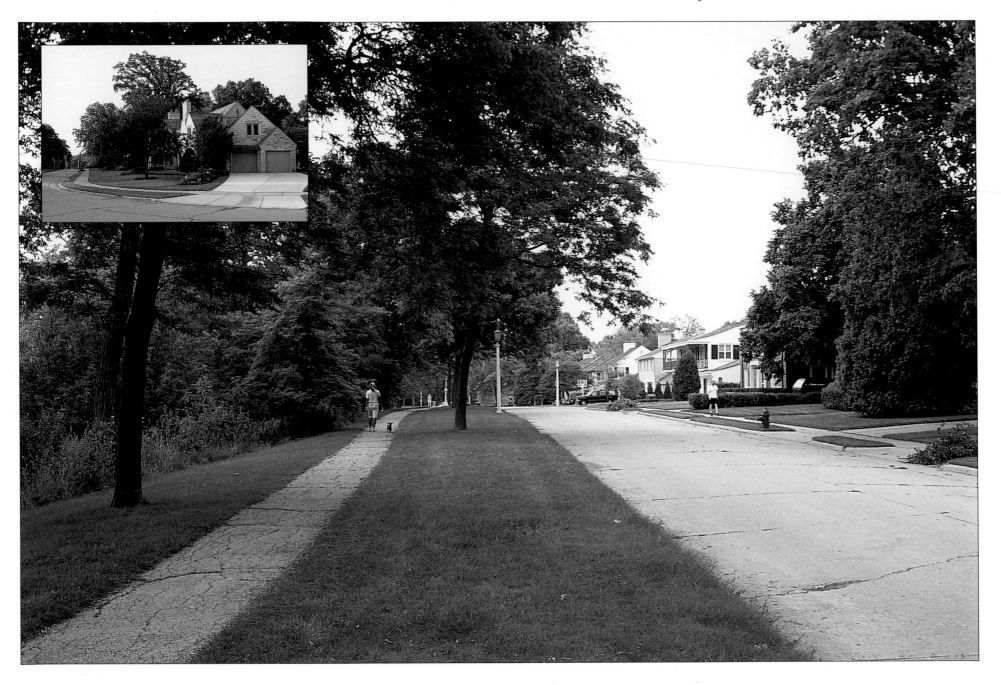

As time passed, people began to bring their own lunches to the resort instead of buying them there. The automobile made it possible to travel greater distances in a day and so resorts closer to town lost their appeal. In 1914, the resort closed and the buildings were razed. The property was subdivided into residential lots, such as the one that the Herman Uihleins moved into at what is now 5270 North Lake Drive (*inset*) in 1919. They hired the architectural firm of Kirchhoff and Rose to design their mansion. Trees now cloak the lake bluff but the slope is still visible to the left.

INDEX